MAX BECKMANN

Peter Selz

MAX BECKMANN

**WITH CONTRIBUTIONS BY
HAROLD JOACHIM
AND PERRY T. RATHBONE**

**THE MUSEUM OF
MODERN ART, NEW YORK**
IN COLLABORATION
WITH THE MUSEUM OF
FINE ARTS, BOSTON
AND THE ART INSTITUTE
OF CHICAGO

REPRINT EDITION PUBLISHED
FOR THE MUSEUM OF MODERN ART
ARNO PRESS, NEW YORK 1980

Reprint Edition 1980 by Arno Press Inc.
Max Beckmann was originally published in 1964 by The Museum
of Modern Art. All rights reserved.
The color plates have been reproduced in black and white for this
edition.
Manufactured in the United States of America

Library of Congress Cataloging in Publication Data

Selz, Peter Howard, 1919-
 Max Beckmann.

 (The Museum of Modern Art reprints)
 "Bibliography, by Inga Forslund": p.
 Includes index.
 1. Beckmann, Max, 1884-1950. I. Beckmann, Max, 1884-1950. II. Joachim,
Harold, joint author. III. Rathbone, Perry Townsend, 1911- , joint
author. IV. Series: Museum of Modern Art reprints.
ND588. B37S4 1980 759.3 79-25867
ISBN 0-405-12888-6

Contents

ACKNOWLEDGMENTS

This book on Max Beckmann, the result of some fifteen years of study, is published to coincide with the eightieth anniversary of his birth in 1884. It reflects the current preoccupation with one of the giants in the art of this century.

Above all, the author's gratitude must go to Mrs. Quappi Beckmann, the artist's widow, who has encouraged the project from its inception and has come forth with significant documentation and indispensable recollections as well as enthusiastic and sympathetic support. Many thanks are due to the contributors to this book, to Harold Joachim for his perceptive analysis of the master's prints, to Perry Rathbone, who was perhaps Beckmann's most intimate friend, for his essay, "Max Beckmann in America," to Inga Forslund for the bibliography, to Alicia Legg for the preparation of the catalogue of the Beckmann exhibition, and to Lucy Lippard for compiling the index. I also want to express my indebtedness to my wife Thalia who has made many useful suggestions during the preparation of the manuscript and to Irene Gordon for her expert editing.

The book has profited from the collaboration of many other individuals in this country and abroad. I particularly want to acknowledge the assistance of Dr. Erhard Göpel, who put many of the resources of the Beckmann Society in Munich at my disposal. Conversations with Dr. Peter Beckmann and his mother, Mrs. Minna Beckmann-Tube, have proved most helpful. I learned much from discussions with former Beckmann students, especially Walter Barker, Warren Brandt, Marielouise Motesiczky, Prof. Th. Garve, and Nathan Oliveira, and from conversations with those persons who have assembled the three largest private collections of Beckmann's work: Günther Franke, Munich, Dr. Stephan Lackner, Santa Barbara, and Morton D. May, St. Louis. I want to thank them as well as my friends Donald and Elizabeth Winston for special assistance in connection with the book which was designed by Werner Brudi and seen so efficiently through the presses by Françoise Boas. Therese Varveris has been of constant help and assistance with book and exhibition.

The Beckmann exhibition itself which accompanies this book was organized in consultation with Perry Rathbone, Director of the Museum of Fine Arts in Boston, and Harold Joachim, Curator of Prints and Drawings at the Art Institute of Chicago. On behalf of the participating museums in this country and abroad, I want to express my thankfulness to the Government of the Federal Republic of Germany for its sponsorship of the Beckmann exhibition and for its generous grants to cover transportation and insurance of all German loans. Especially helpful in these matters were Dr. Hanns-Erich Haack, Cultural Counselor of the German Embassy in Washington, and Dr. Karl Gustav Gerold of the German Foreign Office in Bonn.

Again we are obligated to Dr. Alfred Hentzen of the Hamburger Kunsthalle for allowing us to impose on him once more to expedite shipment of paintings from Germany to the United States. I also enjoyed the cooperation of Dr. Hans Platte, director of the Kunstverein in Hamburg, Dr. Ewald Rathke, director of the Kunstverein in Frankfurt, and Gabriel White, Director of Art of the Arts Council of Great Britain, and am gratified that the exhibition will be seen in three important European museums. I want to acknowledge the help of Dr. Kurt Martin, Munich, Dr. Gert von der Osten, Cologne, Dr. Werner Schmalenbach, Düsseldorf, and Dr. Günther Busch, Bremen.

Mention must be made of the assistance by others who have helped in a variety of ways: William N. Eisendrath, Jr., Susan Flynn, Philip Guston, Dimitri Hadzi, Horst W. Jansen, Virginia H. Laddey, Daniel Catton Rich, Jane Sabersky, Catherine Viviano and Frederick Zimmermann.

And finally I want to acknowledge the generosity of those collectors and museums who, by lending their important works for a long period of time, have made the exhibition possible. Their names appear on page 151.

P. S.

Komisch, daß ich immer in allen Städten die Löwen brüllen höre!

Strange, that in every city I always hear the lions roar!

Max Beckmann
Diary entry, October 23, 1947

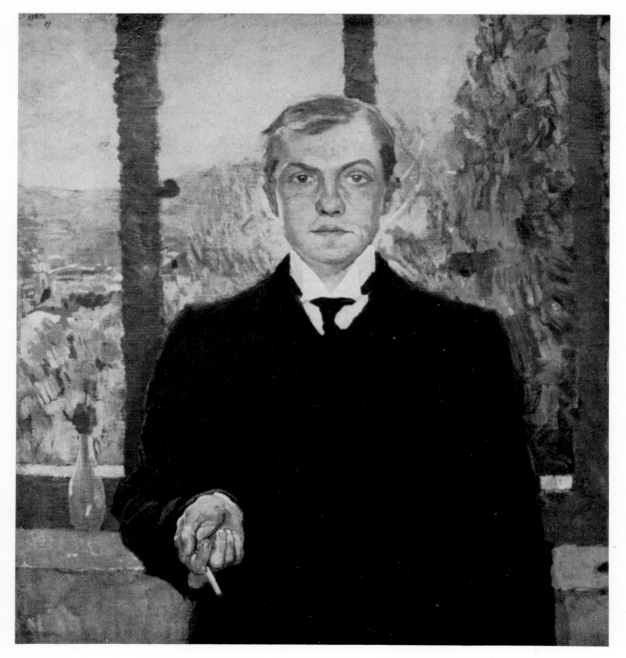

Self-Portrait, Florence. 1907. Oil on canvas, 38¹/₂ × 34⁵/₈″. Collection Dr. Peter Beckmann, Munich-Gauting

MAX BECKMANN by Peter Selz

LEIPZIG — BRAUNSCHWEIG — WEIMAR — PARIS 1884–1903

Max Beckmann had achieved a phenomenal success as an artist when, in the summer of 1914, at the age of thirty, he enlisted in the medical corps of the German army, an experience that was to change his art and his life. The year before, Paul Cassirer, arbiter of taste in the Berlin art world, had given him a successful one-man show and published a monograph on the young artist which listed one hundred and twenty-five paintings completed at that time,[1] including a number of works of such heroic dimensions that neither Cassirer nor Beckmann himself could have expected their sale. If Beckmann's style changed radically during and after the war, this grandness of scale and theme indicate the extraordinary frame of mind of the young painter who considered himself engaged in a dialogue not only with his nineteenth-century predecessors, especially Delacroix and Marées, but also with the Renaissance masters whom he studied and admired, Signorelli, Piero della Francesca, and the painter of the *Avignon Pietà*. In their work Beckmann recognized kindred spirits, artists whose profound human feeling led to an authentic formulation in unique pictorial space.

Although it took years for Beckmann to attain this authenticity, he had shown real talent at an early age. Born in the industrial city of Leipzig in 1884 where his father carried on a prosperous flour business, he was taken back to his parents' home town of Braunschweig at the age of ten. There, in a medieval city, he grew up among sober and perseverant millers and farmers, and had his first significant experiences with art when he saw and studied the magnificent collection of Rembrandts in the Herzog-Anton-Ulrich Museum, entering remarks about Rembrandt in the little sketchbook he kept as a youth.[2] Beckmann's great dialogue with the art of the past started early and never stopped. He had the deepest admiration for that other miller's son, Rembrandt, who was being newly evaluated

in the 1890's. Like the great Dutchman, Beckmann throughout his life drew his own image in a vast number of self-portraits and when, finally, he came to Amsterdam, where he lived for ten years not far from Rembrandt's Rosengracht, he referred to his idol as "the chief." Rembrandt and Bosch and Blake were the "old magicians," the "nice group of friends who can accompany you on your thorny way, the way of escape from human passion into the fantasy palace of art."[3]

The academic subjects in the Braunschweig gymnasium seem to have bored the young Beckmann, who was forever engaged in making sketches of his comrades and teachers — not only their faces, but especially their hands. When he was fifteen a sympathetic aunt took him to Dresden to enter him in the art academy there. He was given the usual entrance examination and placed in a room with a plaster cast. In addition to making a satisfactory copy of the plaster Venus, he added a composition around the statue, and was rejected for showing unwarranted independence. They tried again at the Weimar academy, where he succeeded in gaining admission and where he received a very traditional training.[4]

Around 1898, at the age of fourteen, he made an imaginative self-portrait (page 10). He is alone, sharply outlined in profile against a wide, lonely landscape, aimlessly blowing soap bubbles into the air and looking after them with a tense gaze and eager chin. This picture in the linear style of the turn of the century shows the amusingly romantic fantasy of the young painter. It is a surprisingly bold composition, for which half of the area is given over to the sky.

A few years later he created a technically brilliant etching of his face (page 114), mouth open in a scream, a stylized grimace which recalls the eighteenth-century bronze "character heads" of Franz Xaver Messerschmidt. This etching, the first of the over three hundred prints that account for one of the

great graphic oeuvres of this century, was done during Beckmann's years at the Weimar academy. He stayed there from 1900 until 1903 and studied principally with the Norwegian painter Frithjof Smith, whose practice of drawing a charcoal sketch of the total composition on the primed canvas was to stay with Beckmann for his whole life.

In 1903 the brilliant art critic, Julius Meier-Graefe, always aware of interesting young talent, saw the work of the nineteen-year-old student in Weimar and raised 3,000 marks to send him to Paris so that he "might refine his style." However, Beckmann left a few weeks later, saying, "What they do there, I already know."[5] Yet, while he was in Paris he probably encountered the *Avignon Pietà* at the exhibition *Les Primitifs français*, and was impressed with Manet, van Gogh, and Cézanne. From Paris the journeyman painter chose to go straight to Berlin, walking most of the way in order to see things.

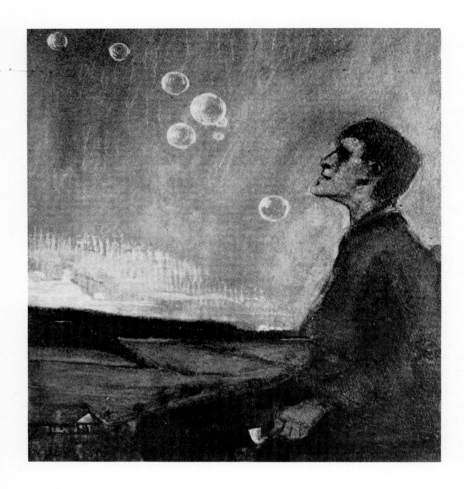

Self-Portrait with Soap Bubbles. (c. 1898). Mixed media on cardboard, $12^5/8 \times 9^7/8$". Collection Dr. Peter Beckmann, Munich-Gauting

Beckmann was a man most at home in an urban, metropolitan environment—much later, when settling in New York in 1949, he spoke of the "freedom of the large cities"[6]—and Berlin at the beginning of the century was just coming into its own as a lively European capital. It was a tough, nervous, and often brutal kind of place—a relatively new city, mainly industrial and administrative, full of vitality and energy, trying to control its undercurrents of violence with Prussian order.

Culturally, the new capital of the Reich was beginning to compete with other European capitals. Its theater, devoted to the revolutionary plays of Ibsen, Strindberg, and Hauptmann, surpassed most European stages. Writers from all over Germany and beyond now settled in Berlin.

In painting, the city was brought into national and international renown when the Secession was founded in 1892 in protest against the closing of a controversial Munch exhibition by the conservative academicians of the Verein Berliner Künstler. The Secessionists stood firmly for modern art, especially Realist, Impressionist, and Post-Impressionist painting. Under the capable leadership of Max Liebermann and the art dealers Bruno and Paul Cassirer, they exhibited works ranging from Leibl to Cézanne, opening their doors also to the younger generation in Germany, showing paintings by Nolde and Kandinsky, as well as by Beckmann, in their new large building on the Kurfürstendamm. Although the Impressionist bias of the Berlin Secession was eventually to be rejected by a new generation of painters, the enterprising Secessionists, especially Liebermann, Corinth, and Slevogt, brought individual sensitivity, strength, and imagination to Parisian plein-air painting, and their presence could not be avoided by the young Beckmann.

He made a number of beach scenes and seascapes around 1905, painted with a broad brush and a heavy, long, curving stroke; in a canvas like *Gray Sea* (page 12) the stroke, although an extension of the Neo-Impressionist *tache*, in fact resembles the rhythmic movement of the waves themselves. Though the brushstroke shows the impact of van Gogh and the general grayness of the picture reminds one of Liebermann's seascapes, Beckmann seems more influenced by Art Nouveau by the way in which he fills the whole canvas with the overall decorative pattern of the sea, interrupting the waves only by the mere indication of a pier. Beckmann loved the sea and whenever possible throughout his life he went there to experience the freedom of its vast expanse, which at the same time filled him with awe and anxiety. Incredibly sensitive to space, it was at the sea that again and again he became disquieted by the "almost spaceless infinity," which led him to both "deep depressions and wild consciousness of the self."[7]

The sea is the background in the large and ambitious composition, *Young Men by the Sea*, of 1905 (page 13). In this virtuoso piece he shows what he had learned. The six young nude men, each painted in a different position, are proof of his anatomical knowledge and do homage to the grand compositions of Signorelli and Marées, whom he greatly admired. The bathers, sea, and sky in the middle and background are done in the vigorous Impressionist technique of *plein-air* painting, but there is little formal relationship between them and the men in the foreground. Many of the motifs we see here reappear throughout his work: the young man playing the pipes on the right, for example—probably influenced by a similar figure in Signorelli's *Court of Pan*, then in the Kaiser-Friedrich Museum—turns up again in a 1943 painting entitled *Four Men by the Sea*, in the City Art Museum of St. Louis, and bears some resemblance to the young boy in the center panel of *The Argonauts*, the last figure ever painted by Beckmann (page 99). The 1905 canvas brought the artist to national attention. He submitted it to the annual exhibition of the German Artists League in Weimar, where Count Harry Kessler, director of the Kunstgewerbemuseum, and Henry van de Velde awarded him the Villa Romana Prize for a six month's stay in Florence. The picture itself was bought by the museum in Weimar.

In 1906, before setting off for Italy, he married Minna Tube, a fellow art student at the Weimar academy whom he had

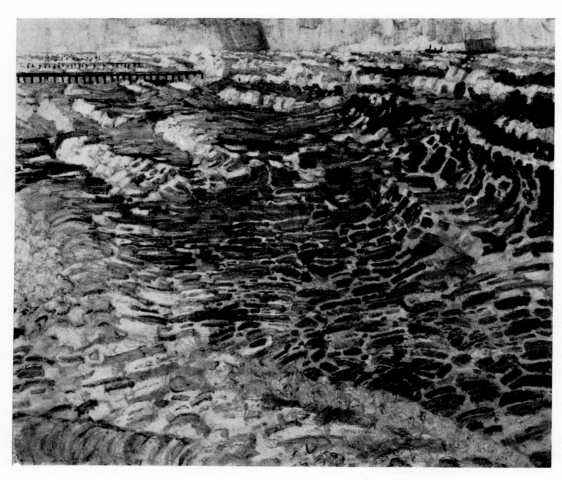

Gray Sea. 1905. Oil on canvas, 37³/₄ × 43¹/₄". Collection Dr. Peter Beckmann, Munich-Gauting

Young Men by the Sea. 1905. Oil on canvas, 58¹/₄ × 92¹/₂″. Staatliche Kunstsammlungen, Weimar

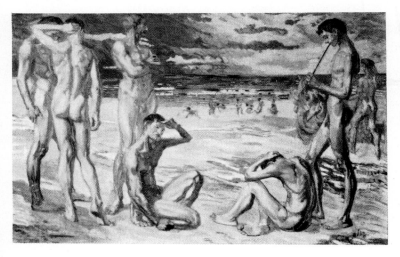

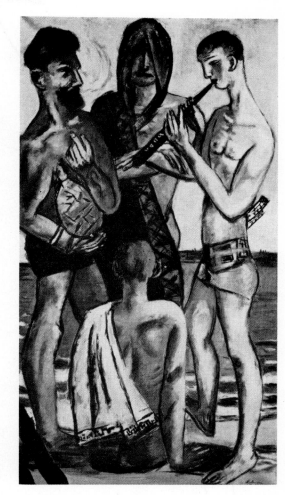

Four Men by the Sea. 1943. Oil on canvas, 74¹/₂ × 39¹/₂″. City Art Museum of St. Louis

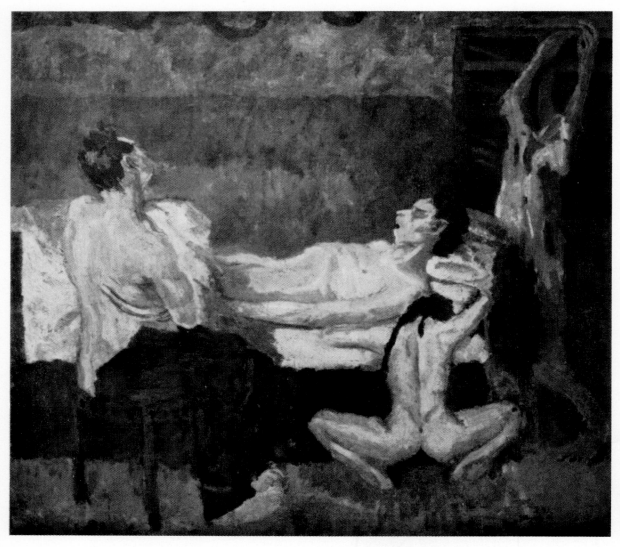

Great Death Scene. 1906. Oil on canvas, 50³/₄ × 54³/₄". Collection Günther Franke, Munich

met at a Mardi Gras costume ball in 1901. (All his life, Beckmann, the conjurer, loved the costume party, the masked ball, Pierrot and Columbine—those border areas of unreality where the essence of life often comes to the surface.) But soon after his wedding he had the first severely tragic experience of his life: his mother, to whom he had been extremely close, died of cancer in the summer of 1906. Her death brought about deep reflection and was expressed in the stirringly tragic *Great Death Scene,* painted in August 1906, a picture of despondency and agony in which three people express different modes of despair for the dead body on the bed. The woman squatting below the corpse, occupying the place of the sorrowing Virgin in early Italian Renaissance Depositions, is a most poignant image. Although the figures seem grossly overstated in the violence of their emotions, the artist tries to restrain them by means of a carefully structured composition of horizontals and verticals. The wailing woman with arms upraised at the head of the bed is contained by a perpendicular window frame, while the window itself, black and shut, seals these mourning figures off from the outside world—a device used with even greater force in Beckmann's postwar period. The light color key—indeed, the pink background—adds to the eloquence of the picture precisely because it is unexpected. There is little doubt that this picture was influenced by the work of Edvard Munch, who was held in high esteem by the younger generation in Germany. It therefore meant a great deal to the twenty-two-year-old Beckmann when Munch himself approached him with high praise for this picture, but not so much that he was ready to accept the older painter's suggestion that he orient his future work along the lines suggested by this tragic scene.

Beckmann's attitude at this time was much too positive, even optimistic, as is apparent in the worldly *Self-Portrait, Florence* (page 8). Here the young artist in his dark, rather formal attire stands in a frontal position, cigarette in hand, against the firm perpendicular of the window frame. Behind the window, in the background below, are the trees of the Florentine hills and the city itself on the left, painted in lovely light Impressionist tones. If there is even less integration between background and foreground than in the *Young Men by the Sea,* there is now a successful contrast between the dark solid mass

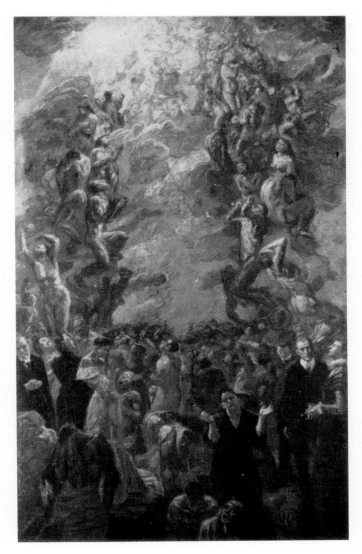

Resurrection. (1908). Oil on canvas, 12′ 11″ × 8′ 2″. Collection Dr. Peter Beckmann, Munich-Gauting

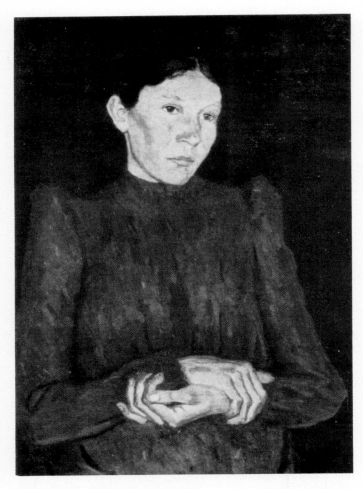

Frau Pagel. 1907. Oil on canvas, 28³/₈ × 20¹/₈″. Collection Dr. Peter Beckmann, Munich-Gauting

of the portrait and the bright, diffuse airiness of the landscape. Where they meet, where the painter has outlined the head in light colors against the landscape, the brushstroke suggests a halo—perhaps an unconscious effect, but a halo nevertheless.

Beckmann returned from Italy to Berlin by way of Paris, and settled in the suburb of Hermsdorf. In 1907 he painted the charming small portrait of Frau Pagel, simple in its stylized outlines and moving in its gesture of the clasped hands over the pregnant belly. But unassuming pictures like this become quite rare, and after Beckmann saw the important Delacroix exhibition which Meier-Graefe had arranged at Paul Cassirer's in 1907, he turned to colossal compositions which are often more rhetorical than eloquent. He painted mythological scenes in the grand style: Adam and Eve in the corner of a garlanded room, Mars leaning over the body of a sensuous Venus. He showed a predilection for religious pictures and painted a large Crucifixion with figures dancing wildly at the foot of the Cross, a huge *Resurrection* (page 15)—modeled after compositions by Rubens and El Greco—with portraits, including his own likeness, in the foreground. These compositions with their viscous brushstroke and dark pigmentation are related most closely to the large mythological paintings of Lovis Corinth. At the same time, however, Beckmann also executed the magnificent portrait of Countess S. vom Hagen which is closely related stylistically to the contemporaneous psychological interpretations of the human physiognomy by Oskar Kokoschka. But such portraits or simple cityscapes were rare in Beckmann's work at the time. Like Géricault and Delacroix, he turned to current cataclysmic events for his theme, and made large theatrical compositions as his comment on them: the *Destruction of Messina*, in 1909, the *Sinking of the Titanic*, in 1912 (page 18). If the latter lacks the feeling for human tragedy and the inventiveness of composition—or the brilliant sense of color—of the *Raft of the Medusa*, it, nevertheless, amounts to a remarkable technical accomplishment. The masses of shipwrecked survivors in their small life rafts are interlinked in one sweeping convoluted rhythm. Certain details of the action are infused with a vitality much like that soon to be seen in mob shots in the film. In fact, the whole picture resembles an old movie frame, but it goes beyond melodramatic reportage.

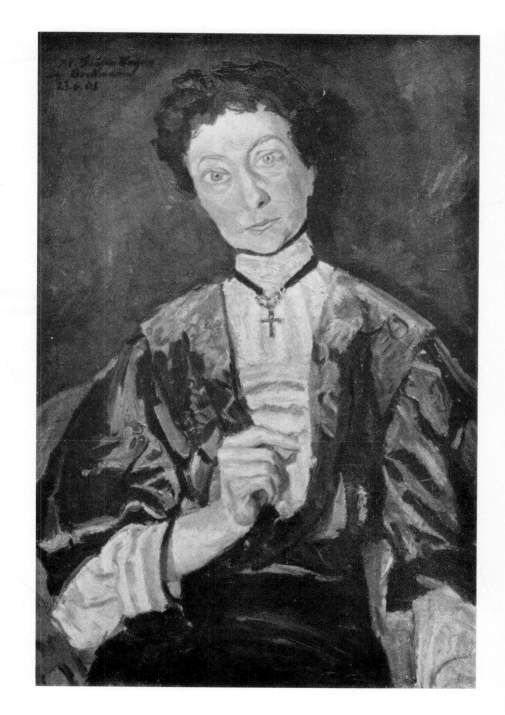

Countess S. vom Hagen. 1908. Oil on canvas,
31 × 20½″. Staatliche Kunstsammlungen,
Gemäldegalerie Neue Meister, Dresden,
German Democratic Republic

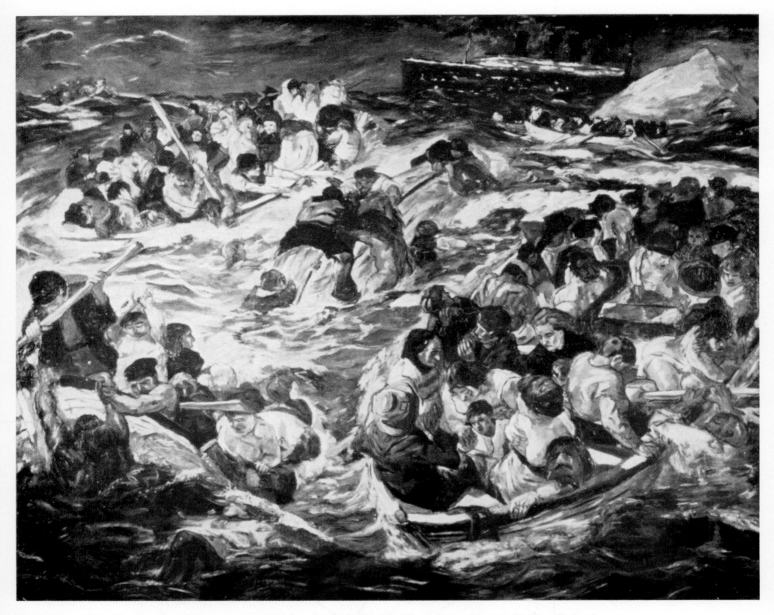

The Sinking of the Titanic. 1912. Oil on canvas, 8′ 8½″ × 10′ 10″. Collection Mr. and Mrs. Morton D. May, St. Louis

Paintings like this were greatly acclaimed and Beckmann was referred to as the "German Delacroix." As early as 1910 he was placed on the executive board of the Berlin Secession, an office generally reserved for artists twice his age. It is true that he resigned from this honorific position the following year in order to devote all his energies to painting, but he remained the great white hope of the older Secessionists, and in 1911, when he held an important large exhibition in Frankfurt, Karl Scheffler, editor of the Secession-oriented *Kunst und Künstler*, lauded him as one of the most promising young artists in Germany.[8] The Frankfurt exhibition was followed by a large retrospective in Magdeburg in 1912, where his work was seen as "a grand synthesis of the pathos of Rubens, the light of Rembrandt, and the brushstroke of the Impressionists."[9] Then, in 1913, Paul Cassirer organized a show of no less than fifty paintings and published Hans Kaiser's monograph.

It was in 1912 that Beckmann took the side of conservatism in an interesting controversy with Franz Marc, who had published an essay in *Pan* in which he spoke of the mystique of seeking "the inner, spiritual side of nature" which ultimately led toward abstraction.[10] Beckmann, who felt disinclined to abandon the tangible object itself, answered at once: "There is something that repeats itself in all good art, that is artistic sensuousness, combined with artistic objectivity toward the things represented. If that is abandoned, one arrives involuntarily in the realm of handicraft.... I, too, want to speak about quality. Quality, as I understand it. That is, the feeling for the peach-colored glimmer of the skin, for the graduated depth of space. Not only the plane but also depth. And then, above all, the appeal of the material. The surface of the oil pigment, when I think of Rembrandt, Leibl, Cézanne, or the spirited structure of the line of Hals."[11]

Even later, when Beckmann stated that he wanted to show "the idea that hides itself behind so-called reality" in his search for "the bridge which leads from the visible to the invisible,"[12] he spoke about a move toward the invisible, very different in kind from Franz Marc's or Kandinsky's. While the abstractionists of the Blue Rider were concerned with the spiritual, with rhythms and cosmic space, Beckmann continued to explore the sensual object itself, and found the mystery in its very object-ness. It is, after all, the object that will keep him from being crushed by the "dark black hole" of space, and it is space—unlimited, eternal, frightening space—which to Beckmann is the "invisible."

Space is crammed in the *Street* (page 20), one of Beckmann's most successful prewar paintings. Perhaps its highly concentrated and bursting quality was enhanced years later, when, in 1928 in Frankfurt, he cut it down to its present size, one third of its original dimension. What he preserved in this detail is an animated scene of people rushing in a narrow city street: Beckmann himself in the center, very definitely a self-portrait, his wife hurrying off to the left, his son Peter approaching the viewer in the frontal plane. On the right, a poor woman carries her child; in the back, there is a beautifully painted horse and his driver. As in a Mannerist canvas, the figures are compressed in a space too narrow for their movements, so that the whole action is pressed forward, out of the picture plane. Compared with the *Street* painted by Kirchner the year before in the same city (page 20), Beckmann's picture seems a good deal more conservative. Beckmann holds to carefully weighed color nuances, where Kirchner uses stridently bold colors. Beckmann's forms are still modeled in a traditional manner, where Kirchner has flattened them into largely two-dimensional shapes. Beckmann's light is natural light coming onto the scene from the right, whereas Kirchner's light belongs solely to the picture itself. A comparison with other avant-garde paintings of the period, of similar subjects—Delaunay's *Windows*, Boccioni's *Power of the Street*, Léger's views of the city—makes Beckmann's painting look very traditional. Indeed, he was not at that time, nor actually even afterward, an important experimenter with form. His modernity consisted rather in his attitude toward experience.

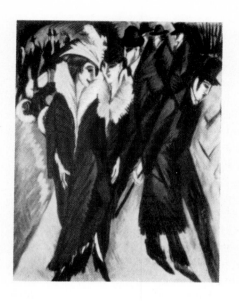

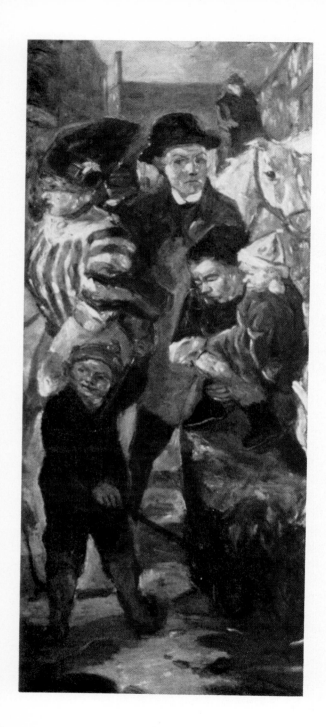

Above: Ernst Ludwig Kirchner. The Street. 1913. Oil on canvas, 47¹/₂ × 35⁷/₈″. The Museum of Modern Art, New York, purchase

Left: The Street. (1914). Oil on canvas, 67 × 28¹/₂″. Collection Mrs. Mathilde Q. Beckmann, New York

"The unhealthy and repulsive aspects of the prewar years were the commercial haste and the quest for success and influence with which each of us was infected in some way. Now, every day for four years, we have looked horror in the face. Perhaps this has touched some of us deeply."[13] Thus Beckmann wrote after the war. He was indeed profoundly affected by what he saw. At the very outbreak of the war, when most of the men of his generation jubilantly flocked to the colors, he made an etching like *Weeping Woman*—a pitiful, dumbfounded woman with a funny little hat, clutching a handkerchief and crying helplessly. This print, or the slightly later *Declaration of War* (page 22), although still largely narrative, no longer resorts to the heroic theme but presents the great tragedy of the actual event as it affected the simple people of the street.

Not wishing to be embroiled in the business of killing, Beckmann volunteered for the medical corps of the German army. By the end of September 1914, he was on the Russian front. His letters from the war[14] testify to a change of attitude during his service in the army. At first he seemed to feel that the war —what a stage for pictorial reportage!—could provide him with direct material for great history painting of a world catastrophe. Slowly he is overcome by the sobering reality of intimate, daily contact with the wounded and the dying. Only his work as an artist—the drawings and etchings he is able to do in his spare hours—keeps him going: "My will to live is at present stronger than ever, although I have already experienced great horror and have seemed to die with the others several times. But the more often one dies, the more intensively one lives. I have drawn—this is what keeps one from death and danger."[15]

Beckmann seemed to feel safe as long as he was able to put pencil to paper. The histrionics of the earlier religious and mythological canvases tend to give way in his war drawings to the simplicity and sobriety of immediately confronted experience. A drypoint like *Carrying the Wounded* exists in several states (page 22). "In the first state the head of the wounded man is reminiscent of a conventional head of Christ, and his bandage and hair recall a crown of thorns. At first glance the drypoint could be taken for a representation of the Good Samaritan. This is not true of the final state. Here all vestiges of romanticized conception and mannered execution are abandoned in favor of a more objective and simpler treatment. In the face of the carnage of war the former sentimentality apparently became useless to the artist."[16]

In February 1915, Beckmann was transferred from the base hospital on the Eastern Front to a field hospital in Courtray in Flanders. There in a small room above the emergency operat-

Weeping Woman. (1914). Drypoint, $9^{13}/_{16} \times 7^{7}/_{16}$". (G. 49 b). The Museum of Modern Art, gift of Abby Aldrich Rockefeller

Left: Carrying the Wounded. 1914. Dry-point, 6¹/₄ × 4³/₄". (not in Gallwitz). Collection Allan Frumkin, Chicago

Right: Carrying the Wounded. 1914. Dry-point, 6¹/₄ × 4³/₄". (G. 52 b). Collection Allan Frumkin, Chicago

ing room he really looked horror in the face every day and sketched what he saw. The resultant drawings and etchings are a scarifying testimony of his observations. It was there in Flanders, near Ypres, that Beckmann received his first mural commission. It is one of the great ironies of the history of modern art that the artist whose monumental form really demanded large public walls received a single mural commission and that for a large delousing bath on the Western Front. At first Beckmann approached the wall with his grandiose prewar ideas. He conceived of an oasis with palm trees in an Oriental desert and wrote of a Battle of the Dardanelles.[17] Three days later, however, he says: "I have given up my plan to paint an Oriental bath. I will paint what is around me."[18] And he actually executed the mural in true fresco in a temporary building.

In these letters from the war—unlike the diaries of his last ten years—he records his thoughts on art, his own plans for the future as a painter. He hopes to become ever more simple in his work, and more concentrated in expression without, however, giving up the fullness and the roundness of plastic form.[19] He constantly draws and etches: soldiers standing around, the carrying of the wounded, the operating room, horses, destroyed cities. As always he also finds time to read and is

Declaration of War, 1914. Drypoint, 7⁷/₈ × 9⁷/₈". (cf. G. 57). The Museum of Modern Art, New York, purchase

22

enthusiastic about Kleist's *Amphytrion*. He is deeply moved by a Cranach portrait and by fifteenth-century German paintings he sees in Brussels. His encounters with Erich Heckel and Ludwig Meidner in Flanders are of great importance to his development. He keeps writing about his "passion for painting" and how he misses paints: "If I only think of gray, green, and purple, or of black-yellow, sulphur yellow, and purple, I am overcome by a voluptuous shiver. I wish the war were over and I could paint again."[20]

On May 24, 1915, he writes about having one of a great many dreams (indeed, the twentieth) about the destruction of the world. He dreams of himself and Minna in flight along a roadway up in the mountains from which he sees infinite vaults, strange raylike white clouds of terrifying magnitude and concentrated form on a burning white sky. These white clouds have strange black cores, which turn in a vast distance. The rays that seem to come from these cores illuminate enormous rooms which are divided by dark shadows.[21]

If this sheds some light on Beckmann's actual way of seeing, another part of the same letter provides a key to his future work, in showing how he tried to become master of his somnambulistic condition by means of his art: "Oh, this infinite space! We must constantly fill up the foreground with junk so that we do not have to look in its frightening depth. What would we poor people do, if we would not always come up with some idea, like country, love, art, and religion with which we can again and again cover up that dark black hole. This limitless solitude in eternity. Being alone."[22]

In the summer of 1915 Beckmann, who had hoped to be an objective observer of events in the war, had reached a stage of complete physical and mental exhaustion and was discharged from the army. Thirty-four years later, when he was suffering from a heart condition, he wrote to his son who had become an eminent heart specialist: "Could it be that my pains are still connected to the injuries of the soul I suffered during the war?"[23]

The Morgue. 1915. Drypoint, 10¹/₈×14¹/₈". (G. 59). The Museum of Modern Art, New York, purchase

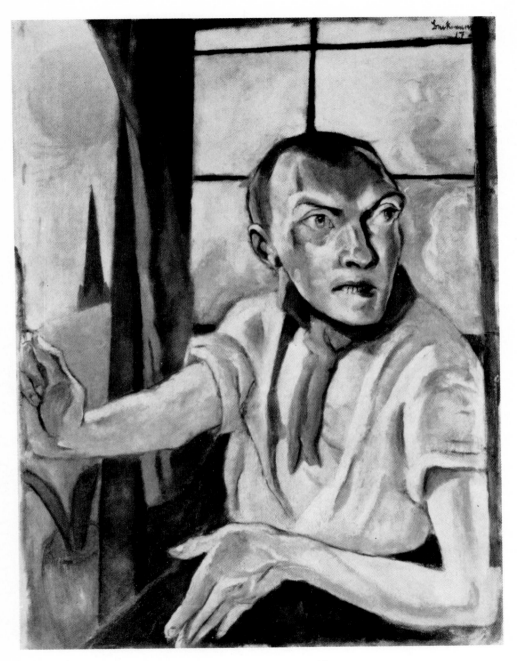

Self-Portrait with Red Scarf. 1917. Oil on canvas, 31¹/₂ × 23⁵/₈".
Württembergische Staatsgalerie, Stuttgart

Upon his discharge from the army, Beckmann settled in Frankfurt because his friend Ugi Battenberg, a former fellow student in Weimar, invited him to live with his family and share his studio. Beckmann's wife Minna, who had become a professional opera singer in the intervening years, was now living in Graz, and in any case, it seemed impossible for him to share his life with anyone after his war experiences. Art, as well as life, had to be started from scratch, and Beckmann renounced all his former achievements and the success which had resulted from them. Alfred Kubin observed that "a frantic pressure must have weighed upon Beckmann to toss out all this beautiful, hard-learned craft."[24]

In *Self-Portrait with Red Scarf* of 1917 he turns an almost grotesque face to the spectator. He sits at his easel more like a man hunted by pursuers than a painter in his studio. His shirt is torn, baring his chest, a red scarf is tied carelessly around his neck, his mouth is half open, his left eye, larger than the right, stares out in defiance. This is the romantically conceived portrait of the rebel accusing society, the man who wrote at the time: "Humility before God is done with. . . . My pictures reproach God for his errors."[25] A comparison with the *Self-Portrait, Florence* of ten years earlier (page 8) shows the drastic change in style: he now uses violent foreshortening and distortion. Pigment is applied thinly and color is light and cold, as if to counteract the emotionalism of the expression and the exaggeration of the gesture. This gesture, both violent and stylized, is related to the style of acting of the war and postwar years as it has come down to us in the abrupt movements of the early German Expressionist films. The only thing left from the earlier *Self-Portrait* is the window frame in back of the head; but now, instead of yielding a view of the beautiful hills of Fiesole, we stare at a blank yellow area, which, like a closed door, shuts out space.

For space is a fearful, terrible thing. Whereas the prewar *Street* was filled with people, the street in *Landscape with Balloon* (page 26) is open and alarmingly empty. "Not having filled up the foreground with junk," he now looks into the frightening depth of space. The viewer is thrown there very quickly by the rapid foreshortening of the houses on the left. A woman carrying an umbrella has walked by the foreboding, gray-green trees, while the gray pavement of the street resembles strange snakelike curves and a balloon hovers in the empty gray sky. Only Munch had expressed a similar anxiety in his paintings and prints. But for Munch the cause of man's anguish lies in the failure of human contact; Beckmann locates it in his conception of space.

This is true even in the religious pictures. After his return from the war, he painted a series of biblical subjects that were in great contrast to the romantically conceived and thickly painted dark canvases of the earlier Berlin period. Once more he turned to the theme of the Resurrection (page 27), but instead of a traditional composition, this unfinished canvas is a huge mural of doom, dwelling on his feeling about the war, destruction, man's fate, a world out of joint. The sun is an extinguished black disk and there is little light to brighten the pallid gray of the scene. Elongated figures reminiscent of El Greco emerge from the bursting pavements. Some of them are actual portraits: we recognize the Beckmanns and the Battenbergs on the lower right. Higher up are ghostlike figures who are distorted in their foreshortening as seen from below. These specters in their war bandages and the winding sheets of the dead stalk across the ruins. As the eye follows the linear intertwine across the ever-shifting planes, we move from scene to scene and are again reminded of the frames in a film. But the montage Beckmann has prepared for us seems to look ahead to the total destruction of cities twenty-five years later.

Beckmann worked on this picture for three years, from 1916 until 1918, when he left it unfinished.[26] He kept it standing upright in his studio in Frankfurt and facing outward, so that he and his visitors constantly saw it. It serves as a major source for the dramatis personae of his later works with their flying, foreshortened figures, stylized gestures, hooded garments. Ambitious in size as well as meaning, preoccupied with death and transfiguration, but enigmatic in iconography, it is the proto-

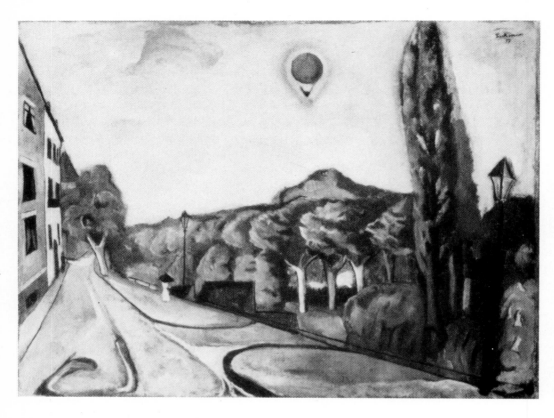

Landscape with Balloon. 1917. Oil on canvas, 29³/₄×39¹/₂". Wallraf-Richartz-Museum, Cologne

type of the triptychs. When Beckmann had to leave his large studio in Frankfurt in 1933, he took it off its stretcher, rolled it up, and carried it to Berlin, Amsterdam, St. Louis, and New York; he would doubtless have liked to be commissioned to complete it.

Instead of the wild dancers at the foot of the Cross in the painting of 1906, the principals in the *Descent from the Cross* of 1917 (page 28) are stiff, sober figures. Did the war cause this fundamental change in style or was it inherent in his nature and talent? Partly it was his new interest in German Gothic painting, which he shared with many German painters of the time and for which he now seemed accessible. When asked by J. B. Neumann, his dealer and publisher of his prints, for an introduction to the catalogue of a show of his graphic work in Berlin, he wrote: "I do not have much to write: To be the child of one's time. Naturalism against your own Self. Objectivity of the inner vision. My heart goes out to the four great painters of masculine mysticism: Mälesskircher, Grünewald, Bruegel, and van Gogh."[27]

Gabriel Mälesskircher was a Bavarian painter, active after the middle of the fifteenth century,[28] to whom the large Tegernsee altarpiece was then ascribed.[29] His heavy emotional style and his crowded compositions mark him as a pupil of Hans Multscher. Grünewald first impressed Beckmann as early as 1903 when, on his return from Paris, he visited Colmar at a time when the Isenheim Altarpiece was hardly known. As soon as the war broke out, Beckmann wrote to Wilhelm von Bode, director of the Kaiser-Friedrich Museum, suggesting that he move the great altarpiece from the Alsace to Berlin for the duration of the war; as Bode showed little interest, it went in-

Resurrection. (1916—18). Oil on canvas, 11′ 4″ × 16′. Württembergische Staatsgalerie, Stuttgart

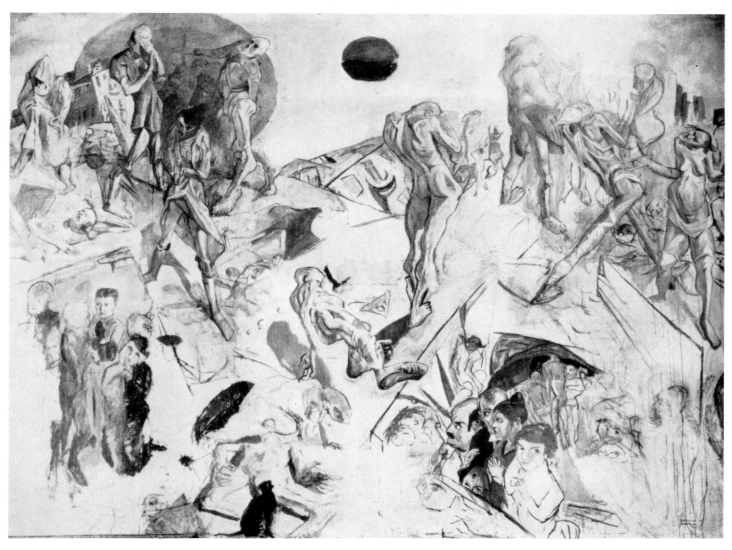

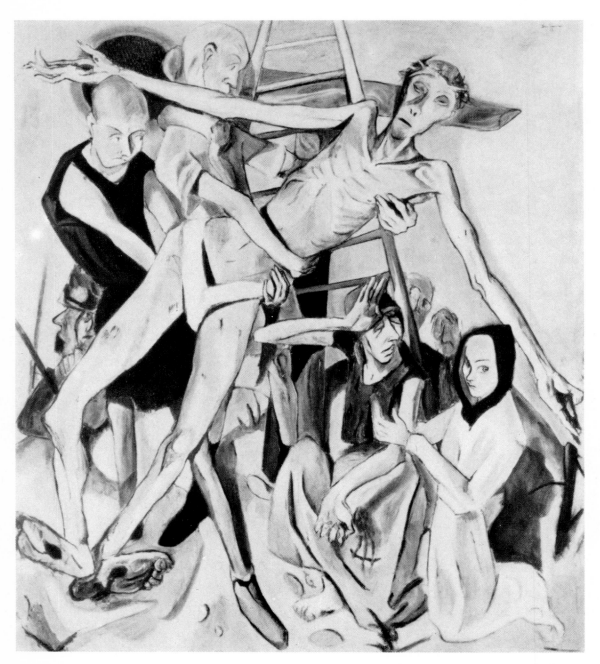

The Descent from the Cross. 1917. Oil on canvas, 59¹/₂ × 50³/₄". The Museum of Modern Art, New York, Curt Valentin Bequest

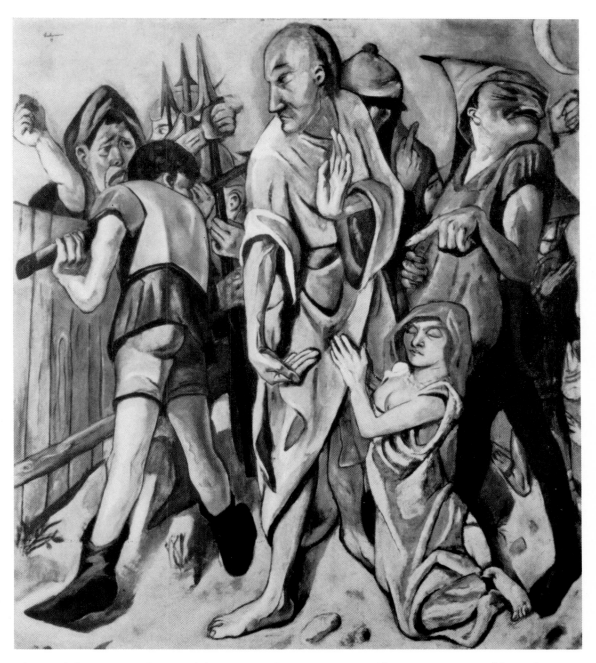

Christ and the Woman Taken in Adultery. 1917. Oil on canvas, 59 × 50½". City Art Museum of St. Louis

stead to Munich[30] where it was to exert considerable influence on artists and became recognized as one of the great masterpieces of world art.

This anecdote indicates Beckmann's great interest in early German art. Other names he mentioned include Hans Holbein the Elder, Jörg Ratgeb, Lucas Cranach, and Baldung Grien. The dialogue with the art of the past continued and it is important to be aware of Beckmann's enthusiasm for German Gothic painting in order fully to understand his postwar work.[31] What Beckmann liked in the work of the old German painters was the direct, intense impact of color and form irrespective of the story, as well as the space, which itself results from the very presence of the figures and their active movements. It is their importance in the pictorial and psychological context and not any scientific laws of perspective which determined the size of the figures. He liked the narrow and compressed stage-like space where characters would appear to be performers enacting a rite. In a painting like the *Descent from the Cross*, the figures, thin and two-dimensional though they are, create the space, which recedes and advances with them in a zigzag movement and relates them intimately to the picture plane. The large body of Christ extends diagonally across the whole plane. The soldiers on the left are seen from below, while the kneeling mourning women on the lower right are seen from above, forcing the eye to return constantly to the pale figure of Christ who, with his arms radiating from his angular body, is one of the most compelling representations of Christ in modern art.

Christ and the Woman Taken in Adultery, the pendant to the *Descent from the Cross,* has the same pale color, the same painful angularity of linear forms, the same narrow space, and similar principles of rotating composition. But this scene of agitation with all the characters going their own way, crowded

Synagogue in Frankfurt. 1919. Oil on canvas, 35$\frac{1}{2}$ × 55$\frac{1}{8}$". Private collection

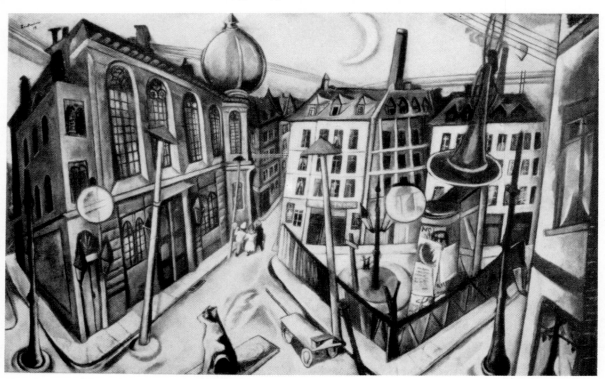

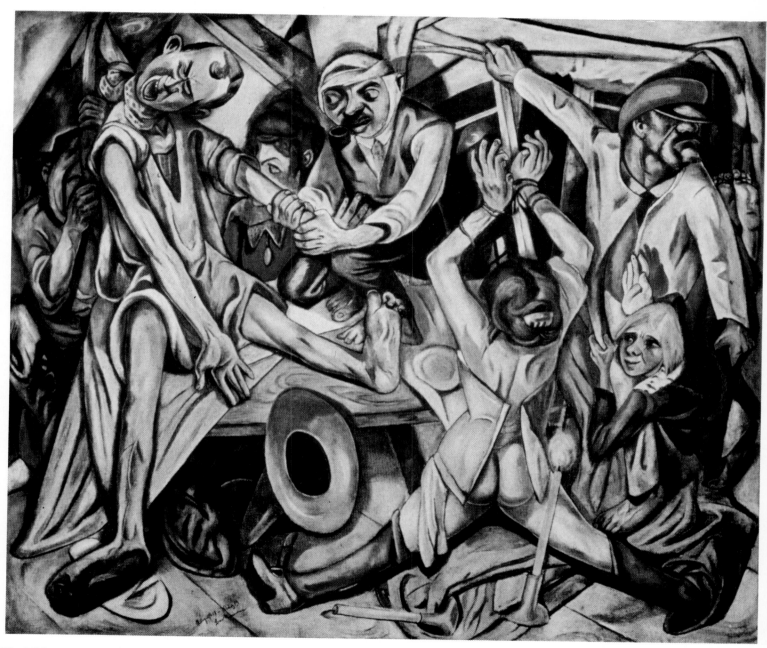

The Night. 1918–19. Oil on canvas, 52³/₈ × 60¹/₄". Kunstsammlung Nordrhein-Westfalen, Düsseldorf

together but with no psychological contact, stresses the nightmarish aspects of his vision. Except for Christ and the man with the troubled face behind the fence, all the characters have their eyes shut, as if to accentuate their detachment. The figure of the striding Christ with His white shroud and dramatically gesticulating hands relates closely to the ghostlike apparitions of the *Resurrection*, except that this Christ embodies both wisdom and benevolence.

If the religious scenes between 1916 and 1918 indicate Beckmann's feeling of anxiety and disquiet, *The Night*, a painting that occupied Beckmann from August 1918 until March 1919, is a statement of outraged protest.

Following the abortive revolution of 1918, life in Germany was marked by hunger, disease, unemployment, incipient inflation, and bloody, savage revolts. As the soldiers returned from the trenches, violence became the order of the day in the newly declared peace, as it had been in war. In rapid succession Kurt Eisner, premier of the revolutionary government of Bavaria, was shot in the streets of Munich; Gustav Landauer, a great ethical philosopher and teacher of Martin Buber, who had joined the Bavarian government, was brutally beaten to death; and in Berlin, the leaders of the Left, Karl Liebknecht and Rosa Luxemburg, were murdered in cruel fashion. On January 17, 1919, Rosa Luxemburg, an important Marxist political theorist and brilliant pamphleteer, was "taken to the front door of the [Eden] hotel. . . . There, for some reason that was not inquired into, Private Runge was also waiting for her. As soon as she got into the car, he swung his rifle and clubbed her on the head. It was doubtful if his blows had actually proved fatal, and it was suggested that he was mentally defective. . . . Lieutenant Vogel, the officer in charge oft his party, then got into the car, accompanied by two other officers. 'Fräulein Luxemburg,' he testified, 'received two violent blows on the head from the butts of rifles of helmeted soldiers. She collapsed, and when we came to a bridge the thought came to us all to throw her body into the river.'"[32] "The body of Rosa Luxemburg, the Spartacist leader who was killed by a mob recently, was found yesterday in the Landwehr Canal, according to a report from Berlin. The body was terribly mutilated. The news is being kept secret for fear of anarchistic reprisals."[33]

Beckmann, who himself had no political affiliations, sought to reflect the life around him. "Just now, even more than before the war, I feel the need to be in the cities among my fellow men. This is where our place is. We must take part in the whole misery that is to come. We must surrender our heart and our nerves to the dreadful screams of pain of the poor disillusioned people. . . . Our superfluous, self-filled existence can now be motivated only by giving our fellow men a picture of their fate and this can be done only if you love them."[34]

The Night, which has its source in drawings of the operating rooms in Flanders, is a ghastly recording of physical torment which does not take place in some medieval torture chamber but in the here and now of somebody's attic. The hoodlums and assassins have arrived. The man with the soldier's cap pulled over his eyes shuts out the dark outdoors by pulling down the shade. The deed must be performed secretly and silently: even the victim's last scream has been choked and the old gramophone has been muffled. The only source of light is a single candle, burning next to the nude buttocks of the bound woman, a symbolism which seems all too clear. This lone candle—the other has fallen over—somehow sheds enough light on the scene so that each person and object is clearly defined with the "objectivity of the inner vision." There is nothing romantic or shadowy about this murder. In reaction against the feverish hot colors and thick brushstroke of the Expressionists, Beckmann paints thinly in cold colors and approaches his monstrous subject with a surgical clarity of detail, registering each heinous action with careful objectivity. These men resemble the executioners in a Kafka-like trial. As they take charge of a night without morning, they and their victims are carefully depicted with attention to specific and singular details that enhance the gruesomeness of the actors by being divorced from a total context, as in a nightmare a single detail becomes invested with horror by virtue of its removal from a normal background. Yet these same details—the hands bound to the window frame, the blue corset, the torturer's pipe—tie the atrocity inescapably to a real situation, thus doubling the horror.

Unlike Picasso's *Guernica*, which deals only with the victims of human brutality, Beckmann's *Night* discloses the perpetra-

Right: The Dream. 1921. Oil on canvas, 71³/₄ × 35⁷/₈″. Collection
Mr. and Mrs. Morton D. May, St. Louis

Below: Hans Hirtz. Nailing to the Cross, panel of the Karlsruhe
Passion. Staatliche Kunsthalle, Karlsruhe

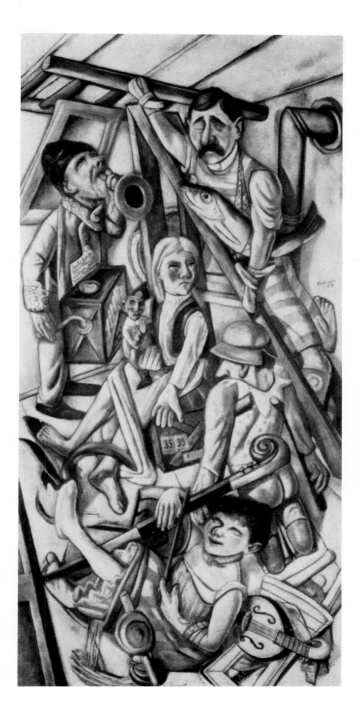

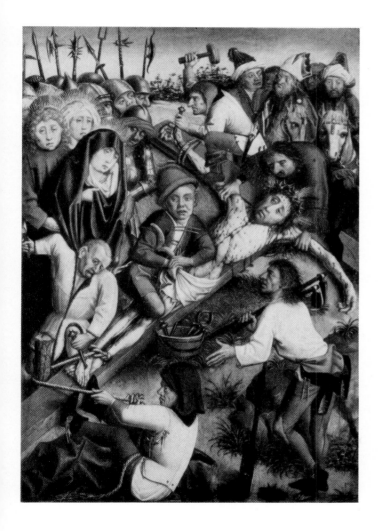

Family Picture. 1920. Oil on canvas, 25⅝ × 39¾". The Museum of Modern Art, New York, gift of Abby Aldrich Rockefeller

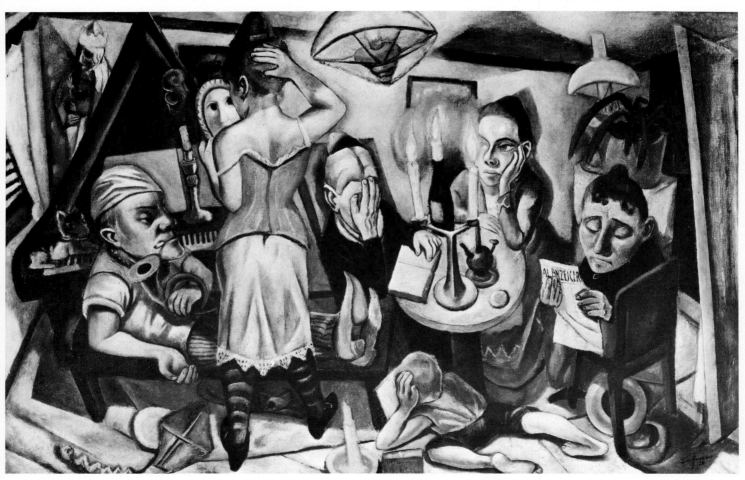

tors as well.[35] His premonitions were as uncanny as they were accurate. After recording his vision of the brutal murder in the *Night*, he looked outdoors, and used a similarly agitated composition for the *Synagogue in Frankfurt* (page 30), a painting of the building that would be burned to the ground seventeen years later, during the infamous *Kristallnacht*, while scenes similar to the *Night* took place all over the city of Frankfurt.

The bright pink synagogue is topped by a green, onion-shaped cupola. This spherical green shape is the central object in the picture, to which the eye keeps returning. The whole composition is again based on the Gothic zigzag line, of which the bottom of the synagogue forms the first chevron and the wooden fence the second one, with the cupola crowning the intersection of both lines. The curve of the white waxing moon in the white sky repeats the convex bulge of the cupola, as do the other rounded shapes, such as the small balloon behind the telephone wires, the suspended street lamps, the kiosk, the toy trumpet (or is it a dunce's cap?) hanging down in the immediate foreground. The painter must have looked out at the scene from a window, past the Egyptian-looking cat on the window sill. No vertical or perpendicular lines exist in this painting, which consists solely of acute angles. The synagogue as well as the other buildings is shaking; the whole city is aquiver, as if during an earthquake or bombing. The buildings, especially the synagogue itself, are lit up but the windows look like empty eyes. The city is silent. The doors are locked. The streets are empty except for three drunken merrymakers who climb up the narrow street toward the only escape route; soon the scene will be completely deserted.

Even life in the circle of his family yields no relief from the anxiety of the period. In the *Family Picture* of 1920 six disparate people are compressed into a small, crowded, low-ceilinged room. The artist himself, clutching a horn and wearing bright yellow shoes, lies on a narrow piano bench. Next to him stands his wife, whose gray face is reflected in an oval mirror and whose state of undress reminds one immediately of the bound woman in the *Night*. Frau Tube, Beckmann's mother-in-law, is seated at the table, hiding her face in her large hand. A sister-in-law stares out into the room, while a servant at the right reads the newspaper. Peter Beckmann, the son, is stretched out on the floor, and a mysterious, small, crowned figure enters the space on the left from behind the piano. Possibly this personage is related to the mysterious king in the central panel of *Departure* (page 59), painted some twelve years later, and stands in the Beckmann iconography as one of the symbols of the painter's self. At any rate, it is only the cramped space which is shared by the uncommunicating family group. No meaningful contact seems possible and, indeed, Beckmann lived apart from them.

The Dream, painted in 1921, is also a picture of man's anxieties and estrangement. Again we find a strange assemblage of people compressed into an attic, but the scene is quieter and calmer than in *The Night*. In fact, nothing takes place here—action is static. A blind beggar grinds his hand organ and blows a trumpet. A prisoner, mutilated, lame, and also blind, has climbed a ladder and holds a fish which confronts the trumpet's bell. On the bottom, a drunken maid rolls on the floor and in her dream fondles a cello clasped between her legs. Above her is a horribly crippled clown, and in the center of it all, with hand outstretched, is an innocent girl from the country, sitting on her trunk and holding on to her toy clown. The whole thing, titled *Madhouse* when it was first reproduced in 1921,[36] is a pantomime of misery, madness, and crime in which all kinds of symbols—ladder, fish, trumpet, hand organ, doll, guitar, cello, lamp, and mirror, as well as mutilated extremities—are introduced to give an allegorical meaning to the confusion.

As mentioned earlier, Beckmann, especially in the postwar years, was very much interested in German Gothic painting and here the *Nailing to the Cross*, a panel of the *Karlsruhe Passion* by Hans Hirtz, seems to be the prototype.[37] The unexpected peasant boy kneeling on the Cross and staring out at the spectator in Hirtz's panel occupies precisely the same place—both formally and psychologically—as the similar-looking girl in Beckmann's *Dream*. The sleeping maid has assumed the position of the soldier tying the rope at the bottom of the picture. Other parallels, less striking but perhaps even more telling, are to be seen between the man driving the nail into Christ's hand on the upper right and the man with his hands

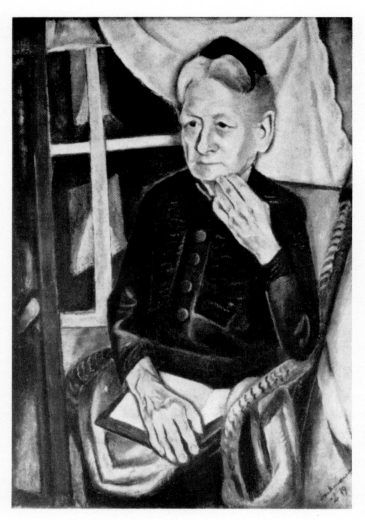

Frau Tube. 1919. Oil on canvas, 35¹/₂ × 23¹/₄". Städtische Kunsthalle, Mannheim

cut off in a similar position in Beckmann's canvas—significantly, the torturer has become the victim in the twentieth century. The diagonal ladder, an important symbol of agony and achievement in Beckmann's iconography, has taken the place of the Cross. It is also very much in the realm of probability that the fish in the *Dream* has been substituted for the Christ in the medieval panel. The fish traditionally has been a symbol for Christ as well as of fertility and creativity, and Beckmann's symbolism, essentially fluid, shifting, open to many interpretations, could easily combine the mystical and the sexual in the prisoner's fish.

Wilhelm Fraenger in a penetrating study of this painting[38] refers to the tension arising from the contrast between Beckmann's chimerical, fantastic subject and its carefully structured form. He points, for instance, to the vertical axis in the very center of the picture which extends from the bandaged hand of the climbing man to the head of the child, to her outstretched hand and the two hands of the maid. In the Hirtz panel the same axis can be observed by following the hand of the man hammering the nail to the nail itself, the head of the boy, his hands, the tools of the Passion, to the head of the soldier. Fraenger sees "a confused and reprehensible chaos made into a well-ordered world by the rational logic of a structural system. In this sense Beckmann is a severe moralist, much like Hogarth, who also places the contemptible market of vice and drunkenness, of dissipation and debauchery, into a rational system of measured structure. Beckmann, the Hogarth of our time!"[39]

But not only artists like Hirtz and Hogarth have brought clear organization to scenes of torture and views of intemperance. Beckmann, by endowing the dream with precise structure and meticulous detail, belongs to that mainstream of modernism which has its parallels in the writings of Kafka and Joyce, in the paintings of de Chirico and Bacon, and the films of Antonioni and Bergman. In all their work the feeling of human estrangement is enhanced by the use of hard physical reality.

Nor was Beckmann's endeavor to grasp the phantom world by means of a precise study of visible reality without parallel in the Germany of the early twenties. This was, in fact, part

of a general postwar reaction to the romantic—often even apocalyptic—prewar movements of Expressionism, Orphism, Futurism. A new aesthetic of palpable reality developed in Europe ever since Picasso, in 1915, drew a precise, realistic portrait of Ambroise Vollard. In Italy, the disquieting sense of mystery of the *pittura metafisica*—itself committed to the object, to be sure—was succeeded by the calmer and more contemplative objectivity of *valori plastici*. In Germany, where Expressionist abstraction (or abstract expressionism) had established a new aesthetic for the avant-garde before World War I, it was Beckmann who, after the war, appeared as the precursor of a new realism[40] which would isolate the object in order to create a sense of suspense and heightened awareness. Beckmann himself emphasized his opposition to Expressionism when speaking to his students in Frankfurt by warning them against following the dictates of their emotional states directly, without transmuting them by acts of reason and formal structure. Always opposed to naturalism, he characteristically referred to Expressionism as a "reversed naturalism."[41]

Aware of this new trend, of which Beckmann was a leader, G. F. Hartlaub, director of the Kunsthalle in Mannheim, coined the term *Neue Sachlichkeit* (New Objectivity) for a projected exhibition which was to "bring together representative works of those artists who in the last ten years have been neither impressionistically relaxed nor expressionistically abstract.... I wish to exhibit those artists who have remained unswervingly faithful to positive palpable reality, or who have become faithful to it once more.... Both the 'right wing' (the Neo-Classicists, if one so cares to describe them), as exemplified by certain things of Picasso . . . etc., and the 'veristic' left wing to which Beckmann, Grosz, Dix, Drexel, Scholz, etc., can be assigned, fall within the scope of my intentions."[42]

Two years later, in July 1925, the exhibition *Die neue Sachlichkeit* was actually held in Mannheim and the important book by Franz Roh, *Nach-Expressionismus*,[43] was published, in which he proposed the name Magic Realism for this new revolutionary tendency which tried to find some firm, tangible, and meaningful reality in the wake of the confusion and dashed utopias of the immediate past. "The new objective painting was of necessity all the more readily interpreted as a

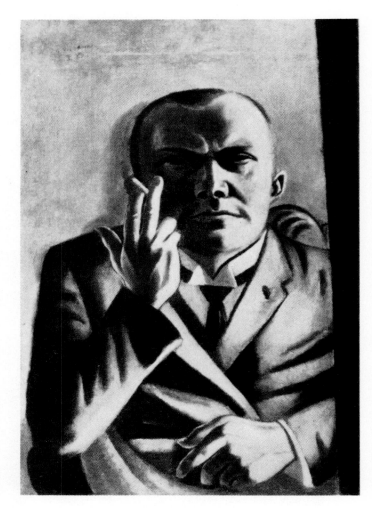

Self-Portrait with a Cigarette. 1923. Oil on canvas, 23³/₄ × 15⁷/₈". The Museum of Modern Art, New York, gift of Dr. and Mrs. F. H. Hirschland

37

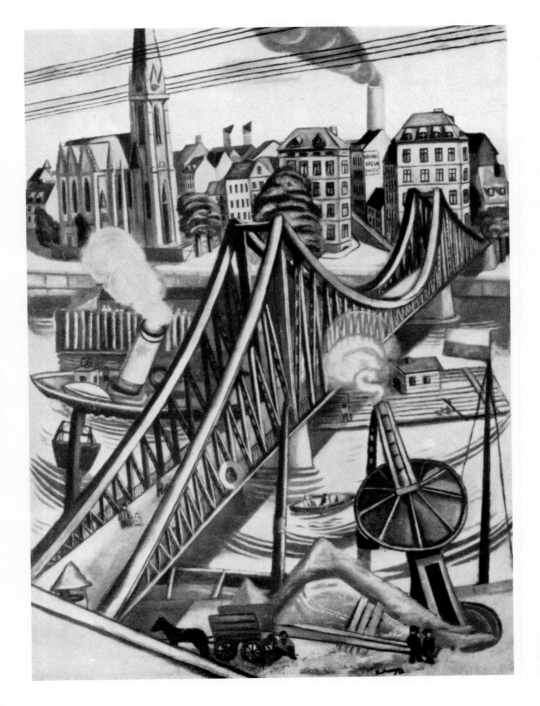

Iron Footbridge in Frankfurt. 1922. Oil on canvas, 47¹/₄×33¹/₄". Collection Richard L. Feigen, Chicago

sign of this revolution in thought and feeling, because abstractness was considered the artistic manifestation of the expressionist attitude of mind."[44] It must be clearly kept in mind, however, that this New Realism would have been unthinkable without Expressionism. Like Expressionism it makes use of distortion, exaggeration, and shock, but instead of employing these for the artist's own subjective emotion—often leading to abstraction—they are directed toward the examination and presentation of the object itself. Beckmann himself wrote a letter to Reinhard Piper in 1922 relating his gratification that his paintings and prints were able to prove to a number of people that "this Expressionist business was really only a decorative and literary matter, having nothing to do with vital feeling for art.... One can be new without engaging in Expressionism or Impressionism. New and based on the old laws of art: plasticity in the plane."[45]

The new realism, a bitter and often dry attitude toward reality, was to dominate much of German literature (Remarque would be a good example) and art between the wars. Hartlaub saw in it an attitude of resignation and cynicism on the one hand and enthusiasm for immediate reality on the other. The outstanding artists in the Mannheim exhibition of 1925 were George Grosz, Otto Dix, and Max Beckmann. While Beckmann certainly engaged in social criticism, he did so less exclusively than Grosz and Dix. Beckmann's unique construction of space and personal symbolism transports paintings like *The Night, Synagogue in Frankfurt,* or *The Dream* far beyond Verist reportage and social comment. Even when painting a most sober and matter-of-fact portrait like that of Frau Tube, his mother-in-law (page 36), he reaches monumentality by means of an unfailing sense of composition, especially the relation of the sitter to the room, of solid volume to engulfing space, or, as he called it, "the plasticity in the plane."

In the splendid *Self-Portrait with a Cigarette* of a few years later (page 37) he paints himself as a robust, solid figure with hard contours. Within the narrow surrounding space he cuts out a niche for himself. He poses somewhat haughtily with cigarette in hand, simultaneously ready to take a stand as the witness of his time and to explore his own self. "For the visible world in combination with our inner selves provides the realm where we may seek infinitely for the individuality of our own souls," he was to say years later in his "Letters to a Woman Painter."[46] He would observe and ruthlessly explore the world around him. A painting like *Iron Footbridge in Frankfurt,* inspired by his "grand old friend Henri Rousseau, that Homer in the porter's lodge,"[47] is a great deal bolder than any Rousseau in its space composition. The picture is so high-keyed in its hues that it almost looks bleached. The eye does not enter the painting slowly but races into it, pursuing the light-blue iron bridge—that memento of the early machine age—and jumping diagonally across the picture to the river bank with its depressing nineteenth-century houses, its fuming smokestacks, and mechanistic Gothic Revival church. In order to enhance the primitive quality of the painting, Beckmann has put some of the telephone wires in front of the steeple and some behind it. This also serves to constrain the tower which thrusts its way out of the picture at this point. The dirty gray Main river is filled with traffic: barges and tug boats, smaller boats, and the floating public swimming pool with its preposterous green fence. In the foreground we see an odd-looking crane, reminiscent of similar contraptions in the distant landscapes of early Flemish panels, as well as a horsecart and a little building site. All kinds of rattling and puffing machines seem to make noise as they crowd out the people, who look more like ants than human beings and appear to be trapped wherever they are. Much like Cézanne in many of his landscapes, Beckmann has made this scene inaccessible: we are confronted with a painting, not invited to enter into the cityscape. Space, so frightening in its emptiness in the *Landscape with Balloon* (page 26), has now been filled up with equipment which may be utilitarian but is surely bizarre. Against the onslaught of the void, Beckmann has fortified himself with objects whose aggressive, thrusting impingement constructs his space. For the same purpose of defense against the void, he will use such a framing device as the telephone wires on top of the picture.

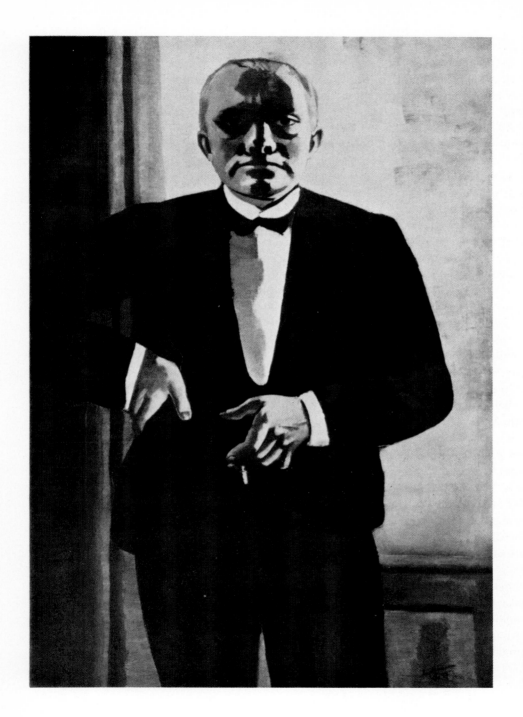

Self-Portrait in Tuxedo. 1927. Oil on canvas, 54½×37¾". Busch-Reisinger Museum, Harvard University, Cambridge, Massachusetts

Beckmann's place in the Mannheim exibition as a leader of the New Objectivity coincides with his general recognition for the second time in his life. In 1924 a major, de luxe monograph with essays by four outstanding critics and scholars— Ernst Glaser, Wilhelm Hausenstein, Wilhelm Fraenger, and Julius Meier-Graefe—had been published in Munich.[48] In 1925 he was appointed professor at the Städelsche Kunstinstitut in Frankfurt, to teach the master class. He was well established in Frankfurt now and counted among his friends such men as the director of the museum, Georg Swarzenski; the important art critics Hausenstein and Meier-Graefe; the publisher of the *Frankfurter Zeitung*, Heinrich Simon, who was soon to write a brief monograph on the artist.[49] Among his patrons were the Berlin connoisseur and collector, Baron von Simolin; the Munich publisher, Reinhard Piper; the Frankfurt city council member Ernst Levi; and, perhaps most important, Mme Lilly von Schnitzler, whose house in Frankfurt was one of the last grand salons for the gathering of noted writers, philosophers, and artists. In 1925 Beckmann also held another important exhibition at Cassirer's in Berlin, to be followed, in 1926, by his first one-man show in New York at J. B. Neumann's New Art Circle. But of the greatest importance, certainly, was his marriage in 1925 to the young violinist Mathilde von Kaulbach, daughter of the celebrated Munich portraitist Friedrich August von Kaulbach, whom he had met two years earlier at the house of the Motesiczkys in Vienna. In the autumn of 1925 he returned from his honeymoon in Italy, where he had revisited Rome and Naples, with renewed self-confidence and great happiness, and subsequently painted the *Self-Portrait in Sailor Hat* (page 42) in which he poses as a bold young seaman. Always part actor, Beckmann painted himself with all kinds of attributes and in many guises. He is the master of ceremonies, the announcer of the act, the ringmaster. He appears with many musical instruments—usually brass ones— such as the saxophone and the trumpet. He may be dressed as a sailor or appear in full evening dress or again as a clown. He may hold a whip or a crystal ball, or represent himself engaged

in painting or modeling in clay. The *Self-Portrait in Sailor Hat* is still done in the light palette typical of the early twenties, but now a red undercoat is allowed to show through, which accounts for the fiery red outlines around the hands and other areas, giving the painting an aspect of mystery. This tension between the strength and solidity of the figure and the mystery of the color and its anxiety in space is so basic to Beckmann's work that it rarely fails to appear.

In 1925 he made his first of a great many portraits of "Quappi," as he was to call Kaulbach's daughter. This narrow, vertical picture (page 43) in which she stands in a somewhat withdrawing pose, is a painting of extraordinary elegance, grace, and simplicity. The following year he did an altogether different picture of his new wife (page 44), who now looks a great deal more self-assured with her short hair and hand on waist. She is dressed in a rich blue dress and set against a blue blackground. Here color is no longer used to tint the shape, but—for the first time—it exists for its own sake as a major element in the pictorial construction. Like his self-portraits, the portraits of his wife form important accents in his work from now on. Beckmann, who had been a colorist working with values rather than hues in his prewar period, had become principally a draftsman concerned with contour, volume, and no more than local color for a ten-year period. Now he turned to the full range of color—blues, reds, greens, and yellows— and it is interesting that this new direction, which was ultimately to lead him to a more harmonious and monumental form, began with a portrait of his new wife.

The portrait of the Duchessa di Malvedi (page 44), painted from memory after an Italian noblewoman he had met in Spotorno a few months earlier, is certainly an aggressive picture, but it is now the woman herself, her features, attitude, and stance rather than the disposition of forms in space, which accounts for the feeling of disdain. And again color—here the ruby-red lips in the marvelous olive-gray face—is an essential element.

During the late twenties Beckmann painted a superb series

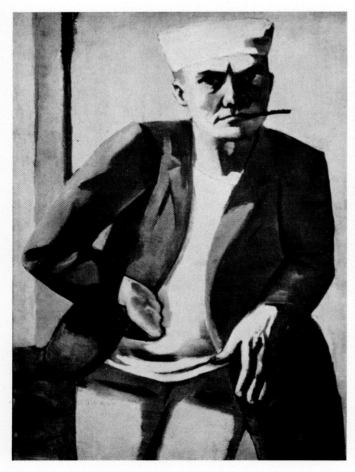

Self-Portrait in Sailor Hat. 1926. Oil on canvas, 39³/₈ × 27¹/₂″. Collection Richard L. Feigen, Chicago

Opposite page: Portrait of Quappi. 1925. Oil on canvas, 49⁵/₈ × 19⁵/₈″. Collection Mrs. Mathilde Q. Beckmann, New York

of portraits, one of the finest, no doubt, being the *Old Actress*, of 1926 (page 45). Light—a bright and soft-yellow light—floods through this tender painting and makes it sing. The black gown, the red upholstery of the chair outlining the woman's angular shoulders, the brown dog whose face resembles that of the actress, are key contrast to the light yellows and beiges of the painting. The woman with her big-featured head and sizable sensitive hands sits in reverie, a symbol of wisdom and fulfilled old age. Beckmann succeeds here in combining the verisimilitude of a unique old woman with universal aspects of old age and its memories.

The painting of the clown Zeretelli (page 46) is a similar fusion of the general and the specific: here is a portrait of the prince from the Caucasus who had become a famous dancer and actor, and here is also the generalized—or universalized—clown with his sharp features, long, cruel, needle-like fingers, and the smirk in the expressive face which mocks those whom he makes laugh. The figure exists in a space that evolves between the green wall and the small black diagonal object, perhaps a railing, in the lower right. It is a narrow space, but it has just enough room for the upright formal chair and the dancer sitting in it in a ballet position. The composition is built up of a few basic, geometric forms: the schematically simplified figure, the vertical rectangle of the chair, the simple large color planes of the back wall. The colors themselves, especially the blue of Zeretelli's leotard and the green of the back wall, set up a contrapuntal relationship that constructs the painting.

Clearly structured by means of large areas, of color and simple geometric shapes, Beckmann's composition reached classic monumentality in the late twenties. One of the most powerful examples of this new grand style, one of the great self-portraits in the history of art, is the *Self-Portrait in Tuxedo* of 1927 (page 40). The artist faces us, a powerful figure in full size, self-conscious, brutal, proud, confronting his public with great self-confidence. Whereas diagonals were essential to the paintings of violence of the immediate postwar years, a severe structure of horizontal and vertical planes makes up this rigidly frontal, highly formal presentation portrait. Beckmann sees himself here at the height of his powers.[50] The colors in

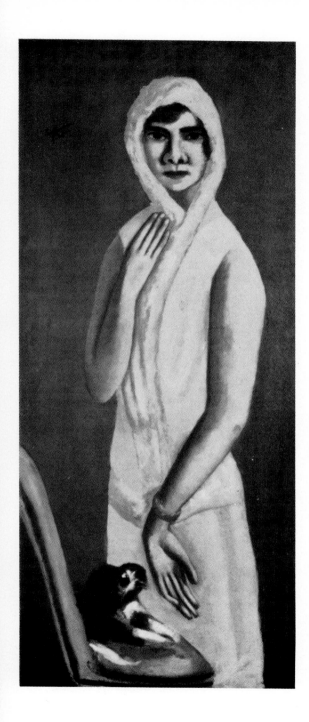

this *Self-Portrait*, which, more than any other, sheds light on his vision of himself, are chiefly black and white. "All these things come to me in black and white like virtue and crime," he stated ten years later. "Yes, black and white are the two elements which concern me. It is my fortune, or misfortune, that I can see neither all in black nor all in white. One vision alone would be much simpler and clearer, but then it would not exist. It is the dream of many to see only the white and truly beautiful, or the black, ugly and destructive. But I cannot help realizing both, for only in the two, only in black and white, can I see God as a unity creating again and again a great and eternally changing terrestrial drama."[51] This "terrestrial drama" between black and white, good and evil, sin and redemption shows a dichotomous vision of the world, stemming from the Judeo-Christian religious traditions which obviously formed Beckmann's thought and the natural structure of his paintings, and occasional statements such as this. Beckmann identifies with this patriarchal god in his role as the artist, the creator of this "changing terrestrial drama." As he stands there with cigarette in hand, he looks out, he observes, and he transforms, he builds a new world.

He is able to look down on the city and harbor of Genoa and take visual possession of the panoramic view below him (page 47). Again, this painting is severely restricted in terms of shape and color. Curved shapes of chair, vase, tunnel, distant church, roof of pier are juxtaposed to the multiplied perpendiculars in the picture. The whites are contrasted to the blacks and both seem to float on the turquoise ground. And perhaps most arresting is the confrontation of the extremely close-up shapes and the deep spaces which open up immediately adjacent, without transition.

The *View of Genoa* was one of the most recent paintings to be included in the retrospective exhibition of his work which, directed by G. F. Hartlaub, opened in Mannheim in February 1928. One hundred and six oils, fifty-six drawings, and one hundred and ten prints were included in this major show. The catalogue also contained some statements by Beckmann himself about his art and his aesthetics. The Mannheim show was followed two years later by another important retrospective of his paintings, arranged by Georg Schmidt, in the Kunsthalle in

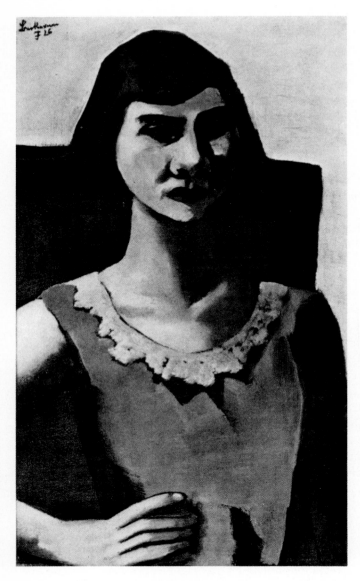

Quappi in Blue. 1926. Oil on canvas, 23⁵/₈ × 14¹/₈″. Collection
Günther Franke, Munich

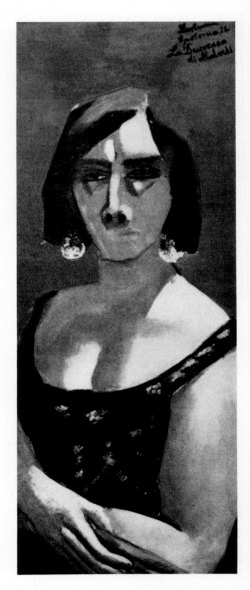

Duchessa di Malvedi. 1926. Oil on canvas,
26¹/₄ × 10⁵/₈″. Collection Günther Franke,
Munich

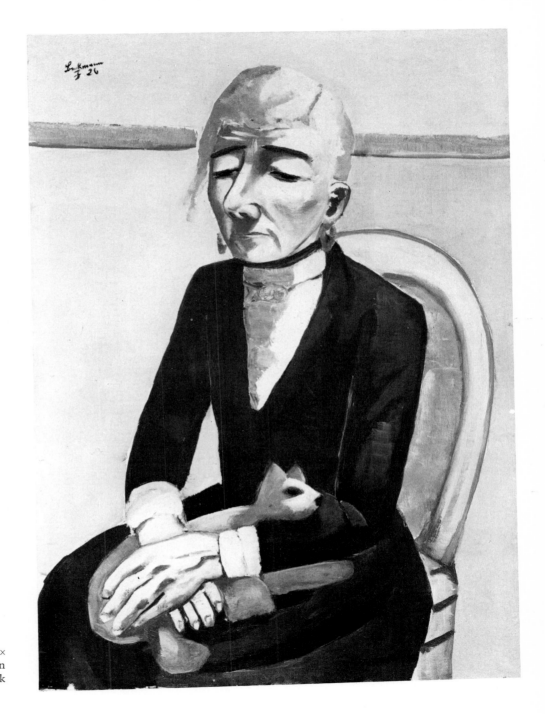

Old Actress. 1926. Oil on canvas, 46³/₄ ×
35¹/₈″. Collection Mr. and Mrs. Jean
Mauzé, New York

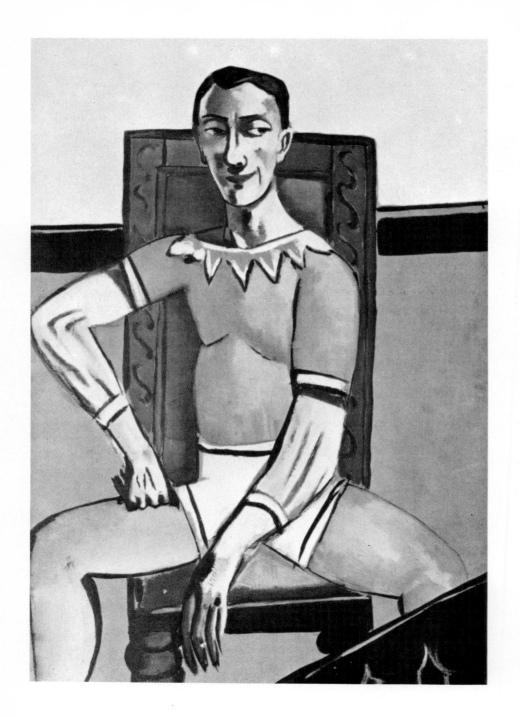

Portrait of Zeretelli. 1927. Oil on canvas, 55¼ × 37¾". Fogg Art Museum, Harvard University, Cambridge, Massachusetts, gift of Louise and Joseph Pulitzer, Jr.

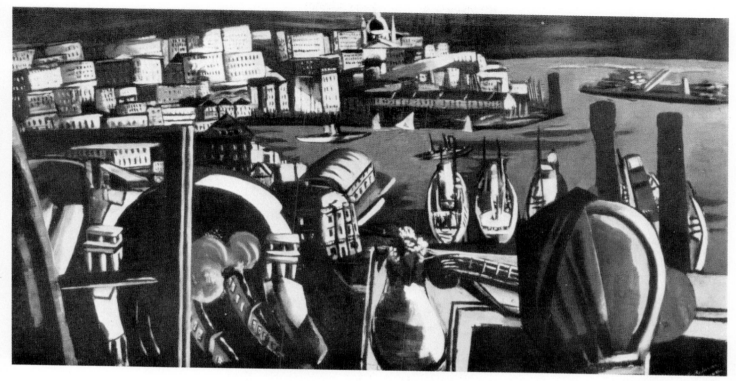

View of Genoa. 1927. Oil on canvas, 35⅝ × 66⅞". Collection Mr. and Mrs. Morton D. May, St. Louis

Basel. In March 1931, eight of his paintings were included by Alfred Barr in the exhibition of German painting and sculpture at the Museum of Modern Art, and a new exhibition of current work was held at J. B. Neumann's in New York. The same year Justus Bier assembled an important Beckmann show at Hanover's avant-garde Kestner Gesellschaft, and the National Gallery in Berlin now had a special room to house its recently acquired collection of Beckmann paintings—an honor given to very few living artists.

All this time Beckmann continued his teaching at the academy in Frankfurt. Even when he was living in Paris during the winters in the late twenties and early thirties he returned to teach his class for one week of every month. His classes were kept small but he inspired his students, who "had no doubt that the world really looked the way Beckmann saw it" because "if, by the power of his insight, an artist has given a face to the world, then the face is there."[52] Yet Beckmann would guide his students to discover themselves and find their own personal answers. He would make them aware of their dreams and fantasies and then help them transform these images into pictorial compositions with real objects. The purpose of painting was not to present a fragment of nature, but to use the forms of nature for pictorial composition. In order to aid his students to this advanced stage, he constantly encouraged them to go to museums and to study the art of the past most congenial to their personalities.

Beckmann's familiarity with world literature was also astonishing and he frequently suggested specific reading to his students. This might be the works of Flaubert and Stendhal, E. T. A. Hoffmann, Jean Paul, or Hölderlin, Joyce, and Dos Pas-

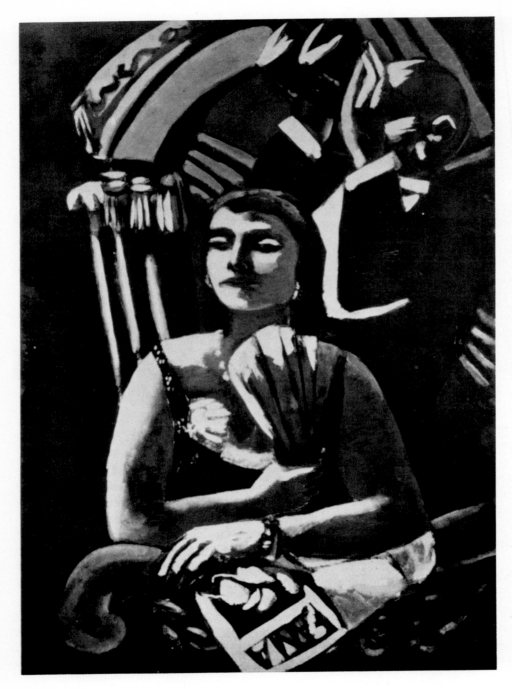

The Loge. 1928. Oil on canvas, $47^{5}/_{8} \times 33^{1}/_{2}''$.
Private collection

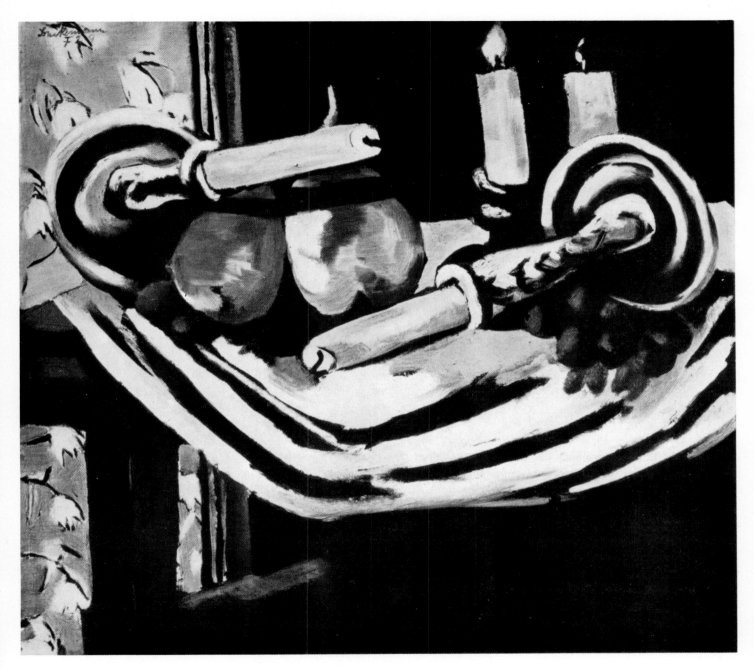

Still Life with Candles. 1929. Oil on canvas, 22 × 24¾". The Detroit Institute of Arts

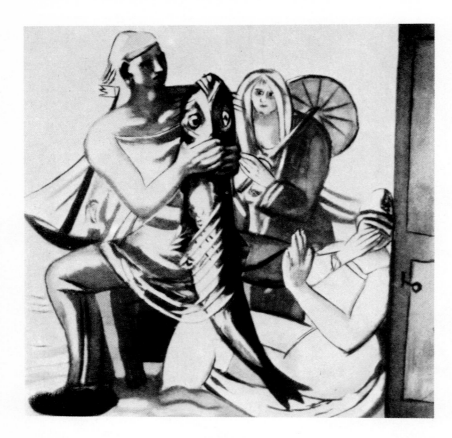

The Big Catfish. (1929). Oil on canvas, 49¼×
49⅜". Collection Baroness von St. Paul,
Seeshaupt

sos. He would, in fact, cite a book like Dos Passos' *Manhattan Transfer* to illustrate his concept of the simultaneity of events.[53] But Beckmann's teaching was by no means literary or intellectualized. Quite the contrary, he was a most reticent talker and remarks about art or literature would be almost monosyllabic. He was, however, much concerned about the craft of painting and would show his students how to paint light, how to get a transparent shadow, and, above all, how to compose. With large brushes and black paint he would go to work on a student's picture and with a few swift strokes alter it until it began to work as a composition. He was admired and a few brief words of approval were able to instill self-confidence in his students.

In Paris he found himself in the focal point of world art and this is where he now had to be. His development toward simplified form and *belle peinture* at that time has often been ascribed to his prolonged stay in Paris, where he now had his own studio on the Avenue des Marronniers. In the spring of 1931 he held his first exhibition in Paris at the Galerie de la Renaissance, which included work that went back to 1907. Waldemar George, the eminent critic, wrote the introduction to the catalogue and Uhde, Vollard, and Picasso seem to have admired the show.[54] Two of his paintings were acquired by the Musée du Jeu de Paume—a very unusual event for a foreigner. Beckmann now made plans for a permanent move from Frankfurt to Paris, and was only prevented from this by political events in Germany.

An interest in French painting is clearly evident in the *Loge*

(page 48), a variant of Renoir's *La Loge* of 1874. Where the nineteenth-century painting was lovely, charming, and gay, however, the twentieth-century version is hard and dramatic. If the couple in Renoir's box suggests a comparison with organically growing flowers, Beckmann's mechanical pair with their piston-like movements belongs to the machine age. The woman, holding her fan and rearing back slightly as she gazes over the balustrade, looks securely, even commandingly, at the performance. Open to all glances, she is yet impersonal and aloof, enigmatic and sphinxlike. Her escort pays no attention to the scene. Armed with large opera glasses, which hide his face, he examines the audience. These glasses resemble nothing more than the barrels of a gun, and while they conceal him, he also projects outward with them, which gives him a most ambivalent character.

There are highlights of white, purple, and yellow, but the painting is mostly a velvety black. Black for Beckmann is a color, not its absence, and like Velázquez, Goya, and Manet, he was always preoccupied with exploring the properties of black. A few restricted colors indicate the ornate architecture of the theater and together with the simplified volumes they create the space, which is not the objective space as it may actually be, but seems to exist solely for the momentary tension of the two antagonists.

Like Renoir's *Loge*, which was among his chief entries in the first Impressionist show of 1874, Beckmann's *Loge* became a milestone in his career. Awarded Honorable Mention in the Carnegie International of 1929, it brought Beckmann again to the attention of the general art world. America's leading art critic, Henry McBride, spoke of the "impact from his brushes that even Picasso might envy."[55] The same year, the first painting by Beckmann entered an American collection when W. R. Valentiner bought his *Still Life with Candles* (page 49) from the Galerie Flechtheim in Berlin for the Detroit Institute of Arts. Here again, black is the dominant color and sets the tragic mood. In contrast to the Cubists who would transform a woman with a guitar into a still life, Beckmann endows his still lifes with human qualities. The table here has become a stage and no shadows are allowed to obscure the austere integrity of the mysterious event. This simple still life, like Cé-

Man and Woman. 1932. Oil on canvas, 68 × 48". Collection Dr. and Mrs. Stephan Lackner, Santa Barbara, California

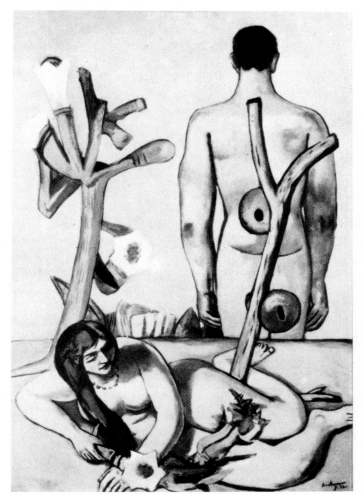

Carnival in Paris. (1930). Oil on canvas, 82⅝×39⅜". Collection Günther Franke, Munich

zanne's *Black Clock*, is a *memento mori:* the two largest candles are fallen heroes, while the other two stand in mourning, guarding against the "dark black hole" of space and infinity behind them. Indeed, a year later he painted a similar composition on a larger scale and introduced a book—a script as it were—with the word "Eternity" on its title page.[56]

Symbols of sexual virility—the candle, the fish, the horn—occur with great frequency in Beckmann's work, but rarely are they as overt as in the *Big Catfish* of 1929 (page 50). An athletic young fisherman has emerged from the sea and grasping a gigantic fish with both hands, displays this amazing catch to two women. The fish, which has huge eyes, is placed in the very center of the painting. One of the women, carrying a green parasol, approaches with eager curiosity, while the other one averts her face, holding her hand over nose and eyes. Yet, significantly, it is this refuting woman in the blue bathing suit on the lower right who is tied compositionally to the blue fish and completes its curvature. In this allusive beach scene flooded with the brightest sunlight, Beckmann returns to the light hues of the earlier pictures.

Carnival in Paris, painted in the same year, again consists of large planes of opaque flat areas of color, and there seems little doubt that during these years in Paris the work of Matisse in particular exerted an influence on Beckmann's palette. Here he used simply a system of intense complementaries: the scarlet red of the man's blouse and the chair against the insistent shades of green of the lady's dress, the wall, and the carpet. All of this takes place in a narrow space between a black diagonal, lower left and the black door behind the soldier, a spatial construction used quite frequently by Beckmann during this time. In this carnival scene the woman is attired in a tight green dress and wears a Greek helmet above her mask, while her mustachioed escort appears in the costume of a hussar with red blouse and striped pants. Most startling is the complex interplay of the dancers' arms, a wheel-like motion which is brought to a stop by the tin horn in the cavalier's left hand. But this carnival trumpet is also a sword with which he stabs his masked lady in the back, while a clown blows a hollow accompaniment to this ominous love scene.

This period of Beckmann's great success was marked by alarming developments in Germany. After about 1930 his paintings become increasingly introverted. He begins to concern himself with ancient myths and draws on the birth of mankind in order to find his self and its meaning. Though he never loses contact with the real, objective world it is "this Self for which I am searching in my life and in my art."[57] In 1932 he produced *Man and Woman* (page 51), which was probably the closest he ever came to Surrealism. He paints a sensuous young woman reclining in the foreground of an arid desert landscape. Self-satisfied as a cat, she contemplates an exotic flower. Two large and fantastic desert plants frame her on either side, and behind a small rise in the earth, looms the large, seemingly obdurate figure of a man. He is seen from the back, standing rigidly at attention, turned away from the viewer as well as the woman, in an attitude of expectation as the artist might wait during a fallow period, analogous to this desert, for the fructifying force of inspiration, that ability to produce and create.

When looking at himself—*Self-Portrait in Hotel*, 1932—Beckmann, too, stands waiting, huddled in his overcoat, his hat pulled down over his face, his muffler high around his neck, and his hands in his pockets. He looks cold, a sensation which is intensified by the cold gray tones of this painting. Again, as in the earlier *Self-Portrait in Sailor Hat*, he allows the underpaint to show through, resulting in a tension between this red primer and the gray overpainting, with reddish areas mysteriously coming to the surface. Beckmann himself is squeezed into a narrow vertical space, and again there is a barrier in the immediate frontal plane, which makes access impossible. All the strength and apparent self-confidence of the *Self-Portrait in Tuxedo* of five years earlier seem to have vanished as he stands here, hunched together, dejected, alone. Those who knew Beckmann well often remark on both aspects of his personality: the imposing man, with a sense of his own importance, and the withdrawn, extremely lonely individual. Here in 1932, with the impending rise to power of the Nazi party, the artist faces an increasingly hostile world in which art is threatened and life itself is uncertain.

Self-Portrait in Hotel. 1932. Oil on canvas, 46½ × 19¾".
Collection Dr. Peter Beckmann, Munich-Gauting

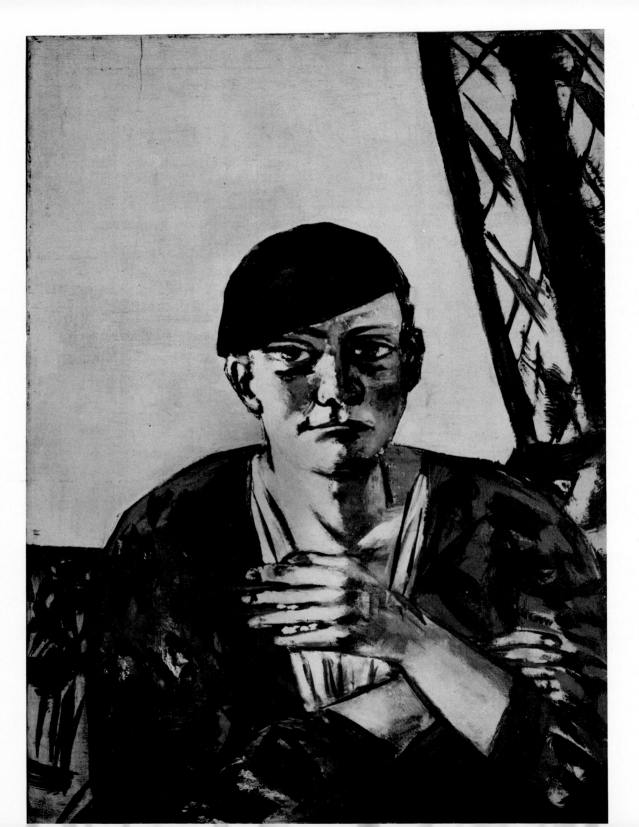

With the Nazi advent to power, Beckmann, who was of course listed as a "Degenerate Artist," was immediately dismissed from his teaching position at the Städelsche Kunstinstitut. He now left Frankfurt, where he felt himself to be too well known, and moved to Berlin in order to live in the seclusion which the large city was able to offer, at least for a while. During these years he began his investigations of Greek and Norse mythology, hoping to find universal prototypes of human fate and action in the ancient myths. It was in 1933, when first moving to his apartment in the Graf Spee Strasse in Berlin, that Beckmann began to paint a superb group of watercolors. Based on mythological scenes, they may be small in size, but they are monumentally scaled.

He paints the story of Odysseus who had himself lashed to the mast of his ship in order to resist the seductive but perilous voices of the sirens. And there is the *Rape of Europa* (page 57), surely Beckmann's finest watercolor: the black bull, the phallic forms of his snout and horns thrusting ahead with dynamic vigor, carries the limp nude white body of Europa thrown over the cramped angle formed by his back and haunches. The bull in this great picture may have been inspired directly by an ancient relief in the Berlin museum showing Nike leading a bull to sacrifice (page 57), a copy of a relief from the balustrade of the Temple of Athena Nike on the Acropolis. But in Beckmann's scene, the wedge-shaped bull's head has become active; more than that, it has assumed an orgiastic force. In *Brother and Sister* (page 56), which was made after a larger oil, he depicts the doomful sibling love relationship of Sigmund and Siglinde, united and simultaneously separated by Gram, the Volsungs' divine sword.

While working with the small watercolor format, Beckmann was also occupied with the large triptych form. His interest in the triptych as a mode does not come solely from his preoccupation with German medieval art. The triptych had first been revived by Hans von Marées, whom Beckmann admired as his predecessor, in his *Judgment of Paris* in 1880, to be followed in rapid succession by *The Hesperides, Courtship,* and

The Three Horsemen. Subsequently the triptych form was used in Germany by Max Klinger, Franz von Stuck, Fritz von Uhde. Emil Nolde painted his highly Expressionist triptych of Mary of Egypt in 1912. Outside of Germany, Edvard Munch and Félix Vallotton executed three-panel compositions, and even Gauguin's masterpiece, *Where Do We Come From? What Are We? Where Are We Going?* is conceptually a triptych. Although most of these triptychs are no longer religious in connotation, they are conceived as large public statements, often hieratic in character.

Beckmann began his great triptych, *Departure,* in May 1932 while he was still in Frankfurt, took the half-finished panels to Berlin with him, and finished the triptych there on December 31, 1933 (page 59).[58] Although completed during the first year of the Nazi rule of terror, *Departure* is far more universal than the "symbolic portrayal of the artist's departure from his homeland and the reasons for it," in which he "symbolized the cruelty of the Nazi torturer on the left-hand side and the madness and despair of the era on the right.... To avoid trouble with the Nazis, Beckmann hid the picture in an attic and affixed the cryptic label *Scenes from Shakespeare's Tempest.*"[59] Such explanations are of little help in deciphering the triptych. Not only was *Departure* completed in 1933, long before Beckmann left his homeland in 1937, but its concept is a great deal broader. He himself pointed out that it "bears no tendentious meaning." And surely his reference to the *Tempest* was no whim or mere ruse: He has, in fact, re-created the world of Caliban and Prospero.

Departure, as Alfred H. Barr, Jr. stated at the time the triptych was shown as a memorial to Beckmann at the Museum of Modern Art in January 1951, is "an allegory of the triumphal voyage of the modern spirit through and beyond the agony of the modern world."[60]

In the left panel an executioner in a striped shirt swings an apparently murderous weapon, which, at closer inspection, turns out to be a muted and ineffectual bludgeon with fish heads coming out of the maul.[61] A woman, whose position in

Opposite: Self-Portrait with Beret. (1934). Oil on canvas, 39³/₈ × 27¹/₂". Collection Frau Lilly von Schnitzler-Mallinckrodt, Murnau

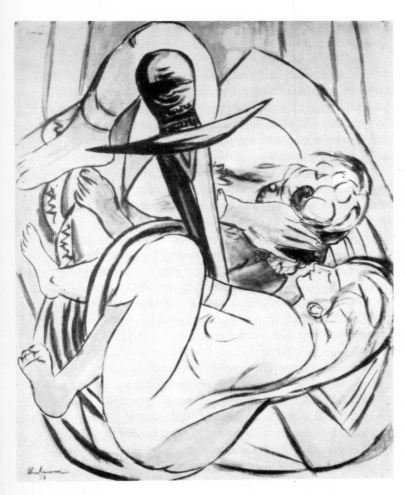

Brother and Sister. 1937. Watercolor, 25½ × 19¾". Collection Mrs. Mathilde Q. Beckmann, New York

the panel is reminiscent of the drunken maid in the *Dream*, has her wrists bound and kneels over a glass globe. Poised directly above the woman's trussed form, and enigmatic in the context of this painting of masochist-sadist brutality, the enormous still life is sensually suggestive in its overtones. It is placed on a cart and seems to be a prop, belonging on the stage or in an artist's studio.[62] In the upper half of the panel appears on the left a man who has been bound and discarded in a trash can, where he stands helplessly. This particular image suggests a device used most effectively a generation later by Samuel Beckett in *Endgame* and *Play*. Next to the trash can figure is a hideously mutilated, gagged man trussed to a column, who lifts his bloody stumps of arms like great emblems of torture. The columns themselves suggest that the action here might take place in some ornate palace or temple.

The right panel seems to represent a narrow stage with stairs; or does the bellboy indicate that we are in the corridor of a hotel? (Among the few remarks that Beckmann made which might shed light on his symbolism is that the hotel boy is the modern messenger of fate.) Here the central place is occupied by a woman who holds a lamp. Tied to her, standing on his head, is her inverted male companion, suggesting an obsessive relationship. On the couple's left is a horrible dwarf-like Eros; on the right the blindfolded bellboy holds a thin green fish whose sly expression repeats that on the face of the woman but is in important contrast to the large fish grasped by the masked figure in the central panel.

Lilly von Schnitzler, Beckmann's friend and patron, remembers explanatory remarks he made in February 1937 in Berlin about the triptych: "On the right wing you can see yourself trying to find your way in the darkness, lighting the hall and staircase with a miserable lamp, dragging along tied to you as part of yourself, the corpse of your memories, of your wrongs and failures, the murder everyone commits at some time of his life—you can never free yourself of your past, you have to carry the corpse while Life plays the drum."[63] Is it Life who plays the drum, or some mechanical functionary, marching below the balustrade, whose head may be a purposeful likeness of Louis XI?[64] A newspaper lies next to the bound woman's globe on which the word *Zeit* is legible. This surely indi-

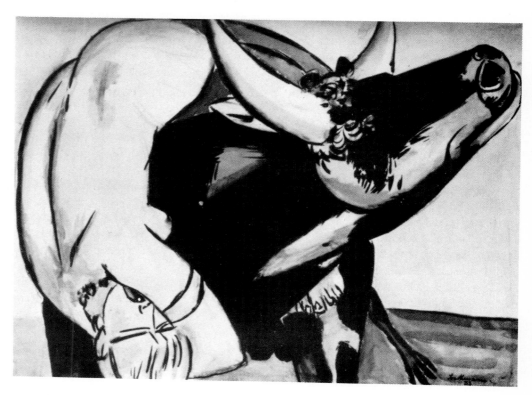

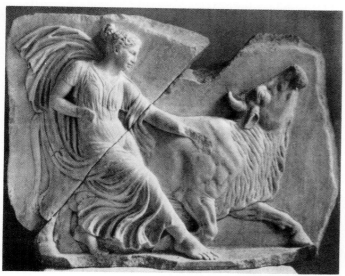

Above: Rape of Europa. 1933. Watercolor, 20^1/$_8$×27^1/$_2$". Collection Frau Lilly von Schnitzler-Mallinckrodt, Murnau

Left: Nike Leading a Bull to Sacrifice. 1st century B.C. Roman copy of Greek 5th-century relief from the balustrade of the Temple of Athena Nike on the Acropolis at Athens. Staatliche Museen, Berlin

cates that the triptych alludes to its time. Although beginning his famous speech in London in 1938 by asserting that he had never been politically active in any way, Beckmann was deeply troubled about the events of his time and *Departure* reflects—among other things—on the cruelty of the time. But Kessler's suggestion that a veiled, distorted swastika is suggested by "the relationship of lines and angles formed by the drumstick, arm, drumstrap, and printed paper beneath"[66] is not convincing.

The darkness, the crowded space, the general oppressiveness and horror of the side panels is in utter contrast to the bright, open, colorful luminosity of the center panel. "Out of this earthly night of torment and mental anguish, the figures of the central panel emerge into the clear light of redemption and release, embarked for Eternity."[67] Here, in the broad mid-day light, floating in their barge on the luminous blue sea are figures whose scale is larger, as their pace is slower. On the left, standing erect and holding a large fish between outstretched arms, is the large masked personage,

> *Gliding wrapt in a brown mantle, hooded*
> *I do not know whether a man or a woman. . . .*[68]

In the center of the boat the woman, who bears a clear resemblance to the portraits of Quappi, holds a child. Her frontal stance and detached look endow her with the appearance of universality. Beckmann, who, like many of his great contemporaries—Joyce, Eliot, Mann, Picasso come to mind—often quotes from the past, has given the woman here a classical appearance—including the almond-shaped eyes and the Phrygian cap—of fifth-century Greece. And if the woman recalls classical antiquity, the fisher-king reminds us of the culture of the Middle Ages. With his three-pointed crown and angular profile he evokes the image of the saints and kings on the portals of Reims and Bamberg and in the choir of Naumburg.

The infant, who may represent the hope embodied in youth, is in the very center of the whole three-panel composition. Next to the mother and child is the largely hidden male figure, who has been interpreted variously, as a Joseph accompanying the central Madonna and Child;[69] as Charon steering the boat to an unknown port;[70] or possibly a veiled self-portrait.[71] The fisher-king, pulling in a full net and gazing across the sea into the distant space, lifts his right hand in a magnificent gesture that rejects the despair or the side panels and at the same time points ahead into an unknown future.

Lilly von Schnitzler also remembers Beckmann telling her that "the King and Queen have freed themselves, freed themselves of the tortures of life—they have overcome them. The Queen carries the greatest treasure—Freedom—as her child in her lap. Freedom is the one thing that matters—it is the departure, the new start."[72]

This is probably as far as an interpretation of this great triptych—or of any of Beckmann's later paintings, which are so deeply involved in a personal symbolism—can be carried. *Departure*, as James Thrall Soby has said, is "one of the major works of art our century has thus far produced," and he points out that it "has often hung in the Museum of Modern Art on the same floor with Picasso's *Guernica*. Between them, the two so different works furnish proof that modern art's symbolism can be as forceful, moving and impressive as anything produced in earlier centuries."[73] But while the symbolism of the great works of our century can be as "forceful, moving and impressive," it is also different in kind. Ours is no longer a period in which a painting can communicate with the clarity of works of the past. The iconographic program and meaning of the great frescoes on the walls of San Francesco in Arezzo or the ceiling of the Sistine Chapel, or even those in the Ajanta caves, becomes clear once the key has been found. But it is an essential aspect of modern art, even when natural forms are retained, that much of it must remain unintelligible. (And this is even truer of *Departure* than it is of *Guernica*, a painting that makes reference to a specific historic event, and where only the bull retains ambiguity.) At a time when the media of communication, the newspapers, magazines, radio, television, spare no effort to avoid interference, "noise," any kind of imprecision, the poet and painter set up all kinds of traps and impediments precisely in order to resist any easy approach. The ambiguity and the unpredictability, so germane to the modern spirit, must find expression, as so clearly stated by Meyer Schapiro: "The artist does not wish to create a work in which he transmits an already prepared and complete message to a relatively indifferent and impersonal receiver. The painter aims rather at such a quality of the whole that, unless

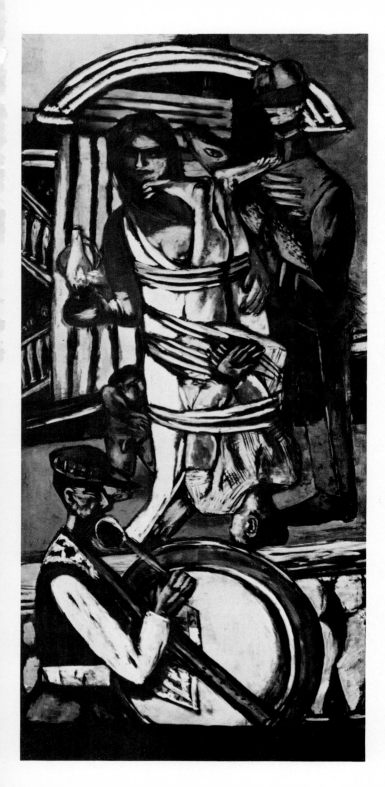

Departure. (1932–33). Oil on canvas; triptych, center panel 84³/₄ × 45³/₈″; side panels each 84³/₄ × 39¹/₄″. The Museum of Modern Art, New York, given anonymously (by exchange)

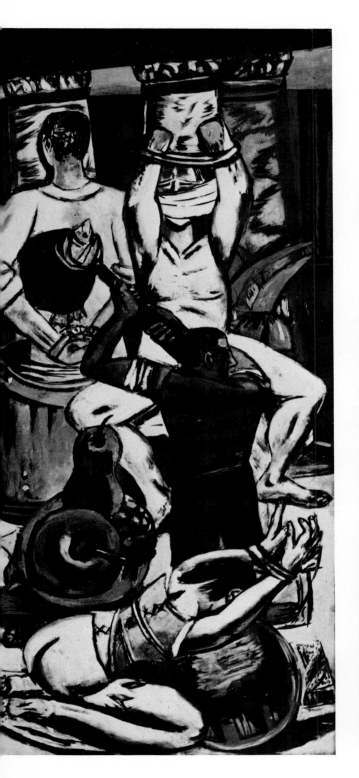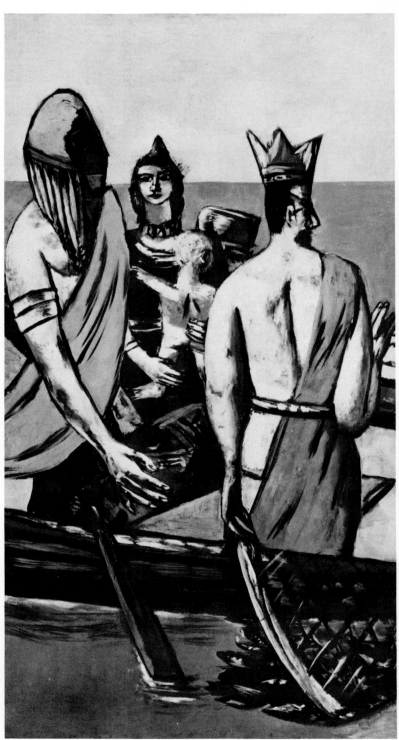

you achieve the proper set of mind and feeling towards it, you will not experience anything of it at all."[74]

Beckmann himself would have been in complete agreement with Schapiro. When Curt Valentin wrote to Beckmann that clients wanted an explanation of *Departure,* the painter replied:

"Take the picture away or send it back to me, dear Valentin. If people cannot understand it of their own accord, of their own inner 'creative sympathy,' there is no sense in showing it. . . . The picture speaks to me of truths impossible for me to put in words and of which I did not ever know before. I can only speak to people who consciously or unconsciously, already carry within them a similar metaphysical code. Departure, yes departure, from the illusions of life toward the essential realities that lie hidden beyond. . . . It is to be said that *Departure* bears no tendentious meaning—it could well be applied to all times."[75]

Beckmann always wished his paintings to remain private and personal, to communicate a feeling but not necessarily to be understood in the literal sense. He used the human figure and a diversity of objects because he wished to have every means at his disposal in order to speak most effectively; not only space and color and shape, but also the active human figure. The frontally hieratic woman and child in the center of *Departure,* the fisher-king with his royal gesture, the man tied to the woman searching with her lamp are symbols charged with allusion, but whose precise meaning must remain as enigmatic—or perhaps as multiple—to the viewer as it was to the artist. This is why the interpreter who believes he has discovered the key to Beckmann's iconography is likely to find that it may open one door but not all.

As a rule, if someone asked Beckmann about the meaning of one of his triptychs, he was likely to whistle through his teeth, point to the ceiling with his thumb and say, "You'll have to ask the one up there."[76] In this evasive response, however, he seems again to be looking at himself as a divine spokesman through whom the great Christian drama is enacted. Here in the contrast of the central panel and the side wings can be seen another of his dramatic interpretations of the dark and the light, of hell and heaven, the damned and the blessed, sin and guilt, on the one hand and redemption on the other. This is certainly one level on which *Departure* and a great many of Beckmann's works appear to take place; it must be emphasized, however, that this is not the only level.

During his years in Berlin, Beckmann became increasingly involved with a highly personal and disquieting symbolism. There is an eerie and highly romantic landscape painted at that time: a night view of the Walchensee during a fog with the crescent moon sitting on top of jagged, pyramidal mountains (page 62). The rocks in the foreground resemble a shoal of fishes in rapid upward movement. This small, lonely landscape has the feeling of shifting earth, water, and mountains. Communicating the artist's highly charged emotions almost directly, it is the closest Beckmann ever came to painting an Expressionist picture.

Then he would find the composure to do as carefully structured a picture as *Self-Portrait with Beret* (page 54). The semicircle of the black cap forces the viewer's eye to the face itself, and we follow the sharp vertical line that separates light from dark along nose, chin, neck, and knuckles of the left hand through the exact center of the picture, while the left hand itself establishes the horizontal balance, the right hand being concealed in a manner traditional in self-portraits. The gesture of the folded arms denotes his wish to withdraw in spite of presenting himself in open, frontal view. Evident in all his self-portraits is Beckmann's ambivalence between his desire to retreat into himself and his need to be a figure of public adulation. The subtitle given by the painter to *Self-Portrait with Beret* is *Gilles:* he now calls on Watteau in his dialogue with the art of the past and paints himself with a large round hat similar to Gilles' and facing the viewer in a like manner; even the use of shading in order to enhance the tactile effect of the face is maintained. Beyond that, the languid character of Watteau's sad and gentle clown, the famous Pierrot of the Italian comedy who is everybody's poor fool, appeals to Beckmann at this time. He sees himself most romantically with large, liquid, almost hypnotic eyes, but unlike Gilles, whose arms hang down loosely, Beckmann's arms are folded in self-protection. For all its pride, this is the portrait of a vulnerable man. And it is all the more stunning for its boldness of composition. He no longer needs the window frame to anchor the

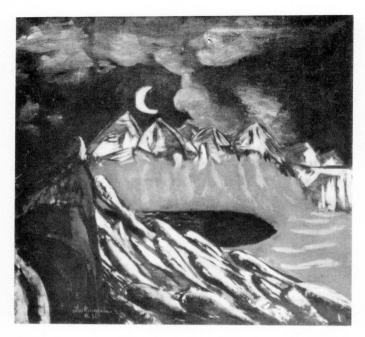

figure, but places the bust against an empty, soft, purplish-gray background, while a pink curtain with a Matisse-like pattern gives dramatic vitality to the painting which, like so many of the self-portraits, is composed with a limited palette.

The pastose application of pigment in the face of the *Self-Portrait with Beret* prevails also in that extraordinary painting of 1935, *The Organ Grinder*. This large picture, painted soon after the completion of *Departure*, is even more veiled in its meaning than the triptych. A woman, standing on the upper left, seems to wish to retain her unborn child. Next to her is a warlike female figure with a wooden leg, who carries a black bowl and a bundle of spears. The uniformed organ grinder himself, sitting below the allegory of war, is placed between a sensuous woman and a cryptically inventive figure on the lower right. The body of this blindfolded woman, holding on to a great anchor or arrow, is covered with blue eyes. Is Beckmann implying that this figure feels with her body what she cannot see with her eyes? Again he has left no key to unlock the realm in which he operates. The painting was later called *Lebenslied*, "The Song of Life," by its owner. But this is a

ritualistic, not a sentimental, song and increasingly the ritual becomes important to Beckmann as a severely constrained expression of emotion. The rhetoric of the pre-World War I scenes make way in the twenties for the more realistic treatment of tragedy, one actually bordering on reportage. Now, in the late thirties, Beckmann's compulsive feelings with their admixture of moralism and criminality, of abuse and constraint, of the affirmation of life and the anxiety about death, find expression in a ritualistic and stylized imagery. This is evidenced again in his second triptych, *Temptation*, inspired by Flaubert's *Tentation de Saint-Antoine* but probably related more closely to an Indian legend he was reading at the time. In this highly colorful triptych, figures are again chained, caged, and gagged. This parable of man's impotence and frustration was completed toward the end of his stay in Berlin in 1937, when he himself acted as forcefully as possible.

Beckmann, as we have noted, had been dismissed from his position as soon as the Nazis took power, and as early as 1933 his paintings were shown in a number of exhibitions defaming modern art which began to tour Germany years before the large Degenerate Art show opened in Munich. As the attack on culture increased in violence, many of Beckmann's pictures —ultimately a total of 509 works—were removed from museums throughout Germany. On July 18, 1937, Adolf Hitler opened the Great German Art Exhibition at the new Haus der deutschen Kunst in Munich, decreeing that the brutally propagandistic art in the exhibition was not to change for the duration of his thousand-year realm. He stated in his speech that any artist who would persist in distorting nature would do so either out of defiance against the state, in which case criminal punishment would be in order, or because of mechanical malfunctioning of the eye, which, being hereditary, would call for sterilization.[77] The very next day Professor Adolf Ziegler opened the infamous Degenerate Art exhibition in Munich as an accumulation of monstrosities by the insane, the insolent, the incompetent, and the degenerate.[78] Ten of Beckmann's important paintings were included in the exhibition. The day after the opening, Beckmann and his wife took the train for Amsterdam where Quappi's sister was living at the time. Beckmann never returned to Germany.

Opposite page: Moonlit Night on the Wal-
chensee. 1933. Oil on canvas, 29¹/₂ × 30³/₄".
Collection Frau Lilly von Schnitzler-Mal-
linckrodt, Murnau

The Organ Grinder. 1935. Oil on canvas,
68⁷/₈ × 49³/₈". Collection Frau Lilly von
Schnitzler-Mallinckrodt, Murnau

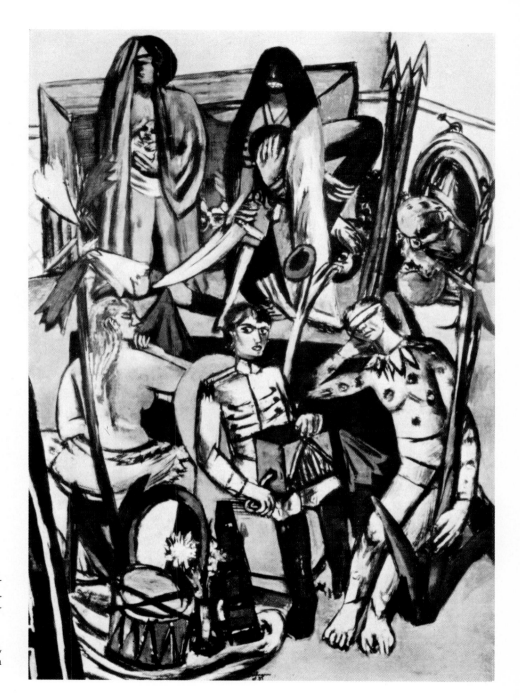

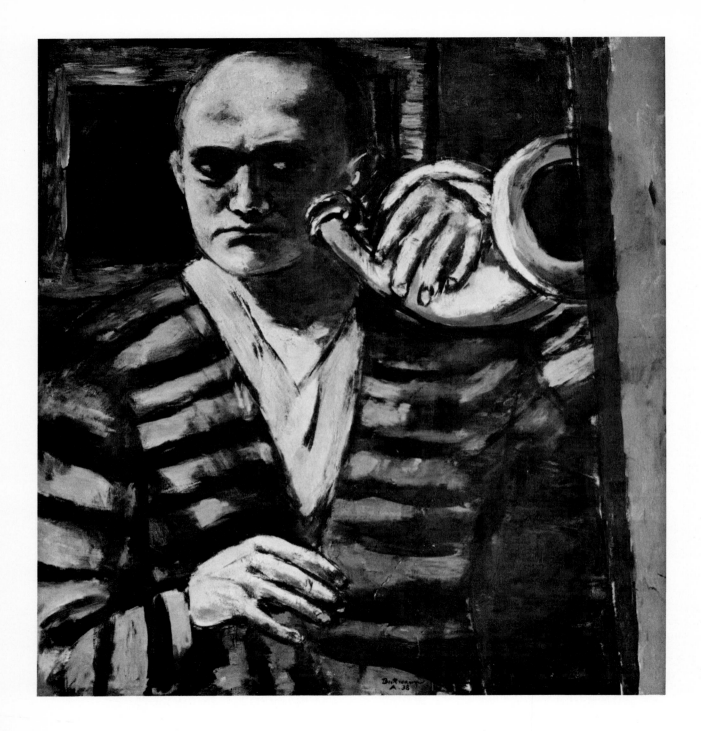

In Amsterdam the Beckmanns rented a modest walk-up apartment in a narrow gabled house on the Rokin in the center of the city. Above the flat in the attic was a tobacco storeroom with a skylight which Beckmann converted into his studio and there he worked almost obsessively, often for ten hours a day. The Beckmanns' life in Amsterdam had few distractions, and they were to become even more isolated during the Nazi occupation. Although Beckmann loved being among people, his primary need was for the privacy of his studio. He had to be able to return from the day's or night's excursions to the complete quiet of his retreat. He liked having his studio close to his living quarters, and was glad that this was possible in Amsterdam, as it had been in Berlin, and as he was to manage again in both his New York residences. The secluded years in Holland were certainly among his most productive ones, and the A, for Amsterdam, stands with his signature in over two hundred paintings.[79]

Soon after his flight to Holland he made a carefree and enchanting portrait of Quappi. *Quappi with White Fur* (page 66) recalls the gracefulness of his first portrait of her of 1925 (page 43), but instead of the inhibited elegance revealed in the earlier picture, he now endows his wife with worldly sophistication. This is the wife of a cosmopolitan traveler, not of a political refugee. Clad in a stylish coat with white fur, topped by a delightful little hat whose veil only emphasizes the provocative black eyes, holding a flower and Butshy, the Beckmanns' Pekinese, she faces the spectator in self-assured calm, while the dashingly painted larkspur behind her repeats her slim elegance. Yet this painting is saved from becoming a fashion plate by the inventiveness of the composition, the painter's insight into his model, and, above all, the sheer visual beauty of his brush.

A canvas of such gaiety, however, remains the exception. *The King*, also from 1937 (page 67), creates a brooding and foreboding mood. Dressed in a rich maroon garment, the king sits in a hierarchic position, his legs spread laterally in a manner that reminds us of the earlier *Zeretelli* (page 46) or the later

drumbeating savage in *Blindman's Buff* (page 82). Crowned, wearing a royal collar, and decorated with earrings, this man of unquestionable kingly bearing supports himself on his large sword. He stares at the viewer from the deep cavities of his eyesockets. On his right in a position of supplication is a small woman wearing a little crown, who peers out at us with a childlike, apprehensive expression. Her head and his large shoulder are outlined by a gray object which may signify a wheel. The third figure in this mysterious painting, the woman behind the king on his left, is in dark shadow and reaches out in a gesture of denial and rejection. How marvelous it is to study the play of hands: the king's resting firmly on the sword guard, the young woman's clinging gently to his forearm, the other woman's pushing forward, with a gesture of disdain!

Who, we wonder, are these people: the powerful, inaccessible king, the apprehensive girl, the hooded woman in the dark identified only by the light outlining her profile? The king, of course, has Beckmann's own features, the young woman to his right seems to resemble Quappi, while the older one brings to mind the 1924 portrait of Minna Beckmann-Tube in Günther Franke's collection in Munich. But even if we could make such identification, the real meaning of the painting remains veiled in the mystery with which the artist endowed it. Beckmann makes use of rich, dark, luminously glowing color in which the black outlines have become so broad, they almost determine the total color relationships. He crowds his space with figures that are immovable in their assumed positions and share the mystery of Beckmann's light, which, he says, serves "on the one hand to divide the surface of the canvas, on the other to penetrate the object deeply."[80] Constantly searching for the self, for his own authenticity, Beckmann has painted a picture of power and fear, supplication and rejection, silence and intrigue.

In the important, reflective speech he delivered to open an exhibition of contemporary German painting at the New Burlington Galleries in London in July 1938, Beckmann declared: "As we still do not know what this Self really is, this Self in

Opposite: Self-Portrait with Horn. 1938. Oil on canvas, 42^1/$_8$ × 39^3/$_4$".
Collection Dr. and Mrs. Stephan Lackner, Santa Barbara, California

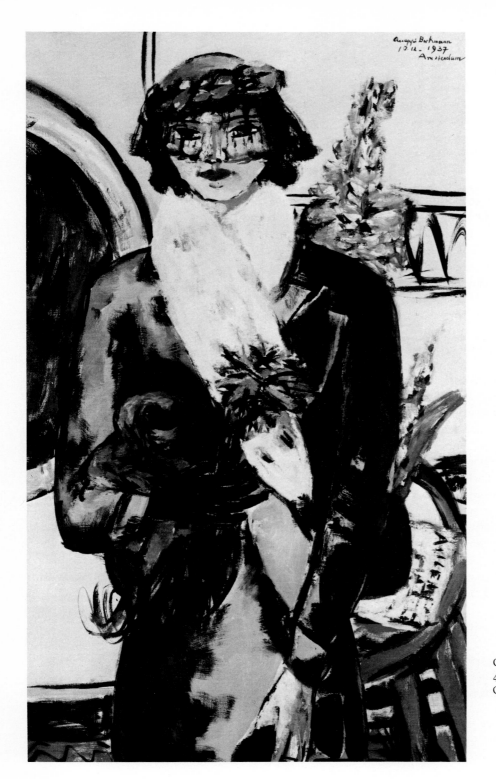

Quappi with White Fur. 1937. Oil on canvas,
42⁷/₈×25¹/₄″. Collection Ala Story, Santa Barbara,
California

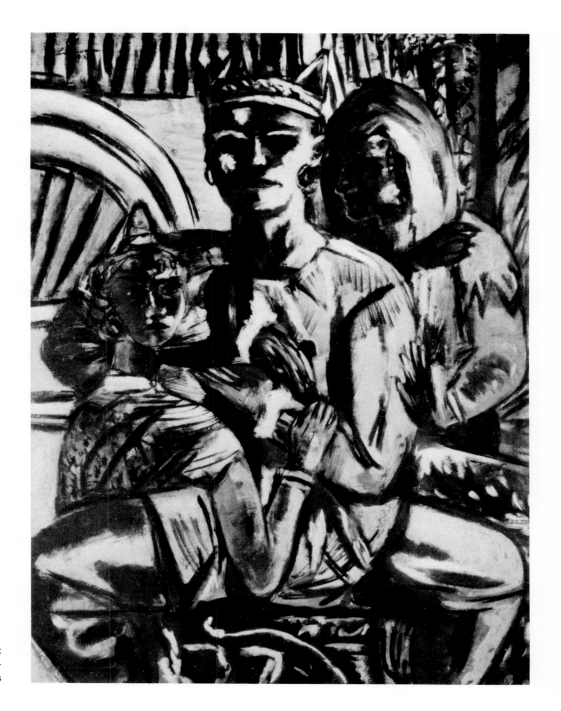

The King. 1937. Oil on canvas, 53¹/₄ ×
39¹/₄″. Collection Mr. and Mrs. Mor-
ton D. May, St. Louis

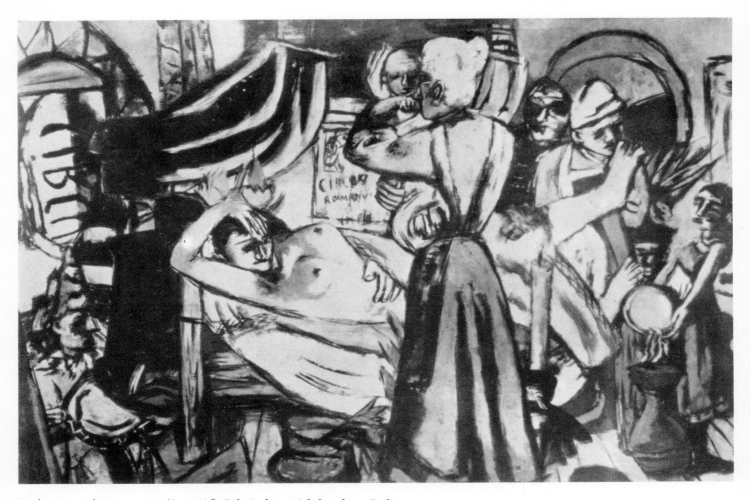

Birth. 1937. Oil on canvas, 47⁵/₈×69¹/₂″. Galerie des 20. Jahrhunderts, Berlin

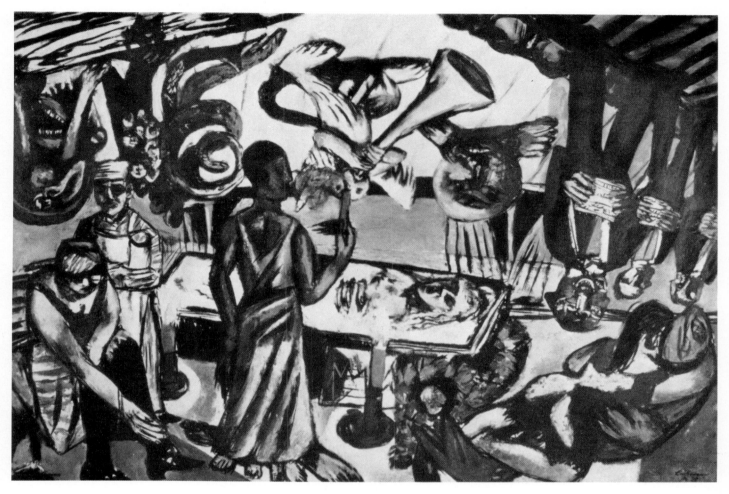

Death. 1938. Oil on canvas, 47⅝×69½". Galerie des 20. Jahrhunderts, Berlin

which you and I in our various ways are expressed, we must peer deeper and deeper into its discovery. For the Self is the great veiled mystery of the world."[81] A man so deeply concerned with the search for the self had eventually to turn to the two certainties in man's existence. In 1937 and 1938 he painted two large horizontal panels, *Birth* and *Death*.

Birth is composed in the manner of a traditional Renaissance scene of the birth of the Virgin. But the central position here is occupied by a large, rather grotesque mother with swollen breasts, legs spread apart. Her attendants, the small circus clown on the left, the stately midwife holding the baby, the odd entourage of exotic personages on the right, locate the confinement room in the crammed backstage of a circus. Beckmann was always captivated by the circus, this place of make-believe and disguise, because there actuality, ritual, and illusion constantly shift to provide that deeper reality nourished by man's fantasy. His *Birth*, therefore, takes place in the gypsy circus, identified clearly by the lettering in mirror image on the left and the poster spelling CIRCUS ROMANY in the very center.

Beckmann frequently made use of lettering in his work, a practice introduced into modern painting by the Cubists in 1911. The Cubists liked to use letters not only as an integral part of the design, but also in order to evoke a new awareness of diverse levels of reality: when Braque places the names of Mozart and Kubelik above a dismembered violin he jolts the spectator into making a new relationship between the abstracted and the familiar. Beginning in 1912, the Futurists made a similar use of lettering, but in a canvas like Severini's *Dynamic Hieroglyphic of the Bal Tabarin* the words and letters locate the scene and evoke multiple associations in the viewer, thereby inquiring about the nature of reality. In German art, letters were introduced toward the end of World War I by the Dadaists, such as John Heartfield, Johannes Baader, and George Grosz, in order to propagate their irreverent, revolutionary messages, while Schwitters used similar means to comment on the irrational and absurd. In 1920 in *Family Picture* (page 34) Beckmann used letters probably for the first time, but then merely to render a newspaper more accurately, just as he depicted a cigar box with some of its lettering as well as the picture on the underside of its lid in *Still Life with Burning Candle* of

1921. While never neglecting the formal placing of the letter within the total compositional framework, he becomes involved in the importance of the object and this includes the prevailing media of communication, such as newspapers, broadsides and posters. At times, as in this birth in a circus, the letters help identify the environment, while in other instances in Beckmann's oeuvre letters are used to concentrate our attention on an event or scene which remains essentially mysterious.

If the nativity takes place in a circus tent, the death occurs on the stage of a night club (page 69). The men in the upper right, singing their dirge in ensemble, seem to be reflected in a ceiling mirror, prevalent in cabarets—why else would they stand upside down, hanging from the canopy? The leader of this chorus has a multiple face and sings out of several mouths. The dead woman is attended by other figures extending from the ceiling, a disembodied head, a horrible little winged monster sounding a huge monotonous horn, various disjointed horror-evoking demons whose inventiveness is comparable with the bestiary of Hieronymus Bosch, whose work would leave Beckmann in a "shattered state."[82] Again, when contemplating the woman riding away on the back of a fish, or other mourners in this unholy ritual, we are transported into a modern Walpurgis Night, in which Beckmann manages to suggest simultaneously moods of disgust and desire. He himself speaks of being impelled by visions that sing to him in the night, ". . . Stars are our eyes and nebulae our beards . . . we have people's souls for our hearts. We hide ourselves and you cannot see us, which is just what we want when the skies are red at midday, red in the blackest night."[83]

Less visionary and a great deal less disturbing is the *Apache Dance*, also of 1938. Here the artist takes us on the stage of the cabaret. A heroic dancer stands with legs spread wide. The powerful legs, typical of a great many of Beckmann's male figures at this time be they kings, clowns, dancers, or musicians, support a huge torso. The apache has thrown the girl over his giant shoulders. There is a garish clash of colors between his chartreuse shirt and her fiery red stockings, echoed clangorously by the flames of her red hair. The girl, limp as a rag doll, seems to enjoy being carried off by her assertive partner.

This abduction recalls Beckmann's great watercolor, *The*

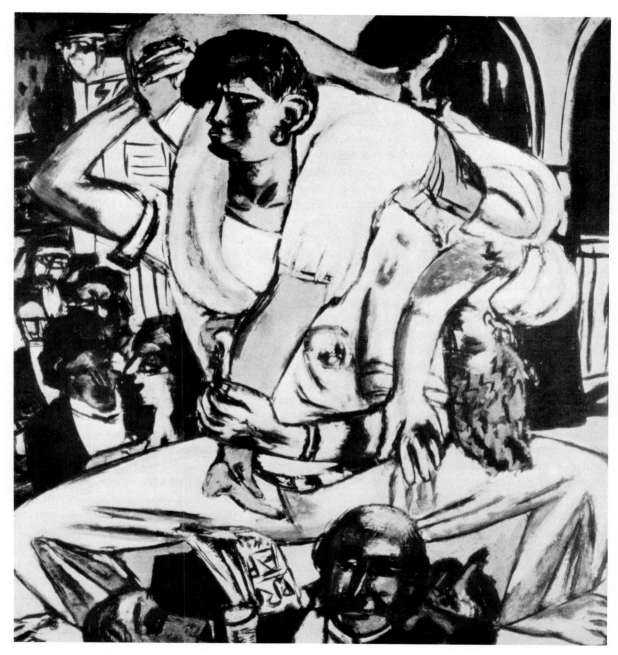

Apache Dance. (1938). Oil on canvas, 67 × 59½". Kunsthalle, Bremen

Rape of Europa (page 57): the female dancer is in a position of submissive surrender similar to that of Europa in the watercolor. Now it seems that a wildly dancing man has been substituted for the charging divine bull. The dancer's classical profile, however, is not that of a supreme Zeus, but of a victorious hero, a Hercules type, who has triumphantly subdued his antagonist. This interpretation may shed some light on Beckmann's concept in his painting of the male-female relationship.

Although Beckmann felt at home in the urban environment of large cities, he always had an understandable need for the countryside, for trees and flowers, fields and the open sky. In his diary he often mentions excursions by train or bicycle to the Dutch seashore or countryside. Throughout his life, in fact, from the pictures of sea and beach in 1905 to those of the Mills College campus in 1950, he frequently turned to the landscape as an important motif. In his landscapes, as in his still lifes, he was able to relax the tensions evidenced in his bristling figure compositions. This less personal involvement resulted at times in pictures that are somewhat softer, but perhaps because he was less directly involved in the theme, they reveal his compositional devices and formal means more clearly and add to our insight into his creative formulation.

Dutch Landscape, of 1938, is a splendid small painting in which a canal carves through the land in the center of the canvas. The area to the left—the houses, lawns, and trees—is dominated by cool greens and blues, while warm yellows and browns prevail in the right-hand section, and a neutral gray expands in the upper part. The cows on the right side pick up the values of the left-hand area, but here all academic devices come to an end. He also plays with the relationship of shapes and juxtaposes the energetic triangular shape of the boat in the foreground to the light gray triangle of the curving canal in the exact center of the picture.[84] In contemplating this landscape we can only agree with his statement in the London lecture: "It is not the subject which matters but the translation of the subject into the abstraction of the surface by means of painting."[85]

During the same year Beckmann painted his self-portrait in the striped suit of a clown, or prisoner, with a large trumpet (page 64): blowing his own horn, so to speak. But he has moved the horn from his lips and placed it close to his ear. Is he listening to its echo? He is the artist who simultaneously creates a noise and listens to its reverberations, who observes the world but also watches his own effects with suspicion. He depicts himself as the large, powerful man he was, but he also appears insecure, unsure of himself, searching. The cellist Frederick Zimmermann—himself a great admirer of Beckmann and a collector of his work—pointed out in a lecture delivered to the Beckmann Society in 1962 that the painter knew the sound and pitch of each musical instrument and painted each in order to evoke a specific response.[86] There is surely a synesthetic relationship between the monotonous sound of the trumpet and the insistent orange-black alternation of the stripes on the artist's garment.

Beckmann, who visualized himself as spokesman and conscience of his time, has placed his head in this painting against a golden frame, which the writer Stephan Lackner interprets as "a square halo."[87] Lackner, who has owned this magnificent self-portrait since Beckmann completed it in 1938, relates a telling episode in which his father discussed the painting with Beckmann at the time and asked him, "Have you always looked so imposing, or is your head, too, the result of artistic effort?" Beckmann nodded pleasantly, "Oh well, you know, after all aren't all phases of this world of appearances the result of our own efforts?"[88]

Stephan Lackner first met Beckmann in Frankfurt in 1927 and began buying his work in 1933 at the very time when the artist needed support most urgently. They met again in Paris in 1937, at which time Lackner "bought an even dozen of Beckmann's canvases, among them the tremendous triptych *Temptation*."[89] At that time Beckmann illustrated Lackner's play, *Der Mensch ist kein Haustier*,[90] with seven lithographs, and Lackner acquired paintings by Beckmann at regular intervals for a specific monthly rate. They remained close friends, visiting each other in Amsterdam and Paris until Lackner left for America in 1939. Years later, when Beckmann arrived at Mills College to teach the summer session, he was surprised by an exhibition of about thirty of his paintings, all but one of which Alfred Neumeyer had borrowed for the occasion from Lackner, who was then living at the foot of the mountains in

Santa Barbara. Beckmann entered in his diary: "Later, viewing Beckmann pictures in the Museum (old Berlin ones—Paris 1932-39—sad reminiscences) my God, all the things one had to live through—and now to meet myself again in California."[91]

But during the last prewar years, when Lackner was among Beckmann's few friends, the latter hoped to leave the narrow confines of Amsterdam which he always considered as only a temporary abode. He vacillated between attempting to settle in Paris and wishing to come to America. His exhibition in New York at Curt Valentin's new Buchholz Gallery in January 1938 had considerable critical acclaim there as well as on its tour to Kansas City, Los Angeles, San Francisco, Portland, and Seattle. In July 1939, he was awarded a $1,000 prize for the *Temptation* triptych at the Golden Gate exposition in San Francisco. In March 1939, he had written to his old friend, J. B. Neumann: "I should like to look into your suggestion to come to America for good, since this country has always struck me as the fitting place to spend the last part of my life. If you could manage to have me called to a post somewhere, even a very modest one, I would leave at once, in spite of the fact that I like it here quite well. . . ."[92]

This letter was written from Paris where Beckmann was preparing an exhibition at the Galerie Poyet. Perhaps, he felt, Paris might be a good place to stay. He announced, in fact, to J. B. Neumann, "Now I am back in Paris, where I shall settle finally in August."[93] But war broke out before the show could take place and as he was in danger of internment, he returned to Amsterdam, making plans to leave for America where Daniel Catton Rich had invited him to teach at the Art Institute of Chicago. But the American consul in Amsterdam would not give him a visa. The first entry in Beckmann's published diary, of May 4, 1940, mournfully remarks: "America is waiting for me with a job in Chicago, yet the American consulate here issues no visa."[94] A few days later the Nazis were in Amsterdam.

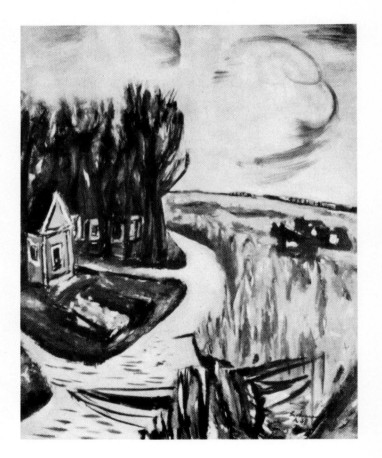

Dutch Landscape. 1938. Oil on canvas, 27$\frac{1}{2}$ × 21$\frac{5}{8}$". Collection Dr. Peter Beckmann, Munich-Gauting

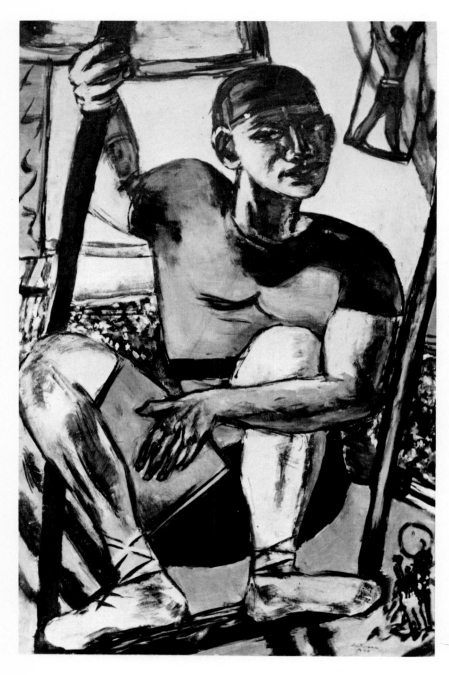

Acrobat on Trapeze. 1940. Oil on canvas, 57$^{1}/_{2}$×
35$^{1}/_{2}$". Collection Mr. and Mrs. Morton D. May,
St. Louis

These are the first sentences in Beckmann's diary: "I begin this new notebook in a condition of complete uncertainty about my own existence and the state of our planet. Wherever one looks: chaos and disorder."[95] At the same time he portrays himself high in the air in *Acrobat on Trapeze*. Squatting at this dizzying height with a quizzical expression in his almond-shaped eyes he faces us in a startling close-up encounter in this unlikely spot. Below we see the orange floor of the tent and a cursory indication of the public. The colors, the bluish green heavily outlined against the chartreuse, are used with startling boldness: "Color, as the strange and magnificent expression of the inscrutable spectrum of Eternity, is beautiful and important to me as a painter; I use it to enrich the canvas and to probe more deeply into the object. Color also decided, to a certain extent, my spiritual outlook, but it is subordinated to light and, above all, to the treatment of form."[96]

Though he was most sensitive to color relationships, it was form—form in space—that remained paramount in Beckmann's painting. *Acrobat on Trapeze,* less complex in its meaning than so many of his late canvases, brings the viewer into almost physical contact with a subject that is pushed up close: this man swinging perilously through the void.

If *Acrobat on Trapeze* seems like an apprehensive parable on man's place in the modern world, the *Double Portrait of Max and Quappi* of the following year (page 76) is a much more positive and less troubled statement. Here, acting as protector to his young wife, he stands firmly on the ground. Again he emphasizes his aspiration to worldliness by presenting himself as an elegant gentleman, white scarf around his neck, cane swinging from his wrist, holding a top hat on whose silk lining the word "London" has been inscribed in huge letters. At his side, smaller than himself and slightly behind him, is Quappi, with her hand placed gently on his shoulder. She is close to him, yet separated also: not only is she smaller in scale but she is also protected by the wall of a house, while he stands against empty yellow space.

In 1945, after the artist had been living in Holland for seven

years, this painting was acquired by the Stedelijk Museum in Amsterdam. Beckmann was little appreciated and very lonely during the war. He lived in partial hiding much of the time and maintained few contacts with Germany. His son, Peter Beckmann, a medical officer in the German air force, was able to come to Amsterdam fairly often: the diaries are filled with notices of these visits. Through Peter, the important contact with his friend and dealer in Munich, Günther Franke, could be maintained. Old friends like Lilly von Schnitzler would visit him on occasion, and it was in Amsterdam that the art historian Erhard Göpel first encountered the artist to whom he was to turn much attention from then on.

The only artist whom Beckmann saw regularly in Holland was Friedrich Vordemberge-Gildewart, a painter working in the geometric abstract idiom, who had come to Amsterdam in 1938. Beckmann, who purposely stayed out of artists' organizations, who never counted painters among his personal friends, and furthermore felt that abstract art was rather sterile and more related to the crafts than to art, nevertheless respected the work and really enjoyed the personality of Vordemberge. He also formed an important friendship with Wolfgang Frommel, the poet and writer of Stefan George's circle, who had sought refuge in Holland from the Nazis, and whose warm humanity and profound mind may have inspired some of the content in Beckmann's late work.[97]

Perhaps most important during the war years, however, were his friendships with Erhard Göpel and Helmuth Lütjens. Dr. Göpel visited Beckmann in Amsterdam, was able to help him in a great many ways during the Occupation, and became committed to his work. Later Göpel became one of the founders of the Beckmann Society and the administrator of the Beckmann archives in Munich. He has written important essays on the artist, has edited the large volume *Blick auf Beckmann,* and is currently working on a definitive catalogue of Beckmann's work.

Dr. Lütjens had been director of Paul Cassirer's Amsterdam branch since the twenties. During the war and their years of

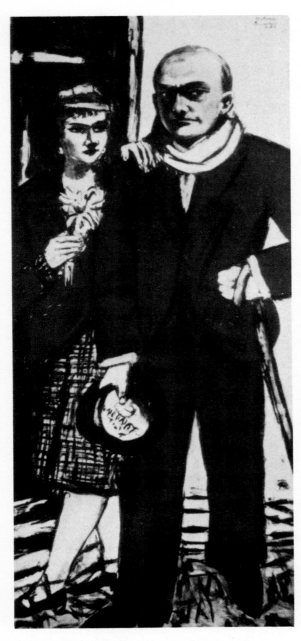

Double Portrait of Max and Quappi. 1941. Oil on canvas, 76³/₈ × 35″. Stedelijk Museum, Amsterdam

great need and poverty he helped make the Beckmanns' life bearable. In the autumn of 1944 there are thirteen entries in Beckmann's diary registering his concentrated work on the portrait of the Lütjens family. Lütjens himself is seated in front of a painting, evidently explaining it to his beautiful young wife whose classical head must have fascinated the artist, while their little girl plays with her puppet and the symbolic candle burns in front of a mirror. A harmonically measured rhythm is established by the expressive play of hands and full, sonorous colors. During that last desperate winter of the war, when this portrait was painted, Lütjens bought a good many paintings, stored the largest works, such as *Blindman's Buff*, and finally invited the Beckmanns to stay with him in his house.

In 1944 the Germans attempted to draft the sixty-year-old painter, who had already suffered from a heart attack, into their depleted army. From then on the diary is filled with apprehensive notices about his heart condition. But he lived through the unending air raids and through that terrible last winter of the war with its great frosts when the Beckmanns were able to heat only one small room in which they slept, cooked, ate, and worked. There was no artificial light; even candles were unobtainable. There was almost no food; even bread was scarce. Yet in spite of cold, malnutrition, and sheer physical exhaustion, Beckmann continued painting and made his monumental triptych, *Blindman's Buff*, during the worst months.

Nothing was ever allowed to interfere with his painting, yet Beckmann was a man who was greatly concerned with physical well-being. He loved to eat and drink well—interests which were probably enhanced by the terrible scarcities of the war years—and the diary is sprinkled liberally with entries about the food he eats, the champagne he drinks (or would like to drink), the cigarettes and cigars he manages to procure. Contemplative thoughts about art, on the other hand, are rare in these diaries, which served primarily to register his activities: the books read, the people seen, the walks taken, and the pictures painted, as well as his meals. He shrank from verbalizing his feelings about art and giving away secrets.[98] He knew that the meaning of art cannot be defined; even as brief

a remark as the first one about his *Odysseus and Calypso* (page 78) is more than he is usually willing to say: "In the morning worked too intensively and with much melancholy on Odysseus and Calypso."[99]

Resting on his bed, Odysseus is most tenderly caressed by the nymph, whose sensuous body, however, cannot keep him from pursuing his own thoughts. This is Odysseus who, even in the arms of the ardent Calypso, knows he must wander on, to return home to Ithaca. A purple snake winds around his leg, while a fantastic green bird with a large golden beak crouches by his side and a statuesque sphinx-like cat watches the futile embrace. The nymph's Greek profile, the meander pattern, the classical features of the Homeric hero, recalling the Olympian Lapiths, give the painting a classical connotation. Indeed, this appears to be a modern version of those poignant carvings of farewell in the fifth-century burial steles of Greece. But it is a modern version: the sense of loss and isolation, the futility of human contact and essential solitude of man exist here and now and no longer wait for the world beyond the Styx. We know that Beckmann identified with the gods of antiquity: arriving in St. Louis in September 1947, he could write, "Now pauvre 'Odysseus' sits again at his green table . . .";[100] and a little later, he would appear at a masquerade party, with a black domino over his eyes, announcing facetiously, "I am Jupiter."[101]

The *City of Brass* (page 79), which he began on Christmas Day 1943 and reworked many times during the succeeding months, takes up the same theme of isolation, but has its origin in one of the tales of the *Arabian Nights* which takes the reader to Maghrib, that land of magic and mystery, and into the City of Brass, a realm richly adorned and filled with fabulous treasure. But a terrible drought and famine have killed every one of its inhabitants, including the city's ruler, a beautiful female who died on her couch in all her Oriental splendor. For Beckmann's painting, done at the height of the war, this tale was surely no more than an agent to prompt his mind and brush. Here, instead of the soft, circular, convoluted composition of *Odysseus and Calypso*, the forms are hard and broken, the lines straight, the angles acute, the colors much harsher. A nude couple rests on the couch, having sought

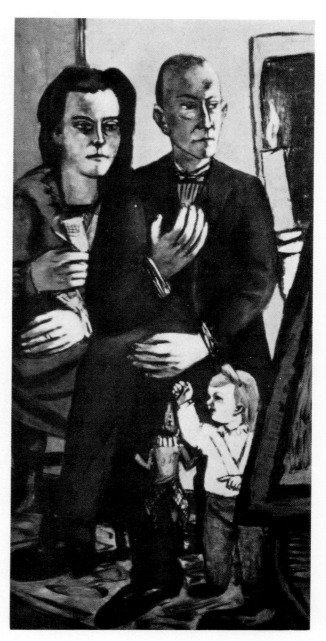

Portrait of Family L. 1944. Oil on canvas, 70⅝ × 33½". Collection Dr. H. Lütjens, Amsterdam

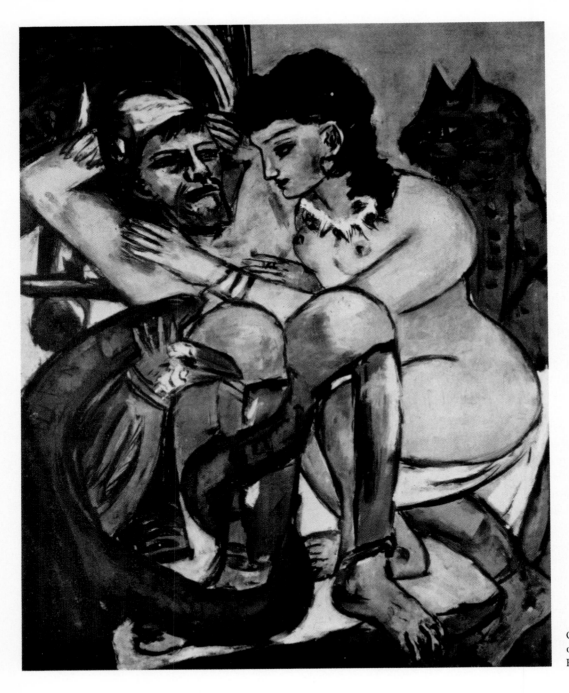

Odysseus and Calypso. 1943. Oil on canvas, 59×45⅝". Kunsthalle, Hamburg

refuge together from an agitated martial scene. They are fenced in by swords and spears, which in themselves may connote either male desire or the actual battle the men must fight. Again no real union is possible between them. They are presented in a state of spiritual and physical exhaustion following the act of love. But it is the woman now who stares into the undefined emptiness of space, while the man turns away, hiding his face—a device familiar to us from the clown's bandaged head in *Pierrette and Clown*, the man concealing his face with large opera glasses in the *Loge* (page 48), and the blindfolded figure in the *Organ Grinder* (page 63). It is used again with great emphasis in two of the great wartime triptychs, *The Actors* (page 80) and *Blindman's Buff* (page 83).

Dealing with significant action—real or fictitious—which is carried out by heroic personages under supernatural guidance, presented with an imposing formal structure and on a monumental scale, Beckmann's triptychs are evidence that epic painting is still possible in our century. During his ten years in Amsterdam, Beckmann was able to complete no less than five of these grand and mysterious compositions,[102] works that are veiled in mystery and defy literal interpretation. "With furious tension one waits for the explanation of the secret. *I believe* in the unknown,"[103] Beckmann noted in his diary, while working on the center panel of the *Actors*. In that panel we see a king thrusting his sword into his chest, but we do not know whether this king—who again resembles the painter—"as a true leader, sacrifices himself, as he must, for his people,"[104] or whether he is merely play-acting: he does wear a paper crown. And what is the purpose of the prompter behind him, or of the masked singer, and does she really recall Beckmann's first wife, and does the woman with praying hands behind and beneath them resemble Quappi in a state

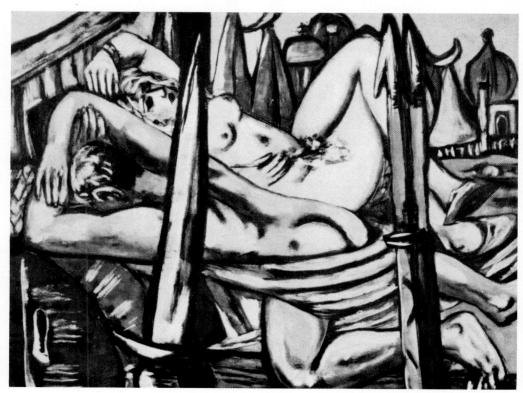

City of Brass. 1944. Oil on canvas, 41³/₈ × 59". Saarland-Museum, Saarbrücken

The Actors. 1942. Oil on canvas; triptych, center panel 78½×59″; side panels each 78½×33″. Fogg Art Museum, Harvard University, Cambridge, Massachusetts

of apprehension, as Göpel suggests?[105] Is the panel on the left a general confrontation of the human spirit with brute force? Or can it be identified with a more specific occurrence when a Nazi patrolman broke into a clandestine meeting of the underground and was miraculously dissuaded from performing arrests by the interference of a Christ-like figure?[106] And what about the man reading the *New York Times*—an American newspaper—in occupied Holland? Clearly, Beckmann is concerned with events of his time, yet this does not explain the triptych. Underneath the staged suicide, the life of the theater follows its course: a languorous woman quietly caresses her cat, stage workers construct a set, the orchestra plays in the pit and low, dark tones emerge from the French horn in the right panel. Above the crowded band a girl observes herself apprehensively in front of a Janus head which has one face in the light and one in the dark, while a bellhop —Beckmann's messenger of fate—stands by. At all times we feel that "they"—Beckmann's figures, the "actors"—and not we, know what they are doing. He gives himself and us just enough clues to arrest the mind and eye but never enough to unravel the mysterious thread. He rejects publicly understood allegories in favor of reality as we truly know it—filled with a multiplicity of possibilities.

"The heavy forms, powerful yet cramped, the confined, claustrophobic space, which pushes in on all sides, and from the back and front, the discontinuity, the paradoxical combination of the motionless and the violent, the opposition of pattern and modeling, these go through the whole work, regardless of subject. From these constant elements, Beckmann constructs his style of impending tragedy."[107] Just as the *Actors* is composed of near complementaries and painted with the full color range of Fauve painting, *Blindman's Buff* surprises the viewer each time by the brightness of its colors (page 83). A gleaming yellow pervades the triptych. It is the color of the railing cutting across the left-hand panel as well as of the candle below, indicating the female protagonist. A similar yellow is selected for the handsome triangle of a harp that occupies the center panel, and it functions again to stress the candle and lamp of the blindfolded man in the right wing. The floors in all three panels are of a higher-toned yellow; and

these yellow accents are so much keener because of the deep blue-violets prevailing throughout the triptych and the broad, luxurious blacks that outline the shapes. In addition, most of the colors of the spectrum add to the sensuous appearance of this polyphonic painting. When seen in daylight, as it is supposed to be, this triptych has the dazzling luminosity of stained glass.

This extraordinary use of color occurs in the very painting that is Beckmann's largest, and probably his most complex in terms of both iconography and composition. Even while working on it, he felt that it was going to be his most outstanding work,[108] a claim he never made for any of his other paintings. The space here is created and crowded by figures, some of those in the background curiously larger than those in the foreground. By this device he succeeds in creating highly tactile forms on a two-dimensional surface: "To transform three into two dimensions is for me an experience full of magic in which I glimpse for a moment that fourth dimension which my whole being is seeking."[109]

The fourth dimension is suggested quite literally here by devices such as the clock, candle, and fire, as well as by the musical tempo. But the reclining pipe player with his classical profile, leaning against this peculiar little cart in the foreground of the center panel, plays a rhythm in total contrast to the savage drummer, who calls the tune. The conflict between civilization and barbarism is among the most striking connotations within the range of meaning of this triptych.

The flexibility of meaning in Beckmann's work is disclosed here by the many different titles he used to refer to this painting during its year of production. It was called "The Concert," "Large Café," "Large Cabaret," "Big Bar," "Great Ox-Feast," before he settled on *Blindman's Buff.* Harold Joachim in his excellent analysis of this triptych makes the point that "Beckmann's symbolism is completely expressed in pictorial terms which he himself found impossible to put into words."[110] Yet Joachim's discussion of this work is extremely helpful:

"To the spectator, it must become clear at once that there is a fateful, predestined connection between the two principal figures on the side panels: the young woman kneeling before a candle on the left panel and the blindfolded young man on

Blindman's Buff. 1945. Oil on canvas; triptych, center panel 80⅞×90¾″; side panels each 75½×43½″. The Minneapolis Institute of Arts

the right panel, figures which are placed and posed in a manner which recalls portraits of donors on fifteenth-century triptychs. But in place of the saints who usually assist such donors, we find oddly assorted groups of people who seem preoccupied with the pursuit of their pleasures and vices. Are the two men on the left panel whispering temptation into the ears of the kneeling young woman who pays them no heed? On the right panel, a large sharply featured faunish head appears between a blond Northern and a dark Mediterranean beauty, while a tiny page girl holds a sign which is half hidden but might possibly read 'Grosse Bar.' Beckmann himself was not sure that the kneeling young woman and the blindfolded young man would find their destiny—that is in this case, each other. The whole trend of ideas is vaguely reminiscent of *The Magic Flute*.

"Beckmann called the figures of the center panel *The Gods*.

There, the immortals play the tunes which govern the lives of the mortals: The chaste, virginal harp player, delineated in rigid, angular forms, is effectively contrasted with the two languorous reclining figures, one male, the other female, both playing the sensuous pipe, and the ferocious savage, beating the drum of war. But what is the role of the man with the animal head, embracing a young woman? Beckmann himself in the diary spoke of the Minotaur, but actually it appears to be a horse's head rather than a bull's head. Perhaps the artist did not wish to commit himself to any definite literal allusion. Therefore it could be Jupiter and Venus, Jupiter and Europa or the Minotaur to whom the flower of Athenian youth had to be sacrificed each year, before he was slain by Theseus."[111]

Joachim also convincingly postulates prototypes for some of these figures in classical Greek sculpture: the Mount Olym-

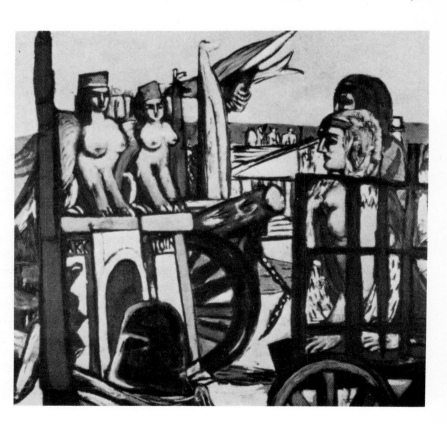

Removal of the Sphinxes. 1945. Oil on canvas, 51 × 55".
Collection Dr. H. Lütjens, Amsterdam

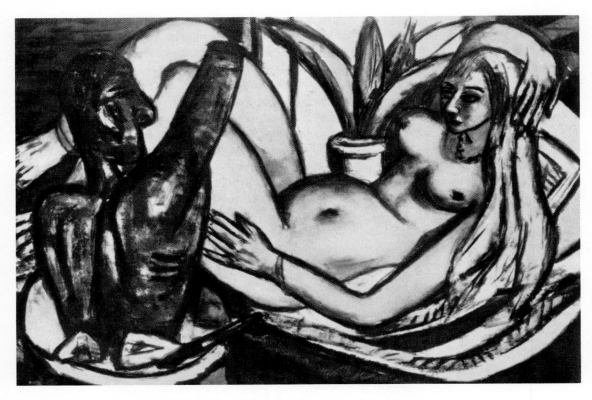

Olympia. 1946.
Oil on canvas, 35½ × 59¼"
Collection Mr. and
Mrs. Morton D. May,
St. Louis

pus from the East Pediment of the Parthenon for the Pan in the center panel and figures from the Ludovisi Throne in Rome and its Boston counterpart for the girls playing the pipe and the harp. The great works of the art of the past remained a never-ending source for Beckmann's transformations.

In the *Removal of the Sphinxes*, painted at the same time as *Blindman's Buff*, he responds again to the art of antiquity, in a painting which seems to have reference to the withdrawal of the Nazi forces in the spring of 1945, but remains most enigmatic in its connotations. The *Olympia*, of 1946, contraposes a most voluptuous earthy woman to Manet's cool, sophisticated demimondaine. Beckmann's Olympia consists of one great undulating curve. Everything about her, the fleshy color, flowing blond hair, the emphasis on the full thighs, round belly, and bulging breasts, the provocative position of the arms, contributes to the great sensuality of this nude. For Manet's

polished bouquet of flowers with its bright color and pleasant scent, Beckmann has substituted a vigorously growing succulent plant. Negress and black cat have made way for a strange black unfinished bust whose upraised right arm may indicate a Fascist salute or just a gesture of command. But the arm is cut off, ending in a stump, a fact that points to an act of violence but also makes for its frankly phallic appearance.

A sensual quality is rarely absent. Beckmann's later still lifes —the *Still Life with Pears and Orchids*—are eloquent, vigorous, erotic affirmations of life: the orchids and bird-of-paradise blooms explode out of the vase, at the height of their exotic life; the mirror behind them hangs upon a heavily ornamented wallpaper; the ripe, superbly shaped pears appear to be bursting from their bowl, while a long, green vase, powerfully formed in the shape of a trumpet, seems to stand guard in the back. In spite of the thin application of the pigment, the paint-

ing gives the feeling of great richness, related clearly to Matisse's still lifes of the mid-twenties which Alfred Barr has called visual banquets.[112]

The liberation of Holland brought about important changes in Beckmann's life: in September 1945, his diary registers a small exhibition at the Stedelijk Museum which was his first show in Europe since 1932. During the summer of 1945 he was able to resume his relationship with Curt Valentin through whom he felt again a part of the "world's nervous system," and could send drawings to New York. In January 1946, he could ship paintings for his first important postwar show, at Valentin's Buchholz Gallery, which opened on 57th Street in April 1946. Beckmann was most apprehensive but then notes with real joy that it was extremely successful and almost entirely sold out. And in July, Günther Franke opened a large Beckmann exhibition in Munich with eighty-one pictures. During that summer Curt Valentin came to visit him in Amsterdam, and Beckmann's diary entry is typical of the whole *Tagebuch*: "Valentin was here, saw a lot, ate with us at the Pays Bas, came on time by plane—2 bottles of champagne, whiskeys, Q. and Butshy [the Pekinese] were very happy."[113] Hanns Swarzenski, a good younger friend from the Frankfurt days and the son of the former director of the Städelsche Museum, also came to see the Beckmanns during that summer. In October, Beckmann made the first sketch for his *Curt Valentin and Hanns Swarzenski* (page 88), one of his most striking double portraits, painting friends who never posed together. He spent a great deal of time and effort on this dark, evocative canvas.

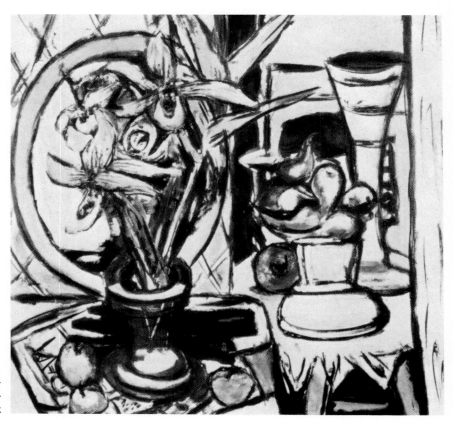

Still Life with Pears and Orchids. (1946). Oil on canvas, 35½×35½". Collection Mrs. Mathilde Q. Beckmann, New York

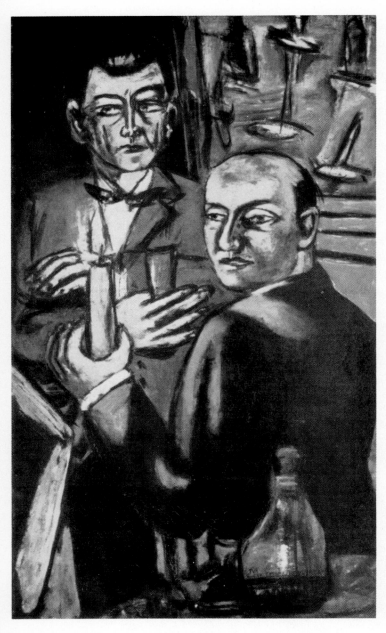

Curt Valentin and Hanns Swarzenski. 1946. Oil on canvas, $51 \times 29^{3}/_{4}$". Collection Mr. and Mrs. Hanns Swarzenski, Cambridge, Massachusetts

Swarzenski, in the back, looks straight at the viewer. His compressed lips, lean cheeks, and folded hands give him a withdrawn, almost ascetic expression in contrast to Valentin who, grasping a large candle, appears more sensuous and outgoing a person. On December 26, when Valentin visited him again, Beckmann presented it to his friend and dealer as a gift, and at the end of the month was able to conclude the year with confidence: "Ah, 46 is finished and it cannot be denied that the sphere has turned a little from black to white."[114]

During the cold and isolated years in Holland, Beckmann yearned particularly for the warmth, colors, and life of the South, and in the spring of 1947, at the very first opportunity, as soon as the ironically declared "enemy alien" in liberated Holland was able to obtain a passport and visa, he took the train to the Côte d'Azur and spent a few weeks in Nice, Cannes, and Monte Carlo. The warm colors, the balmy nights, the water lapping quietly against the sandy shore are reflected in his painting of the Promenade des Anglais in Nice. It is a night scene, but the velvety blacks are relieved by the rusty rose color and the blues and metallic greens. A woman contemplates the peaceful view of the city from the hotel balcony. This canvas is at a vast remove from a cityscape like *Iron Footbridge in Frankfurt*, done twenty-five years earlier (page 38). The excited and agitated linear framework has made way for the subtler relationship of color nuances. Now in his full maturity, and on the eve of his departure from Europe, Beckmann enters into the grand tradition of European (French) *peinture*.

Soon after his return to Amsterdam he received a definite invitation to the United States from Henry Hope, who asked him to teach at the University of Indiana. While he was giving serious consideration to this offer, a second one, from Washington University in St. Louis, arrived, which he decided to accept. Though always worried, he was also very pleased at the prospect of the journey, the new life in the new world; he began to take lessons in English, which are reflected in his diary ("the bettering is beginning"); he finally received his visa for the United States and sailed on the S. S. *Westerdam* on August 30, 1947: "Slowly Europe began to sink back—weather is splendid."[115]

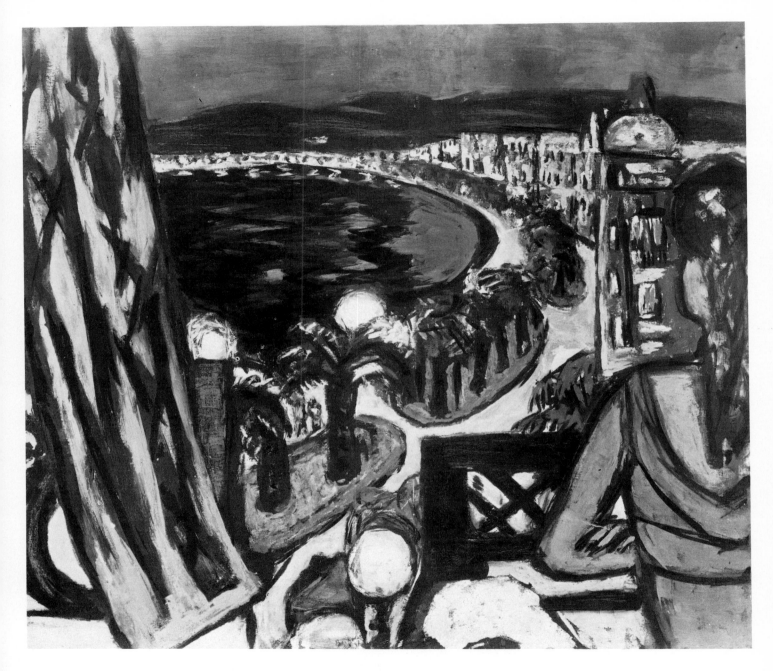

Promenade des Anglais, Nice. 1947. Oil on canvas, 31¼ × 35¼". Folkwang Museum, Essen

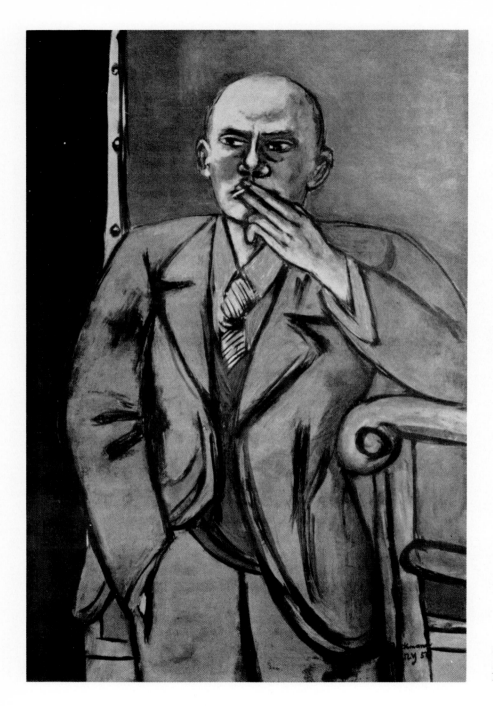

Self-Portrait in Blue Jacket. 1950. Oil on canvas, 55¹/₈ × 35⁷/₈". Collection Mr. and Mrs. Morton D. May, St. Louis

Aboard the S. S. *Westerdam*, Germany's foremost painter met Germany's leading author, but the encounter was hardly rewarding for either. Thomas Mann eagerly showed Beckmann a series of woodcuts by Frans Masereel, for which he was writing a preface. Beckmann crisply commented in his diary: "Quite nice for a fourteen-year-old."[116] He had only a few short days in New York where he seemed to enjoy chiefly the gorillas in the Central Park Zoo, which he discovered on his second day, and Rousseau's *Sleeping Gypsy* at the Museum of Modern Art. But he was exhausted by interviews, parties, and receptions and was happy to leave for St. Louis, where he arrived September 18, 1947. There he was received with great cordiality by Perry Rathbone, then director of the City Art Museum, who had been primarily responsible for his appointment in St. Louis, by Kenneth Hudson, dean of the art school at Washington University, and by H. W. Janson, then curator of the Washington University Collection. Beckmann's two years in St. Louis, broken by visits to New York and to many other cities throughout the United States, by a brief return to Holland in the summer of 1948, and terminated by his teaching the summer session at the University of Colorado in 1949, were active, fruitful, happy years.[117]

Beckmann enjoyed teaching and was glad to be surrounded once more by the young in whom he hoped to instill creative independence. When Beckmann took over Philip Guston's advanced painting class, the students were already prepared for his presence. To his first class he said—as translated by Mrs. Beckmann, who attended all his classes in order to help with the language:

". . . I wish you to discover your own selves, and to that end many ways and many detours are necessary.

"I do not have to tell you that there can be no question of thoughtless imitation of nature.

"Please do remember this maxim—the most important I can give you: If you want to reproduce an object, two elements are required: first, the identification with the object must be perfect; and secondly, it should contain, in addition, something

quite different. This second element is difficult to explain. Almost as difficult as to discover one's self. In fact, it's just this element of our own self that we are all in search of."[118]

This second element meant that the student had to evolve his own image and to that end he had to discover his own personality. Beckmann's help in this inward search was perhaps his greatest contribution to the growth of his students. In addition, they admired the directness and clarity of his approach, the power of his execution, and his steadfast individuality in the face of very different fashions. He was, as Walter Barker has said, the great grammarian, who could serve as point of reference. Some of the students and assistants who were closest to him, such as Albert Urban in Frankfurt and Walter Barker in St. Louis, eventually evolved a style completely different from Beckmann's, yet they were significantly aided in their development by the work and personality of their teacher. Beckmann's relationship to Barker is reflected in the portrait he worked on between February and May of 1948 (page 92). The figure looms large as it occupies virtually the entire length of the vertical picture and is clamped on each side by heavy pieces of furniture. The barefoot young painter is appealing in his boyish awkwardness and vulnerable sensitivity.

Beckmann's attitude toward teaching and his concern about the next generation of painters find poetic formulation in his "Letters to a Woman Painter," which he wrote for a lecture at Stephens College in February 1948, and which, as translated by Mrs. Beckmann and Perry Rathbone, were also read by Mrs. Beckmann to audiences at the Boston School of Art, the University of Colorado, and Mills College during the following years.[119]

The splendid exhibition organized by Perry Rathbone at the City Art Museum of St. Louis in 1948 began to establish the recognition of Beckmann as "one of the most important living European artists."[120] This acknowledgment had been slow in coming because modern art was equated solely with French art by a great many influential critics and collectors; also, other groups were imbued with a type of reactionary chauvinism

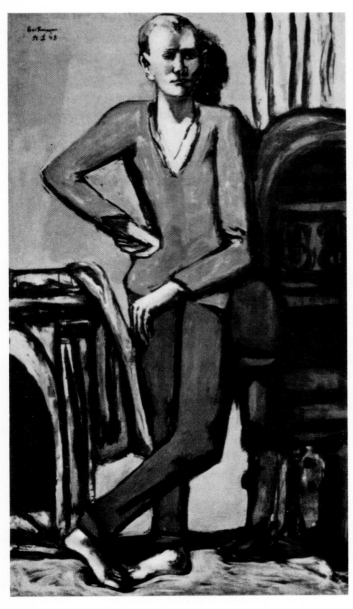

Wally Barker. 1948. Oil on canvas, 45 × 25″. Collection Mrs. Malcolm K. Whyte, Milwaukee

that came amazingly close to the Nazi view Beckmann had battled many years earlier;[121] and, finally, because his arrival in the United States coincided with the emergence of an abstract expressionist idiom considerably at variance with Beckmann's own style.

In spite of a contract with Curt Valentin and frequent and enthusiastic purchases by Morton D. May of St. Louis, who eventually acquired the most important collection of Beckmann's work, his prices were still very low and he was never without financial worries. For that reason, and because of a desire to see as much of the new country as possible, he would travel across the continent when requested to lecture, and expressed his delight about being asked to teach summer school at the University of Colorado: "It's like being invited in Europe to teach at an art school in St. Moritz," he writes to Minna Beckmann-Tube.[122] Finally, in October 1949, he was able to enter in his diary: "Well, well, one has it: First Prize of the Carnegie (1500 D.)."[123]

Twenty years earlier he had been awarded Honorable Mention at the Pittsburgh International for the powerful *Loge*, whose emphatic, rigid forms make it seem spare when contrasted to the later prize winner, *Fisherwomen*. Here the dense fabric of forms is highly complex. The forms are tangled in a space they fill and crowd, the colors too are much richer and deeper, their heavy luxuriousness adding to the sensuality of this painting of four women fondling enormous fishes. "These women," Beckmann told Quappi, "are fishing for husbands, not lover-boys."[124] What he probably meant by this statement is that they are dead serious about their pursuit of the male. The three young girls make use of all their female attractions: the black stockings and garters, the tight corsets, the uncovered breasts and thighs, the exposed buttocks seen through the stem of a suggestively shaped vase, the placement of the fishes —everything is most provocative. The three alluring young women are contrasted to a withered old hag, holding a thin eel in the background, a juxtaposition[125] which Beckmann also used in the slightly earlier painting—*Siesta, Girls' Dormitory*—in which young women recline in suggestive positions while an old crone seems to be reading to them.

Themes of this nature occupied Beckmann for decades, but

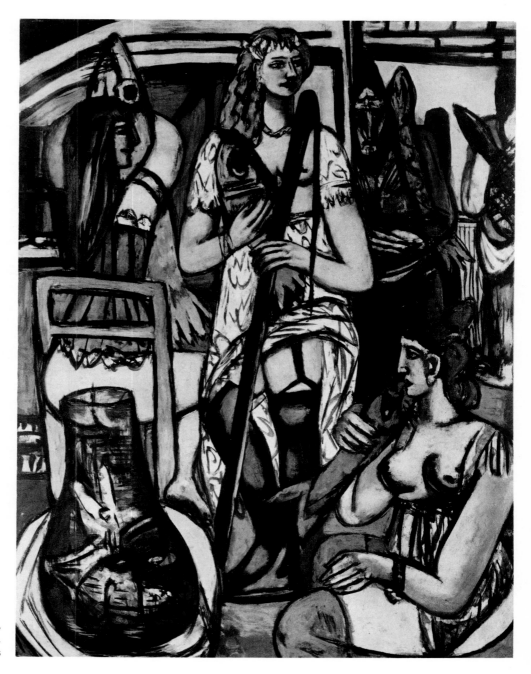

Fisherwomen. (1948). Oil on canvas,
74 × 54⅝". Collection Mr. and Mrs.
Morton D. May, St. Louis

now the symbol of the fish has assumed paramount importance. A huge fish is the central object in the large dark canvas, *The Cabins*, of 1949. A sailor is trying to grasp it, but his passions — symbolized by the fish — are too much for him to hold. Behind this central image we observe shifting facets of human life in the boat's cabins: the expectation of love on the part of the girl combing her hair in the upper right, perhaps its fulfillment in the girl lying on her couch in the central tier on the left. There is creative activity on the part of the young painter on the lower right, the toil of working in the lower center, a vision of an angel in the theatrical scene in the upper center, and death and mourning on the upper left. Life consists of hope, tenderness, love, adventure, drama, death: this multicellular variety has been communicated by a complex interaction of figures, forms, and colors impinging on each other in tight space. Shortly after he completed this compelling painting, on the occasion of the award of an honorary doctorate at Washington University, he stated:

"Indulge in your subconscious, or intoxicate yourself with wine, for all I care, love the dance, love joy and melancholy, and even death!"[126] The task of the artist is to live fully, to experience, to understand, and then to select and arrange all the confusion of life: "Art, with religion and the sciences, has always supported and liberated man on his path. Art resolves through Form the many paradoxes of life, and sometimes permits us to glimpse behind the dark curtain which hides those spaces unknown and where one day we shall be unified."[127]

It is possible to infer from this comment that the remarkable shallowness of his space — the narrow stage upon which, before a blank abrupt backdrop, the crowded action of his pictures almost always takes place — was caused by the fact that he equated space with death. It was really only in the *Falling Man* (page 96) and the center panel of the *Argonauts* (page 99), both of 1950, that he seemed suddenly to use open space without an evocation of horror. At this time he frequently referred to "the unknown space" of another existence.

Like Mondrian, Yeats, and Kandinsky, Beckmann was interested in the theosophical theories of Mme Blavatsky, and delved deeply into the Vedas in his study of Indian philosophy. He became convinced of the existence of the soul and believed in some kind of transmigration of the spirit. Stephan Lackner tells of a visit to the Musée de l'Homme in Paris with Beckmann during which he nodded toward a large Easter Island head, saying, "This too I once was."[128] When Mrs. Beckmann's mother died in the spring of 1948, he wrote in his diary: "Her excellency Frau Frieda von Kaulbach has died . . . well perhaps she will be happier on another plane."[129] And later he stated: "I've continued reading in Pythagoras and determined that one cannot conceive of death but as being called to another level of consciousness."[130]

The *Falling Man*, painted in the winter of 1949/50, is one of the most remarkable paintings in Beckmann's oeuvre. A large, heavy body falls through the sky. Coming from heavenly regions, he is on his way to the earth,[131] passing in his flight from on high a burning house whose smoke becomes intermingled with the clouds in the sky. He travels past the crowded and burning dwellings of mankind toward magnificent burgeoning plants, while supernatural winged beings — part bird, part angel — float in ethereal boats. Most of the painting is taken up by the intense cerulean blue of the sky. Never before had Beckmann opened up his picture in this manner in order to make room for space. "For, in the beginning there was space, that frightening and unthinkable invention of the Force of the Universe. Time is the invention of mankind; space or volume, the palace of the gods."[132]

The *Falling Man* was made in New York, the final station on his long odyssey. His position in St. Louis was tenuous and uncertain, and during a trip to New York in January 1949, he was happy to accept a tenure position to teach advanced painting at the Brooklyn Museum Art School, to begin the following September. Aware of the enormous problems involved in a move to this vigorous world center of art, he anticipated New York with both eagerness and trepidation. Eventually he became extremely fond of his new environment and made it his own. In September he moved into a studio apartment on East 19th Street and began teaching at the Brooklyn school. Almost at once he remarks on the "great impression of the gigantic city in which I am beginning to feel at home."[133] He is fascinated by all aspects of New York, constantly discovers new sections of the city in his never-ending walks and

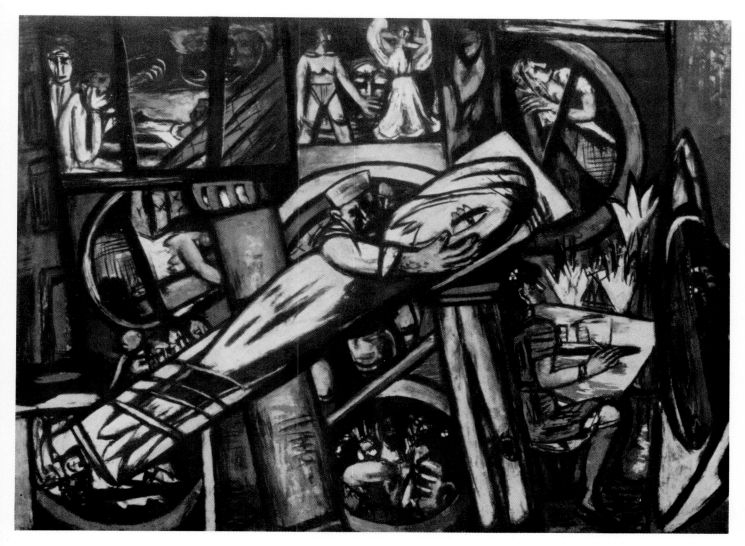

The Cabins. (1949). Oil on canvas, 55×76". Collection Mrs. Mathilde Q. Beckmann, New York

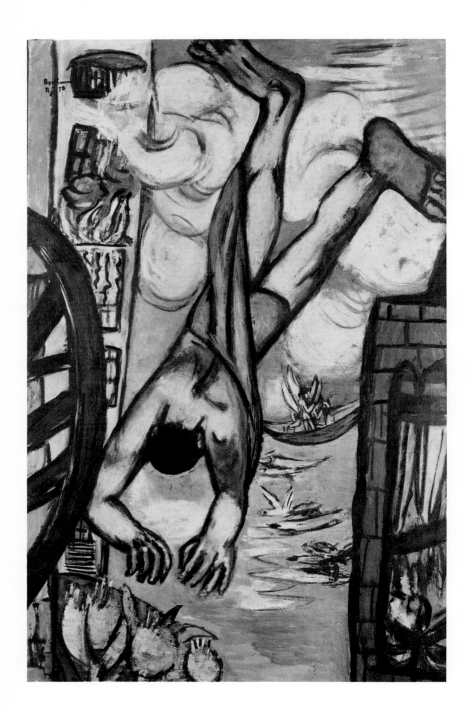

Falling Man. 1950. Oil on canvas, 55½×35″. Collection Mrs. Mathilde Q. Beckmann, New York

subway rides, or just observes life in little dives in the Bowery or Chinatown, or sips champagne, noting the "amusing types" in the cocktail lounge of the Plaza Hotel. In May 1950, he moved to a new apartment on West 69th Street and then began to explore Central Park. It was during one of his regular early morning walks that he died of a heart attack on the morning of December 27, 1950.

In his last self-portrait (page 90), Beckmann looks drawn, tired, exhausted—but still defiant and perhaps more elusive than before. He draws on his cigarette as though for nourishment and leans against the arm of a high chair. The large flashing eyes of Beckmann, always the observer, watch. Behind him looms yet another new canvas. The most startling thing about this picture, however, is the brilliant color: the unrelieved cobalt blue of the jacket, the bright orange shirt, the green chair—all against the dark maroon back wall. The very brightness of the colors contributes to the two-dimensional appearance of this painting; their disparate, almost cruel quality give an insolent air to this wistful figure.

A very different image of an artist is presented by the bearded painter in the left panel of the *Argonauts*. A vigorous figure, he almost attacks his canvas, while an almost nude, sensuous female sits on a mask and holds a blue sword. This panel, originally called "The Artist and His Model" was almost completed before he left St. Louis. Beckmann may have identified with the young painter, yet it is the mask on which the woman is seated that bears a distinct resemblance to his features. The sword, which looks more like a symbol of virility – and creative power—is held by the model who thus becomes the artist's guardian and protector as well as his inspiration.

The painter's canvas forms an acute triangle with the ladder in the central panel. The ladder had often served Beckmann as a symbol of anguish and fulfillment in the same manner as had the canvas, which was the artist's proving ground. But the old man emerging from the sea on this ladder has withstood all his trials and accomplished the journey. He now beckons to the young men with a prophetic gesture. These two men are the Argonauts setting out on their heroic adventure.[134] On the right is Jason, a beautiful youth—the final state of an ideal figure which occupied Beckmann for a lifetime and

had made its first appearance in the *Young Men by the Sea* of 1905 (page 13), but was now reinforced by the splendid bodies he had observed on the coast of California. Jason's head with its classical features was the last thing Beckmann painted on December 26, 1950, the day before he died. The gentle youth in the center, adorned with a wreath of flowers in his hair and golden bracelets on his arm, must be Orpheus, whose orange lyre lies on the yellow sand beside him. Orpheus, according to Apollonius of Rhodes, was the first of the large crew of Greek heroes enrolled by Jason to sail the *Argo*. The old man may easily refer to Phineus,[135] the king who had been blinded by the gods for prophesying the future. He told the Argonauts of the perils that lay before them and advised them to send a dove from their boat to explore the way through the Clashing Rocks; if the bird passed safely, the chances were that they, too, would pass through. The fabulous green, brown, and blue bird with his huge, hypnotic green eye perching on Jason's wrist may indeed be Beckmann's elaborated version of the dove in the legend. In the sky above the heroes we see an eclipse of a dark purple sun,[136] outlined by a fiery orange rim. Two orange planets orbit between this sun and the waxing crescent of the moon. All this takes place against a supernatural pink sky, which is the essence of expanding space.

If the left panel symbolizes the commitment to art, and the center, the adventure and fulfillment, the right panel is reserved for comment and interpretation by the chorus.[137] The chorus in Greek tragedy is the intermediary between action and audience. Its purpose is to provide psychological distance and dramatic structure by means of measured comment. Beckmann's chorus is a chamber orchestra of women playing music and singing, women who are beautiful and calm. While it is for the man to create and to engage in the adventure of life, it is the woman holding a sword who guards his genius, the woman holding a guitar who sings his exploits. The right-hand panel with the women rising in tiers, the stringed instruments with their necks reversed to fit into the oblong composition, and the deeply reverberating colors which resemble stained glass is one of the most beautifully resolved paintings in Beckmann's work.

As in medieval painting, Beckmann makes use of different

scales, and the figures in the central panel are truly heroic in their dimension. After working on the triptych for almost two years, Beckmann had a dream during the night of December 9, 1950, in which the figures came to life and approached him.[138] Although he had been referring to the triptych as "The Artists" until then, he now called it "The Argonauts" and knew exactly how to complete it.

The Argonauts, when compared with the preceding triptychs, is less crowded, less violent and not as disparate. It impresses us with its calm and measure. The struggle between good and evil, the old dichotomy of black and white, no longer fully engages the mature painter. He is now, rather, concerned with that spark of activity which leads man on his adventure to reach the Golden Fleece and, beyond that, to the achievement of peace and transfiguration. The old man-god points, as Beckmann might have said, to a different plane of consciousness.

On December 17, 1950, in his last letter to his son, he wrote: "I am just painting a triptych, 'The Argonauts,' and in 'Dodona' we shall see each other again."[139] This romantic reference to Dodona is to the sanctuary of Zeus where an ancient sacred oak communicated the will of the god by the rustle of its leaves to those mortals who went to consult the oracle.

Opposite: The Argonauts. (1950). Oil on canvas; triptych, center panel 80¼×48"; side panels each 74⅜×33". Collection Mrs. Mathilde Q. Beckmann, New York

NOTES

Unless indicated otherwise, all translations are by the authors.

1 Hans Kaiser, *Max Beckmann*, Berlin, Paul Cassirer, 1913. This is an incomplete listing. Benno Reifenberg and Wilhelm Hausenstein (*Max Beckmann*, Munich, R. Piper & Co. Verlag, 1949) list 139 paintings through 1912. The actual number of finished works exceeds this number by far, for Beckmann burned many of his earliest paintings.

2 Now in the collection Mrs. Mathilde Q. Beckmann, New York.

3 "Letters to a Woman Painter," see below, p. 134.

4 Mrs. Mathilde Q. Beckmann, in an interview with the author, New York, November 1963.
Although the years of his attendance at the Weimar academy are generally given as from 1899, it appears from the minutes of the faculty meeting that he was first accepted on June 21, 1900; cf., Walther Scheidig, "Max Beckmann in Weimar," *Kunstmuseen der Deutschen Demokratischen Republik* (Leipzig), III, 1961, pp. 79–84.

5 J. B. Neumann, in "Die Künstler und die Zeitgenossen, Eine Diskussion," in *Blick auf Beckmann* (Schriften der Max Beckmann Gesellschaft, II), Munich, R. Piper & Co. Verlag, 1962, p. 223.—A few years earlier Emil Nolde had had a similar disappointing experience in Paris. Nolde recalled: "Paris had given me very little, and I had expected so much" (*Das eigene Leben*, Berlin, Rembrandt Verlag, 1931, p. 152).

6 Max Beckmann, *Tagebücher 1940–1950*, Munich, Albert Langen-Georg Müller, 1955, p. 335, entry for August 31, 1949.

7 *Ibid.*, p. 124, entry for September 27, 1945.

8 Karl Scheffler, "Max Beckmann," *Kunst und Künstler* (Berlin), XI, 1913, pp. 297 ff.

9 Paul F. Schmidt, "Die Beckmann-Ausstellung in Magdeburg," *Cicerone* (Leipzig), IV, 8, April 1912, p. 314.

10 Franz Marc, "Die neue Malerei," *Pan* (Berlin), II, 16. March 7, 1912, p. 469.

11 Max Beckmann, "Gedanken über zeitgemäße und unzeitgemäße Kunst," *Pan* (Berlin), II, 17, March 14, 1912, pp. 500–501.

12 Max Beckmann, *On My Painting*, New York, Buchholz Gallery–Curt Valentin, 1941, p. 4. (Lecture delivered at the New Burlington Galleries, London, July 1938.)

13 Kasimir Edschmid, ed., *Schöpferische Konfession* (Tribüne der Kunst und Zeit, Eine Schriftensammlung, XIII), Berlin, Erich Reiss Verlag, 1920, p. 65. (Written 1918.)

14 Max Beckmann, *Briefe im Kriege*, Berlin, Bruno Cassirer Verlag, 1916.

15 *Ibid.*, p. 13, letter of October 3, 1914.

16 Peter Selz, *German Expressionist Painting*, Berkeley and Los Angeles, University of California Press, 1957, p. 286. The first state of this print (*ibid.*, pl. 125) does not appear in Klaus Gallwitz' definitive catalogue of Beckmann's prints (Karlsruhe, Badischer Kunstverein. *Max Beckmann, Die Druckgraphik*, August 27–November 18, 1962.)

17 *Briefe im Kriege*, pp. 31-32, letter of March 27, 1915.

18 *Ibid.*, p. 34, letter of March 30, 1915.

19 *Ibid.*, p. 27, letter of March 16, 1915.

20 *Ibid.*, pp. 72–73, letter of June 8, 1915.

21 *Ibid.*, p. 67, letter of May 24, 1915.

22 *Ibid.*, p. 66, letter of May 24, 1915.

23 Letter to Peter Beckmann, April 1949, quoted in Lothar-Günther Buchheim, *Max Beckmann*, Feldafing, Buchheim Verlag, 1959, p. 34.

24 Quoted in Benno Reifenberg, "Der Zeichner Max Beckmann," in *Blick auf Beckmann*, p. 142.

25 Buchheim, *op. cit.*, p. 102.

26 In 1917 he transposed it into an etching.

27 Quoted by J. B. Neumann in an unpublished manuscript.

28 Not to be confused with the early sixteenth-century Swabian Master of Messkirch.

29 The altarpiece, in the Alte Pinakothek, Munich, is now given to the Master of the Tegernsee Tabula Magna.

30 Max Beckmann, in an interview with the author, Chicago, January 1948.

31 In this connection it is interesting to note that before he died he gave a book on early German painting (Curt Glaser, *Zwei Jahrhunderte deutscher Malerei*, Munich, 1916) to Jane Sabersky in New York, telling her how important these artists were to his own work.

32 *Times* (London), May 22, 1919.

33 *New York Times*, January 25, 1919.

34 *Schöpferische Konfession*, pp. 63–64.

35 Cf. Günter Busch, *Max Beckmann*, Munich, R. Piper & Co. Verlag, 1960, p. 54; Buchheim, *op. cit.*, pp. 55–56; Stephan Kaiser, *Max Beckmann*, Stuttgart, Emil Fink Verlag, 1962, p. 89.

36 *Der Ararat* (Munich), II, 11, November 1921, p. 276.

37 This panel was acquired by the Staatliche Kunsthalle, Karlsruhe, in 1920 and was widely published at the time of its acquisition.

38 "Max Beckmann: Der Traum," in Curt Glaser, Julius Meier-Graefe, Wilhelm Fraenger, Wilhelm Hausenstein, *Max Beckmann*, Munich, R. Piper & Co. Verlag, 1924, pp. 35–58; reprinted in *Blick auf Beckmann*, pp. 36–49.

39 *Ibid.*, p. 57; p. 49.

40 So it appeared to the reviewer of the New Objectivity exhibition; cf. L. Moser, "Mannheim Kunsthalle-Ausstellung: Die neue Sachlichkeit," *Kunst und Künstler* (Berlin), XXIII, 12, September 1925, p. 474.

41 Interview with Marielouise Motesiczky, London, November, 1963.

42 G. F. Hartlaub, circular letter dated May 18, 1923, quoted in Fritz Schmalenbach, "The Term *Neue Sachlichkeit*," *Art Bulletin*, XXII, 3, September 1940, p. 161.

43 Franz Roh, *Nach-Expressionismus Magischer Realismus*, Leipzig, Klinkhardt & Biermann, 1925.

44 Schmalenbach, *op. cit.*, p. 163.

45 Letter to Reinhard Piper, quoted in Reinhard Piper, *Nachmittag*, Munich, R. Piper & Co. Verlag, 1950, p. 40.

46 "Letters to a Woman Painter," see below, p. 132.

47 *On My Painting*, p. 13.

48 Cf. note 38.

49 *Max Beckmann*, Berlin and Leipzig, Klinkhardt & Biermann, 1930.

50 According to J. B. Neumann, in "Sorrow and Champagne," his unpublished essay on Beckmann, he is supposed to have said, after attending a state dinner at which Hindenburg had been present, that he himself would not be adverse to being elected President of Germany.

51 *On My Painting*, p. 6.

52 Marielouise Motesiczky, "Max Beckmann als Lehrer," in *Munich, Günther Franke. Max Beckmann, Bildnisse aus den Jahren 1905–1950*, February 12–mid-April 1964, n. p. (Talk given at the Beckmann-Gesellschaft, Murnau, 1963.)

53 Interview with Th. Garve, Hamburg, November 1963. I owe much of the information about Beckmann's teaching in Frankfurt to two of his students there, Professor Garve, Hamburg, and Marielouise Motesiczky, London.

54 Günther Franke reports Picasso saying "Il est très fort," when seeing Beckmann's show; cf. *Max Beckmann, Sammlung Günther Franke*, Munich, n. d., n. p.

55 "The Pittsburgh International," *Creative Art* (New York), V, 5, November 1929, p. xiii.

56 *Fallen Candle*, 1930, Staatliche Kunsthalle, Karlsruhe.

57 *On My Painting*, p. 6. The published translation uses the word "Ego" for the German "Ich." The meaning, however, is expressed more accurately by the word "Self."

58 According to Beckmann's carefully kept records, the central and right panels were completed in November 1933, and the left panel in December 1933. (Heretofore it was believed that Beckmann worked on Departure until 1935.)

59 Bernard S. Myers, *The German Expressionists*, New York, Frederick A. Praeger, 1957, p. 304.

60 On the label for the triptych during its special installation.

61 In an early pen-and-ink sketch, now in the collection of Frederick Zimmermann, New York, the weapon was still a spear.

62 It is partly because of this still life, partly due to the executioner being dressed like an artist in a casual polo shirt, that some thoughtful critics of the triptych have suggested that the murderer is simultaneously an allegory of the artist; cf. Clifford Amyx, "Max Beckmann: The Iconography of the Triptychs," *Kenyon Review*, XIII, 1951, pp. 613–14; and Charles S. Kessler, "Max Beckmann's *Departure*," *Journal of Aesthetics & Art Criticism*, XIV, 2, December 1955, pp. 206–17.

63 Unpublished letter dated June 1, 1955.

64 Perry Rathbone, in *Max Beckmann 1948 . . . Retrospective Exhibition Organized by [the] City Art Museum of St. Louis*, p. 36.

65 *On My Painting*, p. 3.

66 Kessler, *op. cit.*, p. 214.

67 Rathbone, *loc. cit.*

68 T. S. Eliot, "The Waste Land," 1922, in *Collected Poems 1909–1935*, New York, Harcourt, Brace & World, 1963.

69 Kessler, *op. cit.*, p. 215.

70 Busch, *op. cit.*, p. 76. But how could Charon convey his passengers into such a bright world?

71 Buchheim, *op. cit.*, p. 159.

72 *Op. cit.*

73 James Thrall Soby, *Contemporary Painters*, New York, The Museum of Modern Art, 1949, pp. 90–91.

74 "The Liberating Quality of Avant-Garde Art," *Art News*, CVI, 4, Summer 1957, pp. 40–41.

75 Unpublished letter to Curt Valentin, dated February 11, 1938. Translated by Jane Sabersky.

76 Erhard Göpel, *Max Beckmann in seinen späten Jahren*, Munich, Albert Langen—Georg Müller, 1955, p. 19.

77 Adolf Hitler, in "Der Führer eröffnet die 'Grosse deutsche Kunstausstellung 1937,'" *Die Kunst im dritten Reich* (Munich), I, 7/8, July/August 1937, p. 60.

78 Adolf Ziegler, Opening Speech at the exhibition *Entartete Kunst* held in the Haus der deutschen Kunst, Munich, 1937, quoted in the exhibition catalogue *Munich, Haus der Kunst. Entartete Kunst*, October 25–December 16, 1962, pp. XXI–XXII.

79 Beckmann generally indicated the city in which a painting was completed by an initial preceding the date. Thus, there is F, for Frankfurt; B, for Berlin; A, for Amsterdam; St. L., for St. Louis; N. Y., for New York.

80 *On My Painting*, p. 10.

81 *Ibid.*, p. 11. See above, note 57.

82 *Tagebücher*, p. 243, entry for March 16, 1948.

83 *On My Painting*, p. 12.

84 Cf. Stephan Kaiser, *op. cit.*, for an excellent treatment of this and many other paintings.

85 *On My Painting*, p. 5.

86 "Beckmann in America," address delivered before the Beckmann-Gesellschaft, Murnau, July 15, 1962. Unpublished.

87 *Max Beckmann*, Berlin, Safari-Verlag, 1962, p. 14.

88 "Bildnis des Bildnismalers Max Beckmann," *Das Kunstwerk* (Baden-Baden), XVII, 4, October 1963, p. 25.

89 "Max Beckmann—Memories of a Friendship," *Arts Yearbook 4*, 1961, p. 120.

90 Paris, Editions Cosmopolites, 1937.

91 *Tagebücher*, p. 382, entry for July 5, 1937.

92 Unpublished letter dated March 3, 1939.

93 Unpublished letter dated May 1, 1939.

94 *Tagebücher*, p. 9.

95 *Loc. cit.* This is the first entry in the diary as published. Upon the German invasion of Holland, Beckmann destroyed all his earlier diaries. Mrs. Beckmann was able to preserve only a few pages, such as the one of May 4, 1940. It is a moving record of the artist's last ten years.

96 *On My Painting*, p. 11.

97 This, at least, is maintained by Göpel, *op. cit.*, and in his *Max Beckmann, Die Argonauten*, Stuttgart, Reclam-Verlag, 1957.

98 The question may arise as to why Beckmann kept such careful diaries which reveal so little. The answer is probably twofold: first, it was the custom for noted men of his generation to keep diaries; second, such a personal record of the mundane details of his life quite possibly helped to counteract the extreme isolation of his personality.

99 *Tagebücher*, p. 52, entry for June 1, 1943.

100 *Ibid.*, p. 277, entry for September 27, 1948.

101 Walter Barker, in an interview with the author, October 1963.

102 *The Acrobats*, 1938–39, Collection Mr. and Mrs. Morton D. May, St. Louis; *Perseus*, 1941, Museum Folkwang, Essen; *The Actors*, 1941–42, The Fogg Art Museum, Harvard University, Cambridge, Massachusetts; *Carnival*, 1942–43, State University of Iowa, Iowa City; *Blindman's Buff*, 1944–45, The Minneapolis Institute of Arts.

103 *Tagebücher*, p. 33, entry for April 21, 1942.

104 Rathbone, *op. cit.*, pp. 37–38.

105 *In Memoriam Max Beckmann*, ed. E. Göpel, Frankfurt, 1953, p. 28. (Funeral oration for Max Beckmann, delivered in Stuttgart, December 31, 1950.)

106 Göpel, *Die Argonauten*, p. 4.

107 Robert Goldwater, "Gauguin and the Beginnings of Modern Allegory." Unpublished lecture.

108 *Tagebücher*, p. 113, entry for July 1, 1945.

109 *On My Painting*, p. 9.

110 Harold Joachim, "Blindman's Buff, A Triptych by Max Beckmann," *The Minneapolis Institute of Arts Bulletin*, XLVII, 1, January–March 1958, p. 9.

111 *Ibid.*, pp. 9–10.

112 *Matisse, His Art and His Public*, New York, The Museum of Modern Art, 1951, p. 212.

113 *Tagebücher*, p. 158, entry for July 15, 1946.

114 *Ibid.*, p. 174, entry for December 31, 1946.

115 *Ibid.*, p. 204, entry for August 29, 1947.

116 *Ibid.*, p. 205, entry for September 3, 1947. Once Mann's diaries become accessible, it will be interesting to see his comments on Beckmann.

117 For Beckmann's life in St. Louis, see below, pp. 122 ff., "Max Beckmann in America: A Personal Reminiscence," by Perry T. Rathbone, who became his closest friend in this country.

118 Speech given to his first class in the United States, Washington University, St. Louis, September 1947. I am indebted to the painter Warren Brandt, at that time a student in Beckmann's advanced class, for letting me see the unpublished manuscript of this speech.

119 See Appendix, pp. 132 ff.

120 Libby Tannenbaum, "Beckmann, St. Louis Adopts the International Expressionist," *Art News*, XLVII, 3, May 1948, p. 21.

121 A classic among the attacks on modern art is an editorial by Ernest W. Watson in *American Artist* (XII, 3, March 1948, p. 19) which reads in part: ". . . As revolting an exposition of graphic vulgarity as is likely to be offered the American public in the name of Art. . . . All this ought to be pretty exciting news for Midwest parents. After all, Pop, think of the opportunity for Mary and John to soak up the latest imported ideals! . . . There's altogether too much tolerance of vulgarity and downright obscenity in contemporary art."

122 Letter to Minna Beckmann-Tube, March 3, 1949, quoted in Buchheim, *op. cit.*, p. 178.

123 *Tagebücher*, p. 343, entry for October 13, 1949. Beckmann was almost unique among artists by experiencing within his lifetime three fairly distinct periods of fame, interrupted by rather

lengthy periods of relative neglect. The peaks of renown in his life seem to fall approximately eighteen to twenty years apart: 1912–14, 1928–33, 1947–50.

124 Mrs. Mathilde Q. Beckmann, in an interview with the author, New York, April 1964.

125 Jules Langsner, "Los Angeles Letter: Symbol and Allegory in Max Beckmann," *Art International*, v, 2, March 1921, p. 29. In this penetrating article, Mr. Langsner draws interesting parallels between the sexual connotations in a painting like Beckmann's *Fisherwomen* and Kafka's *The Castle*.

126 *New York, Curt Valentin Gallery. Max Beckmann*, January 26–February 20, 1954. (Address delivered to the faculty of Washington University, June 6, 1950; translated by Jane Sabersky.)

127 *Ibid.*

128 *Max Beckmann*, p. 2.

129 *Tagebücher*, p. 252, entry for May 7, 1948.

130 *Ibid.*, p. 352, entry for December 5, 1949.

131 This is Beckmann's own interpretation, as transmitted by his wife.

132 "Letters to a Woman Painter," see below, p. 132.

133 *Tagebücher*, p. 338, entry for September 17, 1949.

134 Erhard Göpel maintins that the heroic theme of the Argonauts was suggested to Beckmann by Wolfgang Frommel in Amsterdam, which Frommel himself confirms (cf. Göpel, *Die Argonauten*, which includes Frommel's "Das Argonautengespräch"). Mrs. Beckmann points out, however, that Beckmann intended to paint a picture related to the theme of the Argonauts prior to his discussions with Frommel. While working on this triptych Beckmann read Hölderlin's *Empedokles* and the Oedipus trilogy by Sophocles.

135 According to Göpel (*ibid.*, p. 26), Frommel believed the old man referred to Glaucus, a god of the sea, also equipped with the gift of prophecy.

136 On September 4, 1949, he writes in his diary, (*Tagebücher*, p. 336): "In the evening I read in Humboldt for the first time about sun spots. Never knew that the sun was dark—am deeply shaken." Yet a black sun hangs in the sky of the Resurrection done thirty years earlier (p. 27).

137 According to one of the few explanatory remarks ever made by Beckmann. He told his wife that the right panel was the chorus.

138 Letter from Mrs. Mathilde Beckmann to Erhard Göpel, quoted in Göpel, *Die Argonauten*, p. 14.

139 Letter to Peter Beckmann, December 17, 1950, published in *In Memoriam*, p. 55.

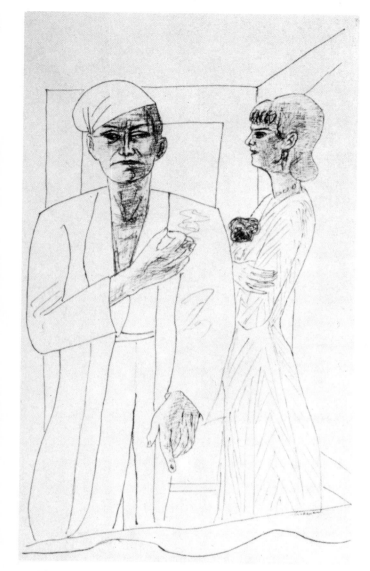

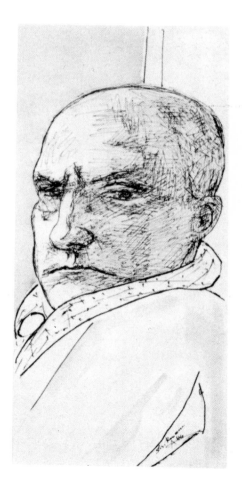

Double Portrait (Max and Quappi). 1944. Pen and ink, 16×10". Collection Mr. and Mrs. Perry T. Rathbone, Cambridge, Massachusetts

Right: Self-Portrait. 1946. Pen and ink and wash, 12³/₄×5⁷/₈". Collection Dr. H. Lütjens, Amsterdam

Mink. 1905. Pencil, 6¹/₄ × 5⁷/₈". Collection Dr. Peter Beckmann, Munich-Gauting

Fridel Battenberg. 1918. Pencil, 18³/₄ × 13¹/₈". Collection Professor Th. Garve, Hamburg

Quappi with Candle. 1928. Black and white chalk, 24¹/₄ × 18³/₄".
Kupferstichkabinett, Kunstmuseum, Basel

Minna Beckmann-Tube. 1923. Pencil, 13³/₄ × 9". Collection Günther
Franke, Munich

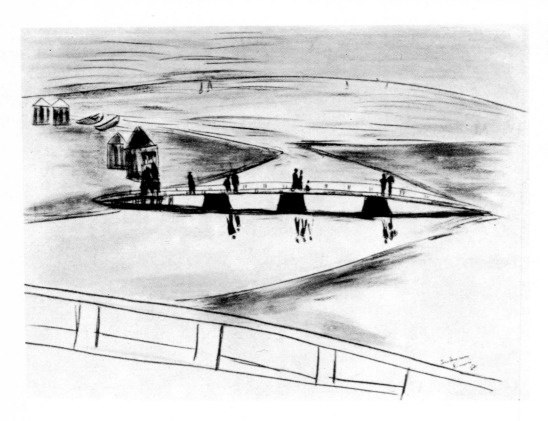

Rimini. 1927. Pastel, 19¹/₈ × 25¹/₄″.
Collection Günther Franke, Munich

Woman Reading. 1946. Pen and ink, 12⁷/₈ × 19⁷/₈″.
Collection Mrs. Mathilde Q. Beckmann,
New York

Champagne Fantasy. 1945. Pen and ink and wash, 19³/₄ × 10¹/₂″. Collection Mr. and Mrs. Frederick Zimmermann, New York

Portrait of Marion Greenwood. (1950). Charcoal, 23³/₄ × 17⁷/₈″. Catherine Viviano Gallery, New York

Carnival in Naples. (1925). Brush with India ink, crayon and chalk, 39$^{1}/_{2}$ × 27$^{3}/_{8}$″. The Art Institute of Chicago

Meeting. 1947. Pen and ink, 13 × 19½". Collection Mrs. Mathilde Q. Beckmann, New York

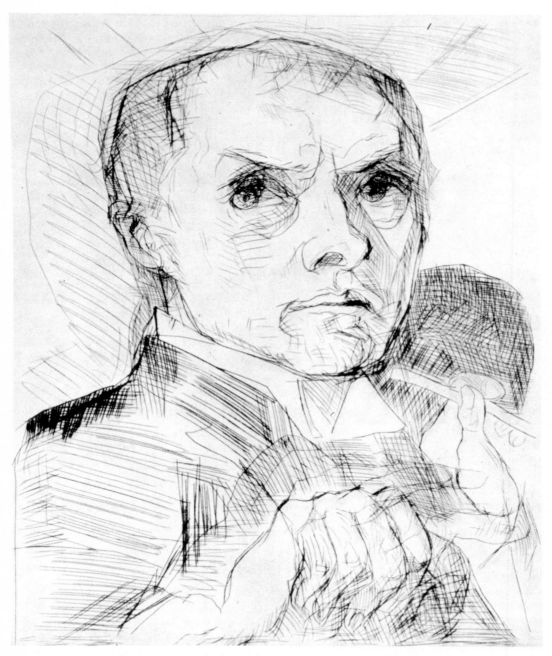

Self-Portrait with Burin. (1917). Drypoint and etching, 11³/₄ × 9³/₈″. (G. 82 b). The Museum of Modern Art, New York, gift of Edgar Kaufmann, Jr.

BECKMANN'S PRINTS by Harold Joachim

Max Beckmann was far too deeply involved with brush and canvas to allow his graphic work to step out of the realm of drawing into that of painting. This is possibly the reason why there is nothing in his work which even remotely resembles the spectacular graphic creations of the leading Expressionists —we hesitate to classify Beckmann as an Expressionist—such as the large color lithographs and woodcuts of Nolde and Kirchner, or those of the great Norwegian, Edvard Munch, whom the younger Germans so deeply admired. Although occasionally in later years he liked to add water colors to a print (page 121), Beckmann rarely worked in large sizes and never in color. His prints, like those of the Old Masters, ought to be studied in the portfolio rather than viewed on the wall. In its technical aspects, his graphic work is remarkably simple and straightforward. More than half of the total is in drypoint, next in importance is lithography, and the woodcut trails far behind. Utterly ignored are all the tonal and textural effects that had become part of the lithographer's and the etcher's repertory by the turn of the century, especially those deep velvety black areas which are so useful for concealing the weakness of drawing.

Perhaps it is this austerity of means and this absence of spectacular effects which have retarded a general recognition of Beckmann's graphic work and obscured from many eyes its true significance. No other major German printmaker of his era had to wait so long for a catalogue that would assist the collector of his work. At last this task has been accomplished, in the finest German tradition of definitive catalogues, by Dr. Klaus Gallwitz,* whose work is based mainly on the collection of Günther Franke of Munich, who with great personal courage remained loyal to Beckmann during the dark years when his work was officially banned in Germany.

Youthful works, done before an artist reaches the age of twenty, can sometimes be prophetic, and this is certainly the case with Beckmann's earliest known print, a self-portrait in

Karlsruhe, Badischer Kunstverein. Max Beckmann, Die Druckgraphik: Radierungen, Lithographien, Holzschnitte, August 27–November 18, 1962.

drypoint, dated January 1901 (page 114). It is a work of startling power of expression in which the seventeen-year-old student of the Weimar academy portrays himself in an ungainly attitude, mouth wide open as if uttering an agonizing scream, or is it perhaps merely a hearty yawn, which is also the subject of two later drypoints of 1917 (G. 79) and 1918 (G. 100). However, in his second print, also a self-portrait, dated 1904 (page 114), he is a well-mannered gentleman, taking justified pride in his handsome appearance, as in the 1907 painting *Self-Portrait, Florence* (page 8). The drypoint of 1904 attempts a subtle differentiation of tiny lines which, if carried one step further, might have become pedantic. Beckmann would only return to this medium eight years later, when he was a mature and successful "realistic" painter.

In the years between 1904 and 1912 he produced forty-five lithographs. The artistic climate of Berlin, where he had been living since 1903, is evident in all of them. They reveal the same agitated, exuberant realism that characterizes much of the graphic work of Liebermann, Slevogt, Corinth and Meid. However, in the last series of these years, *The Bath of the Convicts* (page 116), illustration to Dostoevski's *House of the Dead,* Beckmann's personality begins to assert itself more strongly. The outward turbulence is replaced by concentration on psychological content, and here and there the contour takes on the expressive coherence of his later works.

It was at the end of this period that he again took up drypoint, which was to remain his favorite graphic medium. The loose, spontaneous method of drawing with the drypoint needle on copper had at that time been developed to a very high level by Liebermann, Corinth, and Slevogt, the three great men of the Berlin "Impressionist" school, and Beckmann was clearly under their spell in his prints of 1912 and 1913. (Although it must be remembered that the superbly free and expressive late drypoint style of Corinth had not yet fully emerged at that time.)

Drypoint is not a medium for timid hands—unless it is used merely for textural effect, such as the lustrous hair and fur

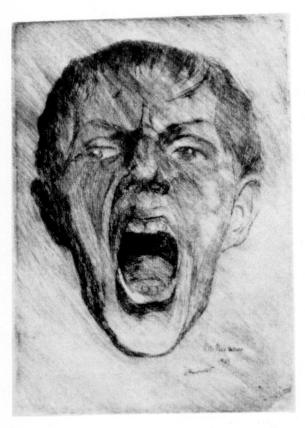

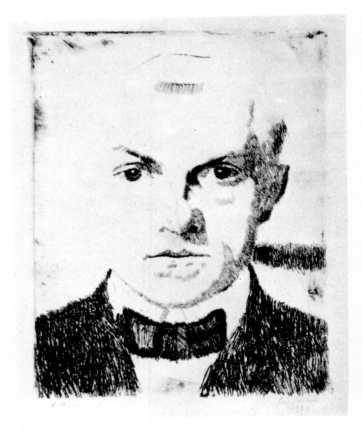

Self-Portrait. 1901. Drypoint, 8½×5⅛". (G. 1). Collection Dr. Peter Beckmann, Munich-Gauting

Self-Portrait. 1904. Drypoint, 8⅞×7". (G. 2). Collection Klaus Piper, Munich

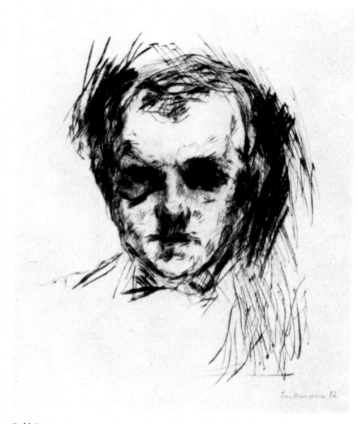

Self-Portrait. 1912. Drypoint, 5⅞×4½". (G. 35). Collection Allan Frumkin, Chicago

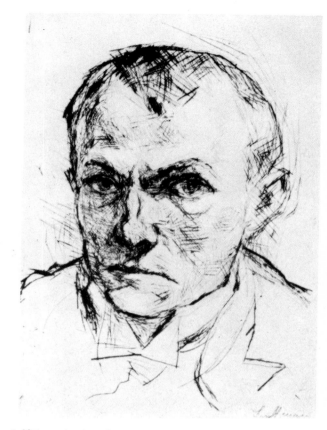

Self-Portrait. (1914). Drypoint, 9⅛×7". (G. 51). The Museum of Modern Art, New York, gift of Paul J. Sachs

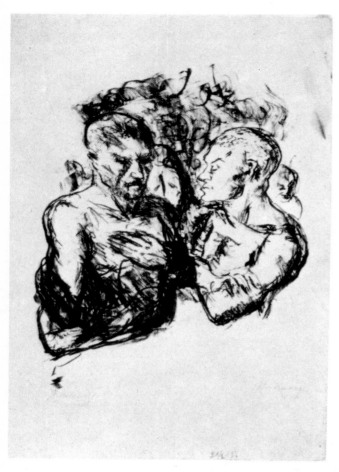

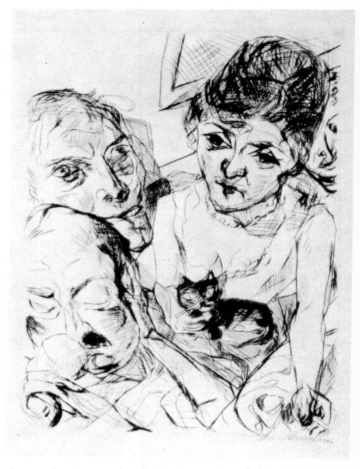

The Bath of the Convicts. 1912. Lithograph, 7¹/₄ × 5¹/₂″. Illustration to Dostoevski's *House of the Dead*, plate 8. (G. 28/8). Collection Allan Frumkin, Chicago

Above right: Evening. (1916). Drypoint, 9⁷/₁₆ × 7″. (G. 67). The Museum of Modern Art, New York purchase

Opposite left: Self-Portrait with Bowler Hat. 1921. Drypoint, 12⁵/₁₆ × 9⁵/₈″. (G. 153 a). The Museum of Modern Art, New York, given anonymously

Opposite right: Self-Portrait with Bowler Hat. (1921). Drypoint, 12³/₄ × 9³/₄″. (G. 153 d). The Museum of Modern Art, New York, gift of Edward M. M. Warburg

pieces in Helleu's portraits of elegant ladies. Corrections are not as easily made as in etchings, and the resistance of the metal must be overcome by a determined mind and a firm hand. Smoothly curving lines do not exist, and every change of direction is more or less angular. Rembrandt was fond of drypoint in his later years, when in his drawings he began to prefer the reed pen which also enforces a certain angularity. A good drypoint has a dynamic quality: one feels the violent action that lacerated the surface of the copper, producing a heavy burr which, in the earliest proofs, may even scuff the surface of the paper. It is easy to see why this technique attracted Beckmann more than any other print medium.

The nervous, agitated style of the early lithographs still characterizes Beckmann's drypoints of 1912 and 1913, but a decided change began to take place in 1914. Perhaps there is no better barometer of the change than a comparative study of his many self-portraits. The small drypoint of 1912 (page 115) depends entirely on startling light effects produced by extremely heavy burrs, the lines are bunched up and have little individual meaning. In the self-portrait of 1914 (page 115) there is a structural firmness that is enhanced by decisive and expressive outlines, as well as a rapport with the spectator which has not occurred before.

In 1914 came the emotional shock of war, whose horrors Beckmann witnessed at first hand in hospitals near the front lines. He compressed his haunting memories into drypoints,

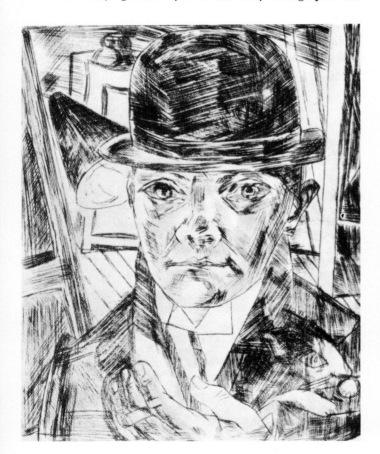

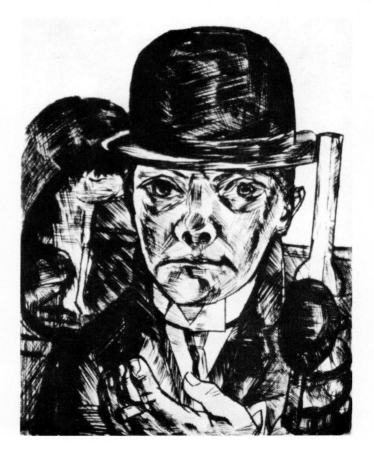

Annual Fair: Shooting Gallery. (1921). Drypoint, 12⅝×9⅞". (G. 166).
The Museum of Modern Art, New York, gift of J. B. Neumann

Right: Annual Fair: Snake Charmer. (1921). Drypoint, 11⁷/₁₆×10¹/₁₆".
(G. 172). The Museum of Modern Art, New York, purchase

and it can be safely stated that during the war years his prints are the very nerve center of his work. Characteristically, the terror depicted in the actual war scenes pales when compared to those prints which reveal the psychological impact of war, such as *Weeping Woman* (page 21) or *Declaration of War* (page 22). Even more haunting are the desperate social gatherings like *Party* (G. 63), *Evening* (page 116), or *Happy New Year 1917* (G. 86). Beckmann had discovered that tragedy and comedy are of the same cloth and that both are integral parts of life. His quest for the truth behind the appearance kept him from devoting his art to exposing social and political ills, although his concern and rage break through often enough. The anxiety and bitterness of these years is also strongly expressed in the "angry" self-portraits of 1917 and 1918.

The years between 1914 and 1920 are the crucial ones in Beckmann's work, and it is only in his prints, and particularly in the drypoints (page 22), that the great consolidation of the

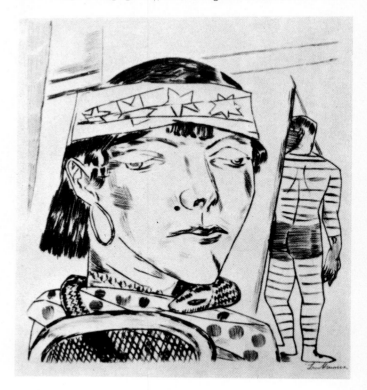

mature Beckmann style can be witnessed. The flamboyant calligraphy is discarded, the nervous tension relieved, and the images become simpler and more distinctive, thereby creating a stronger impact on our immediate perception and on our memory. If in this development one might even venture to speak of a climax, the works of 1920 and 1921 could claim the distinction. This is not meant to imply that they were followed by a decline, but merely that they reveal the exuberant energy that comes with the awareness of having conquered new territory. There must be mentioned, first of all, the magnificent self-portraits with bowler (page 117), and the ten plates of the *Annual Fair*. The first plate (G. 163), again a self-portrait, has the inscription "Circus Beckmann"; the queenly dignity of the girl of the *Shooting Gallery*, the remoteness of the *Snake Charmer*, the ear-shattering tumult of the *Tall Man* and *Merry-go-round* (G. 169) are unforgettable images which forecast paintings of a later period.

Beckmann's monumental graphic style was now firmly established and the years 1922—23 brought a rich harvest in superb prints, mostly but not exclusively in drypoint. There are some great lithograph portraits and the set *Berlin Journey* (page 120), as well as a small group of woodcuts, a comparatively rare medium for Beckmann. In 1924, his print production tapered off almost to a standstill. Painting again took complete possession of him, but the discoveries he made in his graphic work bore fruit in his painting of the following years.

The last lithographs, made in Amsterdam and America, are entirely different. They are intimate reflections of a philosopher whose lifework is nearing completion. The Apocalypse has always inspired turbulent dramatic scenes with earth-shaking trumpet blasts and cosmic disasters, and Beckmann now adds to this tradition with a series of prints which derive much of their sustained and poignant power from their apparent restraint. Finally, there is the set of fifteen lithographs, *Day and Dream* (page 121), published by Curt Valentin in 1946. Here, as in many of his late drawings, Beckmann employed the thin ascetic line of the pen, purest and most exacting of drawing media. Nostalgic and gentle memories alternate with visions of death. Explanations are impossible; only those familiar with the artist's total work can hope to find the key.

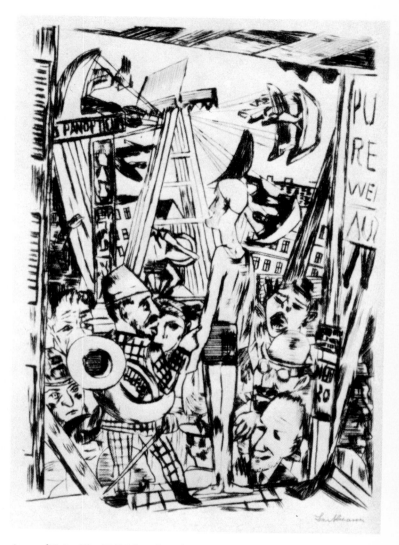

Annual Fair: The Tall Man. (1921). Drypoint, 12¹/₁₆ × 8¹/₄". (G. 167). The Museum of Modern Art, New York, purchase

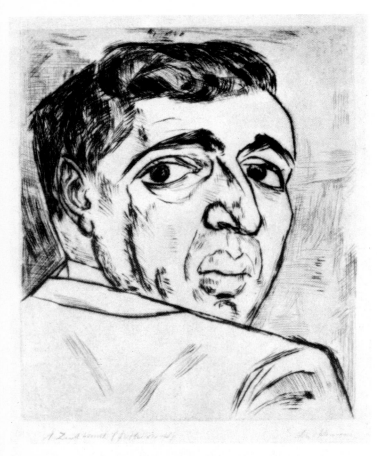

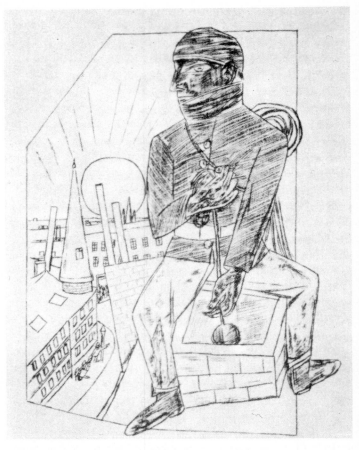

Portrait of J.B.Neumann. (1919). Drypoint, 8³/₈ × 6⁷/₈". (G. 125 b). Collection Allan Frumkin, Chicago

Berlin Journey: Chimney Sweep. (1922). Lithograph, 17³/₄ × 13¹/₈". (G. 191). The Museum of Modern Art, New York, purchase

Right: Day and Dream: King and Demagogue. (1946). Lithograph, 14⁷/₈ × 10″. (G. 296). The Museum of Modern Art, New York, Curt Valentin Bequest

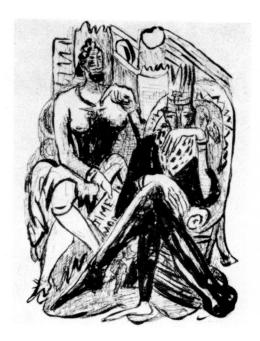

Bottom right: Day and Dream: Circus. (1946). Lithograph, 15⁵/₈ × 11¹/₂″. (G. 300). The Museum of Modern Art, New York, Curt Valentin Bequest

Woman with Candle. (1920). Woodcut, with watercolor, 11³/₄ × 6″. (G. 143 b). Collection Mrs. Mathilde Q. Beckmann, New York

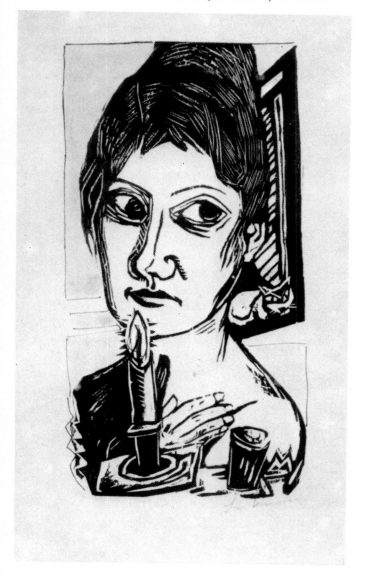

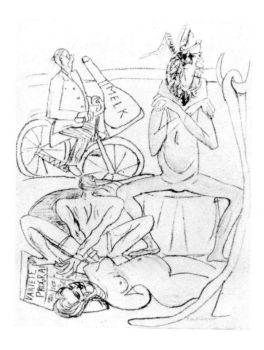

Judging an exhibition, City Art Museum of St. Louis, November 1949

MAX BECKMANN IN AMERICA: A PERSONAL REMINISCENCE by Perry T. Rathbone

Max Beckmann's life was not without adventure, even drama. It was punctuated with challenge and crisis. It was lived out in several places. And his life should not have been otherwise, for Beckmann was born with a restless curiosity about the world and about people. As a boy, like his father before him who wanted to possess a house on wheels, Max yearned to travel. He told me that in his school days he was especially fond of illustrating imaginary journeys. Indeed, he was only half grown when he actually tried to find work on an Amazon River boat! From early manhood he traveled widely, and his trips were as frequent and as distant as the circumstances of his life would permit. But the crowning adventure was reserved for the last—his emigration to the New World. No fantasy or figment of his boyish dreams, no matter how extravagant, could have matched in wonder the reality of that experience. For seven years he waited to embark. Already in 1939 before the outbreak of war, he had hoped, even planned, to leave Amsterdam for Chicago. Beckmann kept a diary, a *Tagebuch*. Unfortunately he destroyed all the diaries he kept before 1940, fearing that under the Nazi tyranny they were incriminating. But on the first page of the surviving volumes we find the following entry under May 4, 1940:

America waits for me with a job in Chicago and the local American consulate doesn't give me a visa.[1]

Very much credit has been given to me for bringing Max Beckmann to America in 1947. I should like to put this credit into proper relationship with the facts. The most important of these is that Max Beckmann had made his decision to emigrate seven years before he came to St. Louis. Through Curt Valentin I learned of this; through him I also learned that Indiana University had invited Beckmann to come there. But in the last analysis, my influence with Washington University in St. Louis resulted in Beckmann's invitation and appointment. Happily this development threw me into close personal contact with him for the last three years of his life.

The appearance of the man I came to know was already familiar from the self-portraits. But Beckmann in life proved to be less formidable than Beckmann as he saw himself. He was a large square man with big forceful hands and a ponderous gait. I was first struck by the perfect dome of his head. His countenance with its intellectual brow, its wide, downturned mouth, was deeply serious, but his eyes were soft and kindly and his smile had genuine warmth. Max Beckmann was a proud man. He did not easily reveal his weaknesses—physical or spiritual—except to his wife and to his diary. As a young man his features were soft, his hair curly, his general aspect romantic. He had been a handsome youth. Now he was a middle-aged man of striking appearance whose self-created image was one of seriousness, masculine courage, and strength. Yet Beckmann's appearance somehow belied the true state of his constitution. He was a man made sleepless by the subconscious projection of his anxieties and fantasies. He told me he had been plagued by wakefulness for twenty-five years. Insomnia had left its mark; his was the face of a tired man, a man with a burden.

Nervousness characterized his waking life as well. To relax his tensions he smoked cigarettes incessantly, and alcohol in moderate quantity was the balm of Gilead to him. In the end it was Max Beckmann's nervous temperament that undermined his health and inflicted a fatal burden upon his heart.

In migrating to America, to choose between the provincial town of Bloomington, Indiana, and the mellow, old, cosmopolitan city of St. Louis with its fine museum, its artistic life, its important art school, its collectors, was for Beckmann relatively easy. And this brings me to the first observation of his character I should like to dwell upon.

I say *relatively* easy because I recognized that all decisions of a vital kind, especially those that involved his bodily or personal existence, were never easy for Beckmann, and they could be agonizing. I was struck in fact by the tension that built up within him over any impending new experience. His appointment in St. Louis was a temporary one. What of the future? He worried about his reappointment. Also tormenting were thoughts of the future when in 1949 he knew he must leave St. Louis for New York. Max Beckmann could not be re-

laxed about the morrow. He never developed any ease of life and rarely knew solid contentment. Ever since the traumatic experience of the first World War the element of anxiety in his nature continued to deepen. The confidence of youth seems to have deserted him at an early age. Needless to say, the pessimism that prevailed in postwar Germany, the catastrophic political events that ensued, and the systematic destruction of a free cultural expression under the heel of Nazism were hardly conducive to optimism. And we must not forget the painful heart condition that accelerated in his later years. As we know, Beckmann's mind was governed by a vivid imagination. That imagination gave him insomnia, but it also generated the extravagant and clear-cut dreams he often refers to in the diary. Under July 24, 1947, for example, we find the following:

Woke up deep in the night—Dream of America, surrounded by countless reporters, asking Quappi permission to make movies.... Deep anxiety and worry about the journey. Greatest nonsense to do—but nevertheless.[2]

I remember the apprehension with which Max undertook almost any journey. Cheerful, capable, optimistic Quappi provided the morale for these undertakings. It goes without saying that she also assumed responsibility for all the details. But Max, driven by anxiety lest there be some slip, always saw to it that the Beckmann couple was on the station platform an hour before train time. My own incurable habit was just the opposite, and inadvertently, I gave Max many anxious moments by turning up at the last minute when we traveled together. So he had reason to observe in the *Tagebuch* when he entrained at St. Louis for Minneapolis:

Perry's were amazingly on time at the station.[3]
(That's because my wife was with me!)

In St. Louis, Max had frequent occasion to ride in my car, an open Ford, and he often recorded his fear of what he considered my fast driving. While I don't mean to equate my driving with flying, it was this same deep-seated anxiety about any exposure to danger that forbade him ever to travel by plane. Fate was not to be tempted.

There was another anxiety he could not shake off even in the free air of the United States—the fear of being suspected. Max was an inveterate walker, not only for bodily exercise but to exercise his eyes, his observation of nature and humanity. The Mississippi, that enormous, almost legendary river, had its fascination for him, and strolling there at dusk one evening about five miles from the University, where he lived, he paused to observe the ever-moving flood, the lights reflected from the Illinois shore, and the beautiful lines of the old Eads Bridge under which he stood. Deep in thought he suddenly caught sight of two policemen who were, he thought, looking his way. Panic seized him. All at once he saw himself, the refugee from Germany, speaking broken English, presumably studying in the half light a strategic structure—the most important bridge across the greatest river in America. Recollection of the police state swept his mind. No American would have thought twice about the policemen, but Max Beckmann left the scene with haste, filled with nervous anxiety.

As I have said, unlike Americans, Max's favorite exercise, in fact his only exercise, was walking. In America he lived at different times in three homes, one in St. Louis, two in New York. Whether by careful planning, whether instinctively, or by happy accident, each of these abodes was near a park, where Max's solitary figure could be seen daily striding across the green no matter what the weather, as content to walk in the rain as in the sunshine. The tensions of creative work—and Max worked unceasingly—needed to be completely relaxed: the exhausting labor, not so much of standing in the studio, but of making aesthetic decisions before the easel, of trial and error, of alternating doubt and confidence about the work in progress—these drained him of nervous energy. It was from such long and tiring encounters with the Muse, so often referred to in the *Tagebuch*. that Max found blessed release in walking: a walk not only braced him, but restored perspective; it aired his mind and cleansed and rejuvenated his spirit.

In the realm of diversion Max had two other passions which he did not relax simply because he had moved from one continent to another. One of these was champagne, which he adored; the other was the show: the stage, the movies, the circus, the cabaret, and of course, the eternal show of humanity itself. In St. Louis, Max was introduced to a somewhat different show: the monkey show at the zoo in Forest Park—an elaborate act of some twelve extraordinary performing

chimpanzees in an outdoor arena, the delight of all the children of St. Louis and most of their parents. Very soon after the arrival of Max and Quappi in St. Louis, my wife, with unfailing instinct, took Max to a performance, and it utterly delighted him. These animals, behaving so much like brainless human beings, appealed to his ironic sense of humor, stirred philosophic reflections, and stimulated his fantasy. With satirical wit he afterward told my wife he would love to have an ape for a valet! And he was delighted to find that the amalgam of humanity in the American scene was all that he expected: he was quick to discover in the audience a western Indian, a cowboy in a ten-gallon hat, and several Negroes.

Max Beckmann loved cabarets. For him they represented a sort of microcosm of the world of humankind where he could observe and scrutinize without self-consciousness or embarrassment. Being less disillusioned about humanity than Max, I did not share the same enthusiasm for cabarets and found them rather depressing. For some reason that he did not explain, he long cherished the idea of taking me alone on a tour of night clubs in Manhattan, not fashionable upper-class night clubs where the dinner jacket is required, but to other kinds. So, one evening, leaving Quappi at home, we began with a low-grade dive in the Bowery on the lower East Side where the music was loud and brash, the lights harsh, and the drinks watered. Yet there was such an assortment of Bowery types, inebriates, exhibitionists, bar flies both comic and tragic, that Max was fascinated. Ironical amusement played across his face as he drew my attention to this character or that with a nudge or a gesture. From there we progressed to Broadway in the heart of the theater district to a huge middle-class night club, a grand cabaret such as I had never seen before but which was one of Max's favorite haunts. In this arena for the masses, vulgarity reigned. Here the tables were set in tiers ring upon ring; here the waiters were dressed in exotic costumes, and here we were treated to an elaborate and pretentious stage show with nearly naked girls merely strutting about when not engaged in some gymnastic dance.

Surrounded by this extravaganza, Max was totally absorbed. He was stimulated by the spectacle, amused by the deliberately lunatic behavior of humanity. He didn't talk much, but

St. Louis, 1949. Photograph J. Raymond

Quappi and Max Beckmann, on the occasion of Beckmann's receiving an Honorary Degree from Washington University, St. Louis, June 1950

once in a while he would smile and chuckle knowingly and then say: "Nothing to do" — which meant, "This is life; it can't be helped; let's face it."

In his daily life Max found diversion on a simple plane by way of another member of the Beckmann family who was never left out of consideration, one who enjoyed every privilege but was exempt from any responsibility. He ate and slept with Max and Quappi, he traveled with them wherever they went. He promenaded daily with master or mistress. I refer, of course, to Butshy, the tiny Pekinese. He was a textbook example of the one-man dog. With the Beckmanns he behaved like a kitten, but to their every friend he was an enemy, a vest-pocket monster. Cerberus was never so ferocious, and few of the Beckmann circle, at some time, escaped his snarling assaults. He succeeded in nipping me in the ankle on first acquaintance in Amsterdam. To Max, however, Butshy was a darling, his spoiled child who asked for and received every indulgence, all the comforts of home, and not infrequently an ice cream cone on the daily walk. To Max he was also a kind of lordly homunculus (he painted his portrait with a bouquet of tulips) whose dignity was incorruptible, whose life made more sense than that of many human beings.

One of the most courageous aspects of Max's decision to settle in America was his willingness to assume the burden and responsibility of teaching. Not that the idea of teaching was repugnant to him. He had known what it was to be a teacher in Frankfurt. But that chapter had closed in 1933. Beckmann was no longer in the habit of teaching and he was fourteen years older. He was sixty-three. Moreover, he would be using a language which he knew imperfectly; he would undertake the task in a country totally foreign. And living under an absolute compulsion to paint, he faced the fact that both his time and energy would in part be absorbed by another activity. Very much credit must be given to his devoted wife for the program which he now undertook. For it was she who attended all his lecture sessions, both in St. Louis and in Brooklyn, in order to translate and to clarify his ideas in her fluent English and with her thorough understanding of Beckmann's artistic principles and his outlook.

Beckmann was devoted to his American students. He was

conscientious, painstaking, and tolerant with them to a degree that is touching. And he was rewarded. His students idolized him. In the first place, they could hardly believe their good fortune in having Max Beckmann himself in their midst. This was almost too good to be true. Secondly, they discovered what all his friends discovered: that Max Beckmann the stranger had a stern, formidable, almost overpowering image—a man whom one met with some trepidation—but who, upon personal acquaintance, was a warm, generous, compassionate, deeply understanding human being with a remarkable capacity for friendship. And I think he was forever in love with youth. In addition to being a great artist, what more could one ask for in a teacher?

Among his pupils Beckmann made friends with many with whom he visited and corresponded after classroom days were over. At a time of increasing abstraction and a close-out of the human factor in painting, which he viewed with profound misgiving, if not alarm, he felt it his mission to inculcate respect for a humanistic art. Abstraction was for him a form of *Kunstgewerbe,* as he so often said.

Max Beckmann was so dedicated to teaching, in fact, that in addition to major teaching appointments in St. Louis and Brooklyn, he accepted invitations for lectures and seminars and summer courses in the Far West, on the West Coast, in the South, and in New England. In other words, he covered more of our vast country with his teaching and personal influence in his brief American period than any native artist I know of. His summer sessions were at the University of Colorado and at Mills College in California. His briefer appearances were at the Boston Museum School, at the Memphis Museum in Tennessee, at Vassar College, and at Stephens College for women in Missouri. It was for Stephens College that he wrote the "Letters to a Woman Painter," that beautiful poetic credo, that testament of an artist drawn from a lifetime of experience and from the depths of his artistic conviction.[4] The experience of assisting in the translation of this piece was, incidentally, one of the rewards of my friendship with Beckmann. Like Max himself, that statement is both tender and strong. Like his art, it is full of his personal imagery, his adoration of nature, his concern with humanity. I feel it is per-

haps a statement he would only have composed in America. In its freshness and its candor, in its freedom from any cynicism, it seems written not only for young people but for a young country, a country whose idealism constantly astonishes the European visitor.

Max Beckmann enjoyed his students not only in the teaching studio where they were engaged in the serious matter of art, but also in their fun and recreation. In St. Louis the most memorable occasions of this kind were the Beaux-Arts masquerade parties given by the Art School of the University. No one was ever more susceptible to the fascination of the mask than Max Beckmann. Had he not used it as a symbol of the mystery of the ego for nearly thirty years? He was also fascinated by the transfer of human identity from real life to play acting. Similarly, he had in his self-portraits repeatedly seen himself as a sailor, a prisoner, a musician, a clown, and an actor. Here then among his students he was actually surrounded by a make-believe world which was to him also the real world of human creatures, from cannibals almost naked to gypsies in elaborate costumes. These parties took place in the vaulted, medieval-style subterranean hall of a great château far out on the Missouri River—a place in itself so unreal, so unbelievable that it was the perfect setting for this phantasmagoria. I shall not forget the figure of Max, now grown rather ponderous in his last years, his broad, handsome face half covered with a black domino across the eyes, moving amid this motley throng in fantastic attire. I can see him, now dancing, now drinking champagne, now with thoughtful humor observing the scene, indulging his fantasy, storing up the images that would insinuate themselves into his painting. One of Beckmann's favorite pupils was Walter Barker, then emerging as a gifted young painter of St. Louis. Barker described to me the following little vignette which made an indelible impression on him. Having arranged to give a masquerade party of his own in his studio, he was busying himself with preparations while awaiting the arrival of the first guest. Suddenly, he heard a heavy tread on the stairs. There was a solemn knock on the door. Barker opened. In the darkness of the hall loomed a big, broad figure in black *smoking* and black hat, a black mask across the eyes. For a moment Barker was startled,

even a bit frightened. Then a deep voice: "It's Beckmann!" Max liked being his own symbol of the enigma of human personality, the Ego's veiled image.

This aspect of Max Beckmann's life in America contributed to whatever contentment and satisfaction his later years held for him. And there were other aspects which offered striking contrast to his life in Amsterdam. There, during his residence of ten years, he had sold only one or two canvases privately, aside from one masterpiece to the Stedelijk Museum. In St. Louis, not only was he again in touch with youth, but he was close to a museum sympathetic to his work and among collectors of modern art, two of whom were especially interested in him, Morton D. May and Joseph Pulitzer, Jr. In 1939 the latter had bought the *Portrait of Zeretelli*, which had formerly been in the Staatliche Gemäldegalerie in Dresden, the first Beckmann to be acquired in St. Louis. But the impact that Beckmann had upon Morton May was decisive. It came through the great Beckmann exhibition of 1948 in the St. Louis museum and the personal friendship that quickly sprang up between them. From that time onward May's purchases were a boost to Max's morale and a boon to his economic situation. In fact, May's devotion and collecting zeal rivaled, if it did not exceed, that of any European enthusiast, so that he became the principal patron of Beckmann's later years.

The striking success of Max's American years cannot be mentioned without reference to the man who was his staunchest ally, his indefatigable entrepreneur. I refer, of course, to the late Curt Valentin. Not only did he give Max exhibitions at his informal but most influential New York gallery whenever possible, not only did he bring out the portfolio *Day and Dream* and numerous catalogues in which he published some of Beckmann's writings as well as reproductions of his works, but he was also a constant encouragement in his purchase of paintings from the artist and in his ability to sell them to American museums and influential collectors. He never allowed Max and Quappi to feel that they were in the slightest way neglected in their new home. There were constant letters, thoughtful gifts, frequent visits. He was often seen in St. Louis, where he was a favorite of all the collectors of the city, and no one could have been more helpful to me in organizing the

1948 exhibition, one of the major undertakings of my directorship in St. Louis. Writing the text for the catalogue brought me into a new relationship with Beckmann. Deeply absorbed though he was in the artistic problems that confronted him, he nevertheless always refused to discuss his own work. He did not discuss it now. But he was naturally sympathetic to my determination not to misinterpret the meaning of the allegories that figured so conspicuously in the work of the preceding twenty-five years. Consequently, in many interviews I placed before him my interpretations. Whether they were precisely correct, he would not say, maintaining that his symbolism was for every man to read as he could. But neither, I believe, would he let me wander far from his own ideas. With an exclamatory "fine, fine," a "why not," a "ja ja," or merely a gesture, I found endorsement for my analyses.

The exhibition was a most important event in Max's life. This large retrospective show was the first major Beckmann exhibition since the Basel show in 1930—and it represented sixteen more years in the artist's career. It was decided upon as soon as Beckmann accepted the invitation of Washington University; and while Max naturally was eager for the show, his anxiety also made him dread it. The *Tagebuch* makes it plain:

Slowly come new waves. The exhibition at the City Art Museum begins to thunder in the distance.[5]

And on the eve of the opening he wrote:

Now the exhibition draws near and everybody is panting. Press bang-bang is imminent, the newspaper full of pictures, the people curious. . . . The modern academic snob will grumble, so will the Babbitts.[6]

This was the first important Beckmann exhibition in this country, and surprisingly, it was the first large Beckmann exhibition he had ever seen. Fortunately, the principal loan-exhibition gallery in the St. Louis museum was a spacious and lofty room. Filled with many of Beckmann's major works, which I had hung with the utmost care, the monumentality, the plastic strength, and the brilliant singing color made an impression that was unforgettable. Here were three of the greatest of the nine triptychs: *Departure, The Actors,* and *Blindman's Buff.* Here were some ninety other works dating from 1906 to the present. For Max to see the creation of forty years

spread out in such a grand array was an overwhelming, an almost unbearable, experience. Here in visual terms were all the deepest experiences of a lifetime. Max gradually accustomed himself to this prodigal exposition. So far as the presentation was concerned, he was completely satisfied. He was not to see anything like it again.

The exhibition toured for almost a year, visiting the museums of Los Angeles, San Francisco, Baltimore, and finally, Minneapolis. For the opening in the latter city in the depth of winter, the Beckmanns and the Rathbones made a memorable trip: 700 miles to the north along the river. Max, the really great traveler in America, was as fascinated by the Mississippi Valley (and he saw it all the way from New Orleans to Minneapolis) as he was by the Rocky Mountains, by San Francisco, and by the skyscrapers of New York. Max and Quappi were beautifully feted in this pleasant city where the arctic cold (15 degrees below zero) was offset by the warmth of the hospitality. Once again Max saw his show. But the shattering experience was my lecture which accompanied it. In the *Tagebuch* we read:

Then exhibition again, lecture by Perry—oh God
my own life passed before me in pictures—like a
dream accompanied by Perry's voice and slides. I
had to bow oh—God, and receive approval—oh God,
Mr. Beckmann was applauded.[7]

The Brooklyn Museum Art School, 1950.
Photograph Paul Weller

Max's wonderful satirical sense of humor never deserted him.

Such events were characteristic of the marked change from Max's ten years in Amsterdam, years which at first during the occupation were secretive, then at best confining, with little or no social activity. In America, and especially in St. Louis, life was very different. St. Louis is a gay city where the traditions of southern hospitality are cultivated. It has numerous circles of society most of which overlap. Consequently, it was easy for the Beckmanns to meet everybody. And because the social life of the town seems to be at a perpetual boil, this was accomplished in a relatively short time. The Beckmanns were guests at luncheons, dinners, cocktail parties; they were entertained by the faculty and trustees of the University, by trustees and friends of the museum, by the collectors of the town, and of course, they were frequent guests in our house. Yes, Max knew what it was to be lionized. While in many ways he was a solitary man, he was also very gregarious and accepted as many invitations as he could and seemed to enjoy the kaleidoscope of party activity. Out of this large group of people he soon made fast friends of all ages. The ease of social life was one more aspect of the atmosphere of freedom and flexibility in the United States which quickly led to his decision to remain in America and become a citizen, in spite of urgent and tempting appeals from Europe to return.

Max Beckmann in America, as we have seen, was an assiduous and inspiring teacher both winter and summer; he was a daily walker, he was an habitué of cafés, he continued to be a diarist—and he was something of a social lion.

How, we may ask, did his creative life progress during these three American years? With all the fatiguing activity that I have touched upon, there was no slackening of Beckmann's artistic production, no compromise. From October 1947 to the day of his death in December 1950, he painted nearly eighty pictures, two of them large triptychs. In addition, he left four unfinished pictures, one of them a triptych, *Ballet Rehearsal*, and many drawings and watercolors.

As we know from his own admission, Beckmann was a compulsive painter. We also know that he was capable of long periods of intense concentration. Locked in his studio for hours, he would paint to the point of exhaustion. Only occasionally would he break his labor and sink into the big, square, over-stuffed chair, which had been an essential studio fixture for years, its olive-drab corduroy cover well caked with oil paint.

In St. Louis he had a proper studio in a University building with north light pouring through a studio window. In New York he was less fortunate, as studios were extremely expensive. Consequently, he twice rented an old apartment with high ceilings and at least one spacious room. The first one was in an early nineteenth-century house on East 19th Street, near Gramercy Park. The second was a roomy first floor of one of the once-fashionable houses of the turn of the century on West 69th Street. The relentless mahogany paneling one can never forget; its imperturbable solid dignity, its built-in mirrors and glazed-tile hearths must have reminded Max somehow of the security of life that prevailed in the days of his first success in Berlin. Lacking sufficient light in both apartments, he had the biggest room equipped with a battery of large fluorescent tubes which simulated daylight and which, incidentally, extended his studio hours. Now he was able to paint at night, and during his life in New York he seems to have done so almost as much as during the day. To keep the bright overhead lights from falling directly into his eyes, he wore a green eye shade which he would give to the visitor to wear when coming to the studio to see the latest works.

Among the many paintings of the three American years, some of the most distinguished were the series of fourteen portraits. These included three self-portraits and the last portrait of Quappi. Beckmann accepted a few portrait commissions, but for the most part his portraits were of people by whom he was personally attracted. To be painted by Beckmann was an experience. As one could imagine, his approach was quite unconventional. It was his habit to make one or two drawings from life but without posing. These he sketched under informal circumstances which he nevertheless arranged. I know this from experience, as Beckmann painted us both—my wife first. Quappi was part of the plan. At our home one morning for an hour Quappi and my wife, wearing whatever Max had suggested, conversed on the sofa. Max himself sat halfway across the room observing and drawing, never saying a word. Indeed, he worked with the deepest possible concentration. My wife

...e Brooklyn Museum Art School, 1950. Photograph Paul Weller

ever having shown the painting in its various stages of development, Beckmann would announce that the portrait was done. He did so in the case of my wife's portrait, inviting us at a specified hour to come to the studio to see it. I will not forget the moment when he turned the canvas around for us to look at it. We were stunned and delighted, conscious at once of the likeness, admiring of the brilliant plastic invention, the beauty of the color. Max watched our reaction with the utmost absorption. Then, satisfied that we considered it a success, he presented it to my wife with a gesture appropriate to such a magnificent gift.

Anyone who has read Max Beckmann's diaries knows that his life was governed by the compulsion to work and the desire to dream. *Arbeit* and *Traum* are the unchanging preoccupations that prompt the passages most significant to our understanding of Beckmann. And with the dream is linked travel—the journeys, real or imaginary, which had figured in his life since boyhood. These preoccupations he summed up in an entry of the *Tagebuch* six months before he died. He was on his way to California, by way of St. Louis where he was to receive an honorary degree from Washington University. In spite of his habitual skepticism about man, his pomps and vanities, he approached the award of this academic distinction with respect and seriousness. As his train sped westward, Max Beckmann, the indefatigable worker, the dreamer, the traveler, spoke in these words to his *Tagebuch*:

One must work and forget everything, just in order to work—to continue to work; now I journey farther to dream—.[8]

was aware of the labor involved and the intensity of Max's mood, for not only did she occasionally catch sight of his penetrating eyes, his deep frown, but also she noted that he uttered sighs and groans as he worked, and when he was finished he was in a state of perspiration. These drawings Beckmann kept. They were his only guide in getting a likeness, except for the visual impressions that he stored up in his mind. While at work on the portrait he would have made it a point to see his subject at some social gathering where, as a silent observer, sitting apart from the stream of conversation, he would fix his steadfast, almost frightening, gaze upon his subject, studying him in every light, in every mood, "piercing the visible in search of the invisible." Days or possibly weeks later, without

[1] *Tagebücher 1940–1950*, Munich, Albert Langen–Georg Müller, 1955, p. 9.
[2] *Ibid.*, p. 198.
[3] *Ibid.*, p. 298, entry for January 17, 1949.
[4] See below, pp. 132 ff.
[5] *Op. cit.*, p. 241, entry for March 8, 1948.
[6] *Ibid.*, p. 252, entry for May 8, 1948.
[7] *Ibid.*, p. 299, entry for January 18, 1949.
[8] *Ibid.*, p. 375, entry for June 2, 1950.

APPENDIX

LETTERS TO A WOMAN PAINTER
translated by Mathilde Q. Beckmann and Perry T. Rathbone

These letters were composed during the first weeks of January 1948 in response to an invitation to speak at Stephens College, Columbia, Missouri. They were finished by mid-January, and Mrs. Beckmann and Mr. Rathbone worked on the translation during the next days. The letters were read by Mrs. Beckmann at Stephens College on February 3, 1948. Subsequently she read them at the School of the Museum of Fine Arts, Boston, March 13, 1948; over the radio in St. Louis during the retrospective exhibition of 1948; at the Art School of the University of Colorado, Boulder, Summer 1949; and at Mills College, Oakland, California, Summer 1950. They were first published in the College Art *Journal, IX, 1, Autumn 1949, pp. 39–43.*

I

To be sure it is an imperfect, not to say a foolish, undertaking to try to put into words ideas about art in general, because, whether you like it or not, every man is bound to speak for himself and for his own soul. Consequently, objectivity or fairness in discussing art is impossible. Moreover, there are certain definite ideas that may *only* be expressed by art. Otherwise, what would be the need for painting, poetry, or music? So, in the last analysis, there remains only a faith, that belief in the individual personality which, with more or less energy or intelligence, puts forward its own convictions.

Now you maintain that you have this faith and you want to concentrate it upon my personality and you want to partake of my wisdom. Well, I must admit that at times you are really interested in painting and I cannot suppress a sort of feeling of contentment that you have this faith, even though I am convinced that your really deep interest in art is not yet too much developed. For, sadly, I have often observed that fashion shows, bridge teas, tennis parties, and football games absorb a great deal of your interest and lead your attentions into idle ways. Be that as it may. You are pretty and attractive, which in a way is regrettable, for I am forced to say a few things to you that, frankly, make me a bit uncomfortable.

In the development of your taste you have already left behind certain things: those fall landscapes in brown and wine red, and those especially beautiful and edible still lifes of the old Dutch school no longer tempt you as they did before. Yes, as you have assured me, even those prismatic constructions, pictures of recent years, give you that sad feeling of boredom that you so much want to get rid of. And yet formerly you were so proud of understanding these things alone.

And now. What now? There you stand not knowing your way in or out. Abstract things bore you just as much as academic perfections, and ruefully you let your eyes fall on the violet red of your nail polish as if it were the last reality that remained to you! But in spite of it all, don't despair. There are still possibilities, even though they are at the moment somewhat hidden. I know very well that in the realm of pure concentration your greatest enemies are the evils of the big wide world: motor cars, photographs, movies —all those things that more or less consciously take away from people the belief in their own individuality and their transcendent possibilities and turn them into stereotyped men.

However, as I have said, we need not give up the hope of searching and finding the way out of the dark circle of machine phantoms in order to arrive at a higher reality. You can see that what you need is difficult to express in words, for what you need are just the things that, in a sense, constitute the grace and gift for art. The important thing is first of all to have a real love for the visible world that lies outside ourselves as well as to know the deep secret of what goes on within ourselves. For the visible world in combination with our inner selves provides the realm where we may seek infinitely for the individuality of our own souls. In the best art this search has always existed. It has been, strictly speaking, a search for something abstract. And today it remains urgently necessary to express even more strongly one's own individuality. Every form of significant art from Bellini to Henri Rousseau has ultimately been abstract.

Remember that depth in space in a work of art (in sculpture, too, although the sculptor must work in a different medium) is always decisive. The essential meaning of space or volume is identical with individuality, or that which mankind calls God. For, in the beginning there was space, that frightening and unthinkable invention of the Force of the Universe. Time is the invention of mankind; space or volume, the palace of the gods.

But we must not digress into metaphysics or philosophy. Only do not forget that the appearance of things in space is the gift of God, and if this is disregarded in composing new forms, then there

is the danger of your work being damned by weakness or foolishness, or at best it will result in mere ostentation or virtuosity. One must have the deepest respect for what the eye sees and for its representation on the area of the picture in height, width, and depth. We must observe what may be called the Law of Surface, and this law must never be broken by using the false technique of illusion. Perhaps then we can find ourselves, see ourselves in the work of art. Because ultimately, all seeking and aspiration ends in finding yourself, your real self of which your present self is only a weak reflection. There is no doubt that this is the ultimate, the most difficult exertion that we poor men can perform. So, with all this work before you, your beauty culture and your devotion to the external pleasures of life must suffer. But take consolation in this: you still will have ample opportunity to experience agreeable and beautiful things, but these experiences will be more intense and alive if you yourself remain apart from the senseless tumult and bitter laughter of stereotyped mankind.

Some time ago we talked about intoxication with life. Certainly art is also an intoxication. Yet it is a disciplined intoxication. We also love the great oceans of lobsters and oysters, virgin forests of champagne, and the poisonous splendor of the lascivious orchid.

But more of that in the next letter.

II

It is necessary for you, you who now draws near to the motley and tempting realm of art, it is very necessary that you also comprehend how close to danger you are. If you devote yourself to the ascetic life, if you renounce all worldly pleasures, all human things, you may, I suppose, attain a certain concentration: but for the same reason you may also dry up. Now, on the other hand, if you plunge headlong into the arms of passion, you may just as easily burn yourself up! Art, love, and passion are very closely related because everything revolves more or less around knowledge and the enjoyment of beauty in one form or another. And intoxication is beautiful, is it not, my friend?

Have you not sometimes been with me in the deep hollow of the champagne glass where red lobsters crawl around and black waiters serve red rumbas which make the blood course through your veins as if to a wild dance? Where white dresses and black silk stockings nestle themselves close to the forms of young gods amidst orchid blossoms and the clatter of tambourines? Have you never thought that in the hellish heat of intoxication amongst princes, harlots, and gangsters, *there* is the glamour of life? Or have not the wide seas on hot nights let you dream that we were glowing sparks on flying fish far above the sea and the stars? Splendid was your mask of black fire in which your long hair was burning—and you believed, at last, at last, that you held the young god in your arms who would deliver you from poverty and ardent desire?

Then came the other thing—the cold fire, the glory.

Never again, you said, never again shall my will be slave to another. Now I want to be alone, alone with myself and my will to power and to glory.

You have built yourself a house of ice crystals and you have wanted to forge three corners or four corners into a circle. But you cannot get rid of that little "point" that gnaws in your brain, that little "point" which means "the other one." Under the cold ice the passion still gnaws, that longing to be loved by another, even if it should be on a different plane than the hell of animal desire. The cold ice burns exactly like the hot fire. And uneasy you walk alone through your palace of ice. Because you still do not want to give up the world of delusion, that little "point" still burns within you —the other one! And for that reason you are an artist, my poor child! And on you go, walking in dreams like myself. But through all this we must also persevere, my friend. You dream of my own self in you, you mirror of my soul.

Perhaps we shall awake one day, alone or together. This we are forbidden to know. A cool wind beyond the other world will awake us in the dreamless universe, and then we shall see ourselves freed from the danger of the dark world, the glowing fields of sorrow at midnight. Then we are awake in the realm of atmospheres, and self-will and passion, art and delusion are sinking down like a curtain of gray fog . . . and light is shining behind an unknown gigantic gleam.

There, yes there, we shall perceive all, my friend, alone or together . . . who can know?

III

I must refer you to Cézanne again and again. He succeeded in creating an exalted Courbet, a mysterious Pissarro, and finally a powerful new pictorial architecture in which he really became the last old master, or I might better say he became the first "new master" who stands synonymous with Piero della Francesco, Uccello, Grünewald, Orcagna, Titian, Greco, Goya, and van Gogh. Or, looking at quite a different side, take the old magicians. Hieronymus Bosch, Rembrandt, and as a fantastic blossom from dry old England, William Blake, and you have quite a nice group of friends who can accompany you on your thorny way, the way of escape from human passion into the fantasy palace of art.

Don't forget nature, through which Cézanne, as he said, wanted to achieve the classical. Take long walks and take them often, and try your utmost to avoid the stultifying motor car which robs you of your vision, just as the movies do, or the numerous motley newspapers. Learn the forms of nature by heart so you can use them like the musical notes of a composition. That's what these forms are for. Nature is a wonderful chaos to be put into order and completed. Let others wander about, entangled and color blind, in old

geometry books or in problems of higher mathematics. We will enjoy ourselves with the forms that are given us: a human face, a hand, the breast of a woman or the body of a man, a glad or sorrowful expression, the infinite seas, the wild rocks, the melancholy language of the black trees in the snow, the wild strength of spring flowers and the heavy lethargy of a hot summer day when Pan, our old friend, sleeps and the ghosts of midday whisper. This alone is enough to make us forget the grief of the world, or to give it form. In any case, the will to form carries in itself one part of the salvation for which you are seeking. The way is hard and the goal is unattainable; but it is a way.

Nothing is further from my mind than to suggest to you that you thoughtlessly imitate nature. The impression nature makes upon you in its every form must always become an expression of your own joy or grief, and consequently in your formation of it, it must contain that transformation which only then makes art a real abstraction.

But don't overstep the mark. Just as soon as you fail to be careful you get tired, and though you still want to create, you will slip off either into thoughtless imitation of nature, or into sterile abstractions which will hardly reach the level of decent decorative art.

Enough for today, my dear friend. I think much of you and your work and from my heart wish you power and strength to find and follow the good way. It is very hard with its pitfalls left and right. I know that. We are all tightrope walkers. With them it is the same as with artists, and so with all mankind. As the Chinese philosopher Laotse says, we have "the desire to achieve balance, and to *keep* it."

1884 Feb. 12. Max Beckmann is born in Leipzig, the youngest of three children of a well-to-do flour merchant.

1894 After his father's death, the family returns to Braunschweig where it originated.

1900 Enrolls at academy in Weimar; studies with Frithjof Smith.

1903 First trip to Paris and move to Berlin.

1906 First exhibitions: Secession in Berlin, Künstlerbund, Weimar. Marriage to Minna Tube, who had been a fellow art student in Weimar. Death of his mother.
Receives Villa-Romana Prize for study in Florence; settles in Hermsdorf, near Berlin.

1907 Two-man show: Max Beckmann and Georges Minne at Kunstgewerbemuseum, Weimar.

1908 Birth of his only child, Peter Beckmann.

1910 Elected to the Board of Berlin Secession, but resigns the following year.

1913 Hans Kaiser publishes the first monograph on Beckmann. One-man show at Galerie Paul Cassirer, Berlin.

1914 Joins medical corps of German army; serves in East Prussia and Flanders.

1915 Discharged from the army for reasons of health. Settles in Frankfurt a. Main.

1917 Exhibition of graphic work at J. B. Neumann's Graphisches Kabinett, Berlin.

1922 One-man show at Zingler's Kabinett, Frankfurt. Participates in XIII Venice Biennale.

1924 R. Piper in Munich publishes the Beckmann monograph, with contributions by Curt Glaser, Julius Meier-Graefe, Wilhelm Fraenger and Wilhelm Hausenstein.

1925 Divorce from Minna; marriage to Mathilde von Kaulbach. One-man show at Paul Cassirer's in Berlin. Work featured at exhibition, *Die Neue Sachlichkeit*, Mannheim.
Appointed professor at Städelsche Kunstinstitut, Frankfurt.

1926 First Beckmann exhibition in the United States at J. B. Neumann's New Art Circle, New York.

1927 Second exhibition at New Art Circle, New York.

1928 Large retrospective exhibition at Kunsthalle, Mannheim. Exhibitions also at Galerie Flechtheim, Berlin; Günther Franke, Munich.

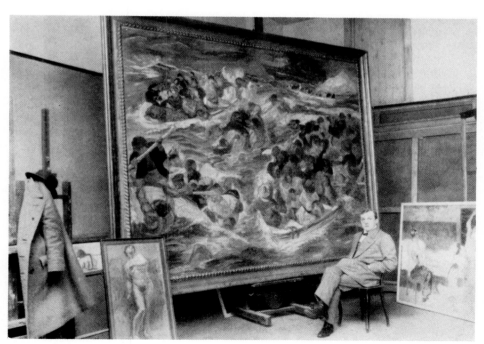

Berlin, 1912

1929 Honorable Mention, Carnegie International, Pittsburgh.

1929–1932 The Beckmanns spend their winters in Paris.

1930 Large retrospective exhibition, Kunsthalle, Basel and Kunsthalle, Zurich. Participates in XVII Venice Biennale.

1931 First Beckmann exhibition in Paris at Galerie de la Renaissance. Exhibitions also at Galerie Le Centaure, Brussels; Kestner Gesellschaft, Hanover. Included in Museum of Modern Art's *German Painting and Sculpture*.

1933 Nazis come to power and Beckmann is discharged from his teaching position in Frankfurt. Moves to Berlin.

1937 Work included in the Nazi "Degenerate Art" exhibition. Beckmann emigrates from Germany and settles in Amsterdam.

1938 First of ten exhibitions at Curt Valentin's Buchholz Gallery, New York (see Bibl. 238).
Beckmann delivers his lecture "On My Painting" at the New Burlington Gallery, London in connection with the exhibition of twentieth-century German art held in protest against Nazi art policy.

1938–39 Winter in Paris.

1939 Awarded First Prize of $1,000 in Contemporary European Section at the Golden Gate International Exposition in San Francisco.

1940–47 Despite the great difficulties of the war years in Amsterdam, this was a highly prolific period for Max Beckmann.

1947 Trip to Paris and the South of France. In the summer he leaves Europe to settle in the United States. Accepts invitation to teach at School of Fine Arts, Washington University, St. Louis.

1948 First Beckmann retrospective in the United States at the City Art Museum of St. Louis. The exhibition traveled to the Los Angeles County Museum, The Detroit Institute of Arts, The Baltimore Museum of Art and The Minneapolis Institute of Arts.
During the summer the Beckmanns return to Holland for a visit. Lecture "Letters to a Woman Painter" delivered at Stephens College, Columbia, Mo. (repeated subsequently in Boston, St. Louis, Boulder, Colorado and Oakland, California).

1949 Teaches summer school at University of Colorado, Boulder. Appointed to teach advanced painting classes at Brooklyn Museum Art School.
First Prize, Carnegie Institute, Pittsburgh, *Painting in the United States, 1949*.
Settles in New York.

1950 Awarded Honorary Doctorate at Washington University, St. Louis. Teaches summer school at Mills College, Oakland, California. One-man show at German Pavilion XXV Biennale, Venice. Awarded prize of L. 250,000.
Dec. 27. Max Beckmann dies after completion of the triptych *The Argonauts*.

1951 Memorial Exhibition, Haus der Kunst, Munich.

1953 Founding of Beckmann Society, Munich.

For the ever-growing interest in Beckmann's works see the listing of exhibition catalogues and publications on the artist in the Bibliography.

Laren, Holland, 1947

BIBLIOGRAPHY by Inga Forslund

WRITINGS, STATEMENTS, AND SPEECHES
BY BECKMANN (arranged chronologically)

1. Im Kampf um die Kunst. (Die Antwort auf den "Protest deutscher Künstler.") Mit einem Beitrag Beckmanns. München, Piper, 1911.

2. Gedanken über zeitgemässe und unzeitgemässe Kunst. *Pan* (Berlin) 2: 499–502 Mar. 1912.

3. Das neue Programm. *Kunst und Künstler* 12: 301 incl. 1 ill. 1914.

4. Feldpostbriefe aus dem Westen. [Mit Zeichnungen.] Zusammengestellt von Frau Beckmann-Tube. *Kunst und Künstler* 13: 461–467 incl. ill. 1915.

5. Briefe im Kriege. Gesammelt von Minna Tube. Berlin, Cassirer, 1916. 75 p. incl. 17 ill.
 2 Aufl. München, Langen-Müller, 1955. 76 p. incl. 22 ill. Nachwort von Peter Beckmann.
 Reviewed in *Werk* 43: sup. 92*, May 1956. Excerpts see bibl. 247, 259, 276.

6. [Foreword]. *In* Neumann, J. B., Graphisches Kabinett, Berlin. Max Beckmann: Graphik, 1917. (Bibl. 223.)

7. Schöpferische Konfession. Herausgegeben von Kasimir Edschmid. 2. Aufl. Berlin, Reiss, 1920. p. 61–67. (Tribüne der Kunst und Zeit. 13.)
 Also published as "Ein Bekenntnis" in *Der Kreis* 10: 80–82 Feb. 1933.
 Written at the end of the first World War.

8. Ebbi. Komödie. Wien, Johannes-Presse, 1924. See also bibl. 302.

9. [Foreword]. *In* Mannheim. Städtische Kunsthalle. Max Beckmann: das gesammelte Werk. 1928. (Bibl. 226.)

10. On my painting. N.Y., Buchholz Gallery, Curt Valentin, c1941. 13 p.
 English translation of lecture entitled "Meine Theorie der Malerei," given at the New Burlington Galleries, London, July 21, 1938.—Reprinted in *Centaur* v. 1, no. 6: 287–292 Mar. 1946; in German, in *Werk* 36: 92–95, Mar. 1949, in *Thema* no. 7: 8–12, Jan. 1950 and in bibl. 34, 276.—Excerpts in Artists on art, ed. by Robert Goldwater and Marco Treves, N.Y., Pantheon, c1945, p. 447–448 and in bibl. 248, 250, 275, 286.

11. [Speech to Beckmann's first class in the United States given at Washington University St. Louis., Mo., 1947]. 3 p.
 Typescript in the Museum of Modern Art Library.

12. Letters to a woman painter. *College Art Journal* 9: 39–43 Autumn 1949.
 Translation by Mrs. Max Beckmann and Perry T. Rathbone of lecture written in German but read by Mrs. Beckmann in English at Stephens College, Columbia, Mo., Feb. 3, 1948.—

Published in German "Drei Briefe an eine Malerin" in Benno Reifenberg, Max Beckmann. München, Piper, 1949, p. 43–46 (bibl. 34). Excerpts reprinted in bibl. 253, 255, 286.

13. Ansprache für die Freunde und die philosophische Fakultät der Washington University, St. Louis, 1950. *In* In memoriam: Max Beckmann, Frankfurt am Main, Lohse, 1953, p. 51–60 (bibl. 25). English translation in bibl. 269, 286.—Excerpts in bibl. 48.

14. Aus Briefen Max Beckmanns. Herausgegeben von Stephan Lackner. *Kunstwerk* 10, no. 1/2: 4–6 plus 4 pl. 1956/57.
 Excerpts of letters from Beckmann to Lackner, written from 1938 to 1950.

15. Tagebücher 1940–1950. Zusammengestellt von Mathilde Q. Beckmann. Herausgegeben von Erhard Göpel. München, Langen-Müller, 1955. [430] p. incl. ill., facs., port.
 Reviewed in *College Art Journal* 15: 283–284 Spring 1956 and in *Werk* 43: sup. 91* May 1956. Excerpts from his diary see bibl. 269.

MONOGRAPHS

16. BECKMANN, PETER. Max Beckmann. Nürnberg, Glock & Lutz, 1955. (Nürnberger Liebhaberausgaben. 4.)
 Based on the article "Das Fenster bleibt offen" in *Die Besinnung* (Nürnberg) 6: 149–158 May/June 1951. (Bibl. 92.)

17. BLICK AUF BECKMANN. Dokumente und Vorträge. [Herausgegeben von Hans Martin Frhr. von Erffa und Erhard Göpel.] München, Piper, c1962. 298 p. incl. 130 ill. and 3 mount. col. pl. (Schriften der Max Beckmann Gesellschaft. 2.)
 A collection of articles and essays about Beckmann by various authors.—Includes explanatory notes for text and illustrations and "Beckmanndaten nach 1950."

18. BUCHHEIM, LOTHAR-GÜNTHER. Max Beckmann. Feldafing, Buchheim, c1959. 216 p. incl. ill. (pt. col. mount., 1 fold.), port. Bibliography p. 210–211.

19. BUCHHEIM, LOTHAR-GÜNTHER. Max Beckmann. Holzschnitte, Radierungen, Lithographien. Mit einer Einleitung von Lothar-Günther Buchheim. Feldafing, Buchheim c1954. 14 p. incl. 5 ill. plus 41 ill. (Buchheim Bücher. Series A.)
 Cover title: Welt des Einzelnen. Max Beckmann.

20. BUSCH, GÜNTER. Max Beckmann. Eine Einführung. München, Piper, c1960. 131 p. incl. 71 ill., 10 col. mount. pl. (1 fold.), facs. Bibliography p. 129–131.

21. GÖPEL, ERHARD. Max Beckmann, der Maler. Auswahl und Einführung von Erhard Göpel. München, Piper, c1957. 63 p. incl. 46 ill.

22. GÖPEL, ERHARD. Max Beckmann, der Zeichner. Auswahl und Einführung von Erhard Göpel. München, Piper, c1954. 15 p. plus 43 ill. (Piper-Bücherei. 74.)

Reviewed by Alfred Werner in *College Art Journal* v. 15, no. 3 : 283–284 Spring 1956.

23. GÖPEL, ERHARD. Max Beckmann: Die Argonauten. Ein Triptychon. Einführung von Erhard Göpel. Stuttgart, Reclam, 1957. 32 p. incl. 15 ill., facs. (Werkmonographien zur bildenden Kunst in Reclams Universal-Bibliothek. 13.)

24. GÖPEL, ERHARD. Max Beckmann in seinen späten Jahren. München, Langen-Müller, 1955. [69] p. (Langen-Müllers kleine Geschenkbücher. 40.)

 HAUSENSTEIN, WILHELM. See bibl. 34.

25. IN MEMORIAM: MAX BECKMANN 12.2.1884–27.12.1950. [Frankfurt am Main, Lohse, 1953.] 60 p. port.

 400 numbered copies. First publication of the Max Beckmann Gesellschaft. Includes tributes by Perry T. Rathbone, Erhard Göpel, Peter Beckmann, Benno Reifenberg, Georg Meistermann, Theo Garve and excerpts from the writings of the artist ("Briefe und Aufzeichnungen" and "Ansprache für die Freunde und die philosophische Fakultät der Washington University, St. Louis, 1950.")

 Text in German.

26. KAISER, HANS. Max Beckmann. Berlin, Cassirer, 1913. [69] p. incl. ill. plus pl. (Künstler unserer Zeit. 1.)

 Includes catalogue of Beckmann's works.

27. KAISER, STEPHAN. Max Beckmann. Stuttgart, Fink, c1962. 135 p. incl. ill. (pt. mount. col. pl.). (Fink-Reihe. Maler: ihre Werke und ihre Zeit. 7/8.)

 Bibliography p. 135.

28. KRIEGER, HEINZ-BRUNO. Die Ahnen des Malers Max Beckmann. Göttingen, Heinz Reise, 1959. 20 p. (Veröffentlichung der Familienkundlichen Kommission für Niedersachsen und Bremen sowie angrenzende ostfälische Gebiete E. V.)

29. LACKNER, STEPHAN. Max Beckmann 1884–1950. Berlin, Safari, 1962. [24] p. incl. 10 mount. col. pl. (Safari Kunstreihe.)

 Commentaries to each plate.

29a. LACKNER, STEPHAN. Max Beckmann. Alhambra, California, Cunningham Press, 1964.

 In preparation.

30. MAX BECKMANN. Von Curt Glaser, Julius Meier-Graefe, Wilhelm Fraenger und Wilhelm Hausenstein. Mit einer Radierung. München, Piper 1924. 87 p. incl. 16 ill. plus 52 pl.

 Includes catalogue of Beckmann's works. A de luxe edition includes an additional etching, a lithograph and a woodcut.

31. MAX BECKMANN. n. p. n. d.

 Collection of mimeographed texts by various critics. Contents: Max Beckmann by Edmond Jaloux. 3 p. (In French.) – Max Beckmann's mystical pageant of the world by Stephan Lackner. 3 p. (German version in bibl. 155). – Max Beckmann's latest by Helen Appleton Read. 2 p. (See also bibl.

179) – Max Beckmann by Heinrich Simon. 2 p. (Excerpts from bibl. 37).

32. NEUMANN, J. B., ed. Max Beckmann. Edited and published by J. B. Neumann and G. Franke. N.Y. and München, [1931]. 47 p. (mostly ill.). (The Artlover Library. 5.)

 Issued in connection with exhibition held at J. B. Neumann, New Art Circle, New York.

33. NEW YORK. MUSEUM OF MODERN ART. LIBRARY. [Album of photographs of Beckmann's work from 1903 to 1950.] Unpublished. 3 volumes. – Gift of Curt Valentin Gallery, deposited in the Photo Archives of the Library.

34. REIFENBERG, BENNO. Max Beckmann. Von Benno Reifenberg und Wilhelm Hausenstein. München, Piper, 1949. 82 p. incl. 8 ill. plus 81 ill. and 5 col. pl.

 Contents: Werke und Leben, by Benno Reifenberg. – Der Maler in dieser Zeit, by Wilhelm Hausenstein. – Drei Briefe an eine Malerin, by Max Beckmann. – Meine Theorie der Malerei, by Max Beckmann. – Includes incomplete catalogue of Beckmann's paintings up to 1949. p. 62–82.

 Also published in a numbered edition of 100 copies with two original lithographs, signed by the artist.

 Reviewed by Bernard Myers in *College Art Journal* v. 10, no. 1 : 85–87 1950.

35. ROH, FRANZ. Max Beckmann als Maler. München, Desch, c1946. 4 p. plus 7 col. pl. (Kunst des XX. Jahrhunderts.)

36. SCHÖNE, WOLFGANG. Max Beckmann. Berlin, Deutscher Kunstverlag, 1947. 16 p., col. ill. (Künstler unserer Zeit.)

37. SIMON, HEINRICH. Max Beckmann. Berlin & Leipzig, Klinckhardt & Biermann, 1930. 20 p. plus 32 ill. and col. front. (Junge Kunst. 56.)

 Bibliography p. 20. – Excerpts in bibl. 31.

GENERAL WORKS

38. BARR, ALFRED H., JR., ed. Masters of modern art. N.Y., Museum of Modern Art, 1954. p. 62–63 incl. ill.

39. BRION, MARCEL. German painting. N.Y., Universe Books, c1959. p. 138 and passim, 1 col. ill.

 Translation of the French edition, Paris, Tisné, 1959.

40. BUCHHEIM, LOTHAR-GÜNTHER. The graphic art of German expressionism. N.Y., Universe Books, c1960. p. 55–56 and passim, ill.

 Translation of the German edition "Graphik des deutschen Expressionismus," Feldafing, Buchheim, 1959.

41. CANADAY, JOHN. Mainstreams of modern art. N.Y., Holt, 1959. p. 436–439 incl. 1 ill.

42. DICTIONARY OF MODERN PAINTING. Published under the direction of Fernand Hazan. General editors: Carlton Lake and

Robert Maillard. N.Y., Paris Book Center, [1955?]. p. 21–22 incl. 1 ill.

Translation of the French edition "Dictionnaire de la peinture moderne," Paris, Hazan, 1954. — Also published in German as "Knaurs Lexikon Moderner Kunst," München, 1955. — Completely revised French edtion, 1963, under the title: "Nouveau dictionnaire de la peinture moderne."

43. DRESSLER, ADOLF. Deutsche Kunst und entartete Kunst. München, Deutscher Volksverlag, 1938. p. 56, ill.

44. EINSTEIN, CARL. Die Kunst des 20. Jahrhunderts. 3. Aufl. Berlin, Propyläen, c1931. p. 181–184 and passim, ill.

45. GEROLD, KARL GUSTAV. Deutsche Malerei unserer Zeit. Wien, München, Basel, Desch, c1956. p. 108–112 and passim, 3 ill. (1 col.)

46. GROHMANN, WILL. Bildende Kunst und Architektur. Berlin, Suhrkamp, 1953. p. 66–70 and passim, ill. pl. 9 (Zwischen den beiden Kriegen. 3.)

47. DIE GROSSEN DEUTSCHEN. Deutsche Biographie. Herausgegeben von Hermann Heimpel, Theodor Heuss, Benno Reifenberg. 2 Aufl. Bd. 4. Berlin, Propyläen, c1957.

p. 534–547: Max Beckmann 1884–1950 von Erhard Göpel. (incl. 5 ill., 1 col.)

48. GROTE, LUDWIG. Deutsche Kunst im zwanzigsten Jahrhundert. München, Prestel, 1953. p. 50–52 plus 4 pl.

Includes excerpts from "Ansprache für die Freunde und die philosophische Fakultät der Washington University, St. Louis, 1950," (Bibl. 13.)

49. HAFTMANN, WERNER. Painting in the twentieth century. N.Y., Praeger, 1960. v. 1 (text) p. 224–228 and passim; v. 2 (ill.) p. 285, 296–300, 302–305.

A completely revised version of the German edition, published in 1954–1955 and 1957 by Prestel, München.

50. HAMANN, RICHARD. Die deutsche Malerei vom 18. bis zum Beginn des 20. Jahrhunderts. Leipzig & Berlin, Teubner, 1925. p. 455–456.

51. HÄNDLER, GERHARD. German painting in our time. Berlin, Rembrandt, c1956. p. 16–17, pl. 33–38 (1 col.)

Translation of the German edition, 1956.

52. HARTLAUB, G[USTAV] F[RIEDRICH]. Die Graphik des Expressionismus in Deutschland. Stuttgart & Calw, Hatje, 1947. p. 44–45 and passim, 4 ill.

53. HARTLAUB, G[USTAV] F[RIEDRICH]. Kunst und Religion. Leipzig, Kurt Wolff, 1919. p. 83–85 and passim, ill. pl. 37–39.

54. HARTLAUB, G[USTAV] F[RIEDRICH]. Die neue deutsche Graphik. 2. Aufl. Berlin, Reiss, 1920. p. 78–82. (Tribüne der Kunst und Zeit. 14.)

55. HAUSENSTEIN, WILHELM. Die bildende Kunst der Gegenwart. 2. Aufl. Stuttgart & Berlin, Deutsche Verlags-Anstalt, 1920. p. 297–299 and passim.

1st edition published 1914.

56. HAUSENSTEIN, WILHELM. Meister und Werke. München, Knorr & Hirth, 1930. p. 257–261.

57. HUYGHE, RENÉ, ed. Histoire de l'art contemporain. La peinture. Paris, Alcan, 1935.

p. 441–446: La peinture de l'Allemagne inquiète par Fritz Schiff. (Beckmann, p. 442–443, 446, 2 ill.)

58. JANSON, H[ORST] W[ALDEMAR]. History of art. N.Y., Abrams, [1962]. p. 519 incl. 1 ill. plus 1 col. pl.

59. JOEL, HANS THEODOR, ed. Das graphische Jahrbuch. Darmstadt, Karl Lang, [1919].

p. 22–27: Max Beckmann von Julius Meier-Graefe.

60. JOLLOS, WALDEMAR. Arte tedesca fra le due guerre... Verona, Mondadori, 1955. p. 119–122 and passim.

61. JUSTI, LUDWIG. Von Corinth bis Klee. Berlin, Bard, c1931. p. 144–146 plus 2 ill.

62. KUHN, CHARLES L. German expressionism and abstract art: the Harvard collections. Cambridge, Mass., Harvard University Press, 1957. passim. (index p. 149), ill.

63. KÜNSTLERISCHE UND KULTURELLE MANIFESTATIONEN. Ulm, Hermelin, [1924?].

Cover title: Situation. 1924.

p. 9–14: Über Max Beckmanns Graphik (An Benno Reifenberg) by Wilhelm Hausenstein.

64. LANDAU, ROM. Der unbestechliche Minos. Hamburg, Harder, 1925. p. 61–62 plus 1 col. pl.

65. LEHMANN-HAUPT, HELLMUT. Art under a dictatorship. N.Y., Oxford University Press, 1954. p. 24, 64, 78, 81.

66. MEIER-GRAEFE, JULIUS. Entwicklungsgeschichte der modernen Kunst. 2. Aufl. München, Piper, c1915. v. 3, p. 676–678 and passim, 2 ill.

An edition of this volume appeared in 1927 under the title: "Die Kunst unserer Tage."

67. MYERS, BERNARD. 50 great artists. N.Y., Bantam Books, c1953. p. 223–228.

68. MYERS, BERNARD. The German expressionists. A generation in revolt. N.Y., Praeger, c1957. p. 294–307 and passim. ill.

Includes bibliography.

69. NEMITZ, FRITZ. Deutsche Malerei der Gegenwart. München, Piper, c1948. p. 48–55 incl. ill. plus 1 col. pl.

70. NEW YORK. MUSEUM OF MODERN ART. German art of the twentieth century. By Werner Haftmann, Alfred Hentzen, William S. Liebermann. Ed. by Andrew Carnduff Ritchie. N.Y., The Museum, 1957. p. 96, 99–100, 204–205 and passim, ill.

71. PFISTER, KURT. Deutsche Graphiker der Gegenwart. Leipzig, Klinkhardt & Biermann, 1920. p. 22–23 and passim. pl. 30 (original lithograph "Pierrot und Maske").

72. PLATTE, HANS. Malerei. München, Piper, c1957. p. 226–232 incl. 4 ill. (Die Kunst des 20. Jahrhunderts. Hrsg. von Carl Georg Heise.)

73. POMMERANZ-LIEDTKE, GERHARD. Der graphische Zyklus von Max Klinger bis zur Gegenwart. Berlin, Deutsche Akademie der Künste, 1956. p. xx, ill. pl. 46–49.

74. RAYNAL, MAURICE. Modern painting. Geneva, Skira, c1953. p. 261, 263 and passim. 1 col. pl.
> Also other language editions and revisions.

75. ROETHEL, HANS KONRAD. Modern German painting. N.Y. Reynal, [1957?]. p. 64–66 incl. 3 col. ill.
> Translation of the German edition, Wiesbaden, Vollmer, 1957?

76. ROH, FRANZ. "Entartete" Kunst. Kunstbarbarei im Dritten Reich. Hannover, Fackelträger, 1962.
> p. 115–116: Das Elend der äusseren und inneren Emigration. Max Beckmann als Emigrierter.

77. ROH, FRANZ. Geschichte der deutschen Kunst von 1900 bis zur Gegenwart. München, Bruckmann, c1958. p. 160–163 incl. 3 ill. plus 1 col. pl. (Deutsche Kunstgeschichte. 6.)

78. ROMDAHL, AXEL L. Det moderna måleriet och dess förutsättningar. Stockholm, Natur och Kultur, 1926. p. 101 plus 1 ill. (Natur och Kultur. 56.)

79. SCHEFFLER, KARL. Geschichte der europäischen Malerei . . Berlin, Cassirer, 1927, p. 137–138, 218–219. (Die europäische Kunst im neunzehnten Jahrhundert. 2.)

80. SCHMIDT, PAUL FERDINAND. Geschichte der modernen Malerei. Stuttgart, Kohlhammer, c1952. p. 191–196 and passim, 2 ill. (1 col. pl.)
> Frequently revised.

81. SELZ, PETER. German expressionist painting. Berkeley and Los Angeles, University of California Press, 1957. p. 284–287 and passim. 10 pl.
> Includes bibliography.

82. SOBY, JAMES THRALL. Contemporary painters. N.Y., Museum of Modern Art, 1948. p. 85–91 incl. ill.

83. VOLLMER, HANS, ed. Allgemeines Lexikon der bildenden Künstler des XX. Jahrhunderts. Leipzig, Seemann, 1953. Bd. 1, p. 150–151.

84. WALDMANN, ÉMILE. La peinture allemande contemporaine. Paris, Crès, 1930. p. 60–62 plus 3 ill.

85. WEDDERKOP, H. VON, ed. Deutsche Graphik des Westens. Weimar, Feuer, 1922.
> p. 42–43: Max Beckmann von Kasimir Edschmid.

86. WESTHEIM, PAUL. Für und wider. Kritische Anmerkungen zur Kunst der Gegenwart. Potsdam, Kiepenheuer, c1923.
> p. 98–104: Beckmann: "Der wahre Expressionismus."

87. ZIGROSSER, CARL. The expressionists. A survey of their graphic art. N.Y., Braziller, 1957. p. 26, ill. nos. 111–117.

ARTICLES ON BECKMANN

88. AMYX, CLIFFORD. Max Beckmann: the iconography of the triptychs. *Kenyon Review* 13:613–623 1951.

89. ASHTON, DORE. Beckmann in prints. *Art Digest* 26:16 incl. 1 ill. Oct. 1, 1951.
> On the occasion of the exhibition of prints by Beckmann at the Museum of Modern Art, New York, Sep. 18–Oct. 24, 1951. (No catalogue published.)

90. ASHTON, DORE. New York commentary. *Studio* 163:154–155 incl. 1 ill. Apr. 1962.
> Review of exhibition at Catherine Viviano Gallery.

BARR, ALFRED H., JR. See bibl. 235.

91. BASLER, ADOLPHE. Deutsche und Schweizer in Paris. *Kunst und Künstler* 29:360–361, June 1931.
> Review of exhibition at Galerie de la Renaissance in Paris.

BECKMANN, MATHILDE Q. Zu dem Triptychon "Argonauten" von Max Beckmann. See bibl. 268.

92. BECKMANN, PETER. Das Fenster bleibt offen. Kurzbiographie eines Malers. *Die Besinnung* (Nürnberg) 6:149–158 incl. ill. plus 1 pl. May/June 1951. See also bibl. 16.

93. BECKMANN, PETER. Der frühe Beckmann. 1956. *In* Blick auf Beckmann (bibl. 17) p. 95–100 plus ill.
> Speech at the Beckmann exhibition in Würzburg, March 1956.

94. BECKMANN, PETER. Max Beckmann und seine Freunde. *Gesellschaft* no. 3:16–18 incl. ill. 1962.

BECKMANN, PETER. Das Schwert des Perseus. See bibl 266, 267.

95. BECKMANN, PETER. Verlust des Himmels. 1961. *In* Blick auf Beckmann (bibl. 17) p. 23–24 plus 4 pl.
> On *Die Auferstehung*, 1917.

BECKMANN, PETER.
> See also bibl. 25, 283, 287.

96. BEUTLER, ERNST. Beckmanns Illustrationen zum Faust. 1956. *In* Blick auf Beckmann (bibl. 17) p. 155–173 plus ill.
> Lecture given at the Max Beckmann Gesellschaft in Munich, July 7, 1956.

BIER, JUSTUS. See bibl. 234.

97. B[REESKIN], A[DELYN] D. Max Beckmann. *Baltimore Museum of Art News* v. 12, no. 2: 1–3 incl. ill. Nov. 1948.

98. BURROWS, CARLYLE. Beckmann oils, graphics show commanding styles. *New York Herald Tribune* Oct. 23, 1949.
> Review of exhibitions at Buchholz Gallery and at Brooklyn Museum.

99. BUSCH, GÜNTHER. Bei Schiffbruch weiter auf dem Floss. Am 12. Februar 1884 wurde Max Beckmann geboren. *Feuilleton* Febr. 12, 1964: 8 incl. 1 ill.

100. BUSCH, GÜNTHER. Max Beckmann. Vortrag – Gemeentemuseum

den Haag, April 1956. *The Hague. Gemeentemuseum. Mededelingen.* v. 11, no. 3: 3–20 incl. 17 ill. 1956.

BUSCH, GÜNTHER. See also bibl. 267, 278.

101. CHETHAM, CHARLES. The Actors, by Max Beckmann. *Harvard University. Fogg Art Museum. Annual Report.* 1955–56, p. 54–55, 62–64, 1 ill.

CLAUS, JÜRGEN. See bibl. 288.

102. CLURMAN, HAROLD. Max Beckmann. *Tomorrow* 7: 52 Mar. 1948.

103. DORR, GOLDTHWAITE HIGGINSON, III. The Putnam Dana McMillan collection. *Minneapolis Institute of Arts Bulletin* v. 50, no. 4: 20 plus 1 pl. Dec. 1961.

On Beckmann's painting *The Skaters.*

104. DÜRR, ERICH. Max-Beckmann-Ausstellung in Mannheim. *Der Cicerone* 20: 240–241 April 1928.

105. ECKSTEIN, HANS. Der Maler Max Beckmann. *Das Kunstwerk* v. 1, no. 2: 18–21 incl. 3 ill. 1946.

106. ECKSTEIN, HANS. Max Beckmann. *Der Kreis* 8: 328–332 plus 2 ill. June 1931.

107. ECKSTEIN, HANS. Zur Münchner Beckmann-Gedächtnis-Ausstellung. *Das Kunstwerk* v. 5, no. 3: 73, 1951.

EDSCHMID, KASIMIR. Max Beckmann. See bibl. 85.

108. FEINSTEIN, SAM. Beckmann's passionate hardness. *Art Digest* v. 28, no. 9: 14, 30 Feb. 1, 1954.

Occasioned by exhibition, Curt Valentin Gallery.

109. FISCHER, OTTO. Die neueren Werke Max Beckmanns. *Museum der Gegenwart* 1: 89–100 incl. 5 ill. 1930.

110. FISCHER, OTTO. Radierungen und Holzschnitte von Max Beckmann. *Die Graphischen Künste* 55: 37–44 incl. 8 ill. 1932.

111. FRAENGER, WILHELM. Max Beckmann: Der Traum. Ein Beitrag zur Physiognomik des Grotesken. 1924. *In* Max Beckmann (bibl. 30) p. 35–58 incl. ill. and *In* Blick auf Beckmann (bibl. 17) p. 36–49 plus ill.

FRANKE, GÜNTHER. See bibl. 231, 283.

112. FROMMEL, WOLFGANG. Max Beckmann. Die Argonauten. Aus einem Brief. *Castrum peregrini* 33: 29–44 incl. 1 ill. 1957/58.

GALLWITZ, KLAUS. See bibl. 287, 290.

GARVE, THEO. See bibl. 25.

113. GENAUER, EMILY. Triple enigma. Max Beckmann's seven-foot triptych "Departure" holds many meanings for viewers at the Museum of Modern Art. *This Week* Aug. 16, 1953: 12 incl. col. ill.

114. GEORGE, WALDEMAR. Beckmann, the European. *Formes* no. 13: 50 plus 2 ill. Mar. 1931.

115. GEORGE, WALDEMAR. Kokoschka and Max Beckmann. *Creative Art* 8: 459 June 1931.

Occasioned by exhibition, Galerie de la Renaissance, Paris.

GEORGE, WALDEMAR. See also bibl. 236.

116. GLASER, CURT. Berliner Ausstellungen: [Beckmann]. *Kunst für Alle* 28: 264, 1913.

Occasioned by exhibition, Galerie Paul Cassirer, Berlin.

117. GLASER, CURT. Max Beckmann. *In* Max Beckmann (bibl. 30) p. 1–26 incl. ill.

Extract of this article published in *Kunst und Künstler* 21: 311–314 incl. 3 ill. 1923.

118. GLASER, CURT. Max Beckmann. Ausstellung in der Galerie A. Flechtheim, Berlin. *Kunst und Künstler* 27: 223–226 incl. 4 ill. Mar. 1929.

119. GLASSGOLD, C. ADOLPH. Max Beckmann. *Arts* (New York) 11: 241–247 incl. ill. May 1927.

120. GOERGEN, ALOYS. Beckmann und die Apokalypse. Versuch einer theologischen Deutung. 1955. *In* Blick auf Beckmann (bibl. 17) p. 9–21 plus ill.

Lecture at the Max Beckmann Gesellschaft in Munich, Oct. 22, 1955.

121. GÖPEL, ERHARD. Beckmann und Wilhelm R. Valentiner. 1962. *In* Blick auf Beckmann (bibl. 17) p. 90–94.

122. GÖPEL, ERHARD. Beckmanns Farbe. 1956. *In* Blick auf Beckmann (bibl. 17) p. 133–138.

Excerpts from the opening speech at the Beckmann exhibition in Basel. A more complete version printed in the catalogue of the exhibition (bibl. 277).

123. GÖPEL, ERHARD. Der Maler mit der Laterne des Diogenes. Die Ausstellung "Max Beckmann — Das Porträt" in Karlsruhe. *Frankfurter Allgemeine Zeitung* no. 203: 18 incl. 1 ill. Sep. 3, 1963.

124. GÖPEL, ERHARD. Zeichnungen und Aquarelle von Max Beckmann. Ausstellung in der Graphischen Sammlung, München. *Kunstchronik* v. 7 no. 4: 91–93 Apr. 1954.

125. GÖPEL, ERHARD. Zirkusmotive und ihre Verwandlung im Werke Max Beckmanns. Anlässlich der Erwerbung des "Apachentanzes" durch die Bremer Kunsthalle. *Die Kunst und das schöne Heim* 56: 328–331 incl. ill. (1 col.) June 1958.

GÖPEL, ERHARD. See also bibl. 25, 47, 259, 271, 276, 277, 280.

126. GREENBERG, CLEMENT. [Max Beckmann.] *The Nation* 162: 610–611 May 18, 1946.

Review of exhibition, Buchholz Gallery, New York.

127. GROHMANN, WILL. L'Art contemporain en Allemagne. *Cahiers d'art* 13: 5–12 plus 16 p. of ill. 1938.

Beckmann p. 7, 11, ill. p. 14.

128. GROSSMANN, RUDOLF. Begegnung mit Max Beckmann. *Kunst und Künstler* 26: 361–362 incl. 3 ill. June 1928.

Occasioned by exhibition, Galerie Flechtheim, Berlin.

GROTE, LUDWIG. See bibl. 259.

HAFTMANN, WERNER. See bibl. 274.

129. HARTLAUB, G[USTAV] F[RIEDRICH]. Chronique d'Allemagne. Max

Beckmann. *Chroniques du jour* no. 5: 21–23, 4 ill. Mar. 1930.

HARTLAUB, G[USTAV] F[RIEDRICH]. See also bibl. 226.

130. HAUSENSTEIN, WILHELM. Max Beckmann. *In* Max Beckmann (bibl. 30) p. 59–73 incl. ill.

131. HAUSENSTEIN, WILHELM. Max Beckmann. *Der Querschnitt* 8: 859–860 incl. 1 ill. Dec. 1928.

Reprinted from bibl. 228. More complete version published in bibl. 56.

132. HAUSENSTEIN, WILHELM. Max Beckmann. *Die Kunst für alle* v. 59: 157–165 incl. 10 ill. Feb. 1929.

133. HAUSENSTEIN, WILHELM. Max Beckmann. *Werk* 34: 161–168 incl. 5 ill. May 1947.

Speech at the opening of the Beckmann exhibition at Galerie Günther Franke, Munich, June 21, 1946. — Also in *Die Gegenwart* v. 1, no. 14/15: 30–33.

HAUSENSTEIN, WILHELM. Über Max Beckmanns Graphik. See bibl. 63.

134. HEILBRUNN, RUDOLF M. Erinnerung an Max Beckmann. *Das Kunstwerk* v. 5, no. 3: 57–59 incl. ill. 1951.

135. HEILBUT, EMIL. Die Ausstellung der Berliner Sezession. *Zeitschrift für bildende Kunst* n. s. 18: 256–259, 1907.

Beckmann mentioned p. 259.

HENTZEN, ALFRED. See bibl. 253, 268.

136. HOLST, NIELS VON. Deutsche Maler sehen Paris. *Die Kunst und das schöne Heim* 52: 415–417 July 1954.

Beckmann p. 417 incl. 1 ill.

HOLZINGER, ERNST. See bibl. 287.

137. Hommage to Max Beckmann. *Arts Yearbook* no. 4, 1961: 117–140 incl. ill. plus 8 col. pl.

Contents: Memoirs of a friendship by Stephan Lackner. — Paintings from the Lackner collection. — The vision of Max Beckmann by Charles S. Kessler.

138. HÜTT, WOLFGANG. Die Darstellung der Novemberrevolution in der deutschen bildenden Kunst. *Bildende Kunst* 1958: 728–735.

Beckmann p. 728–729 incl. 1 ill.

JALOUX, EDMOND. Max Beckmann. See bibl. 31.

139. JANSON, H[ORST] W[ALDEMAR]. Max Beckmann in America. *Magazine of Art* v. 44, no. 3: 89–92 incl. ill. Mar. 1951.

140. JEDLICKA, GOTTHARD. Max Beckmann in seinen Selbstbildnissen. 1959. *In* Blick auf Beckmann (bibl. 17) p. 111–113 plus ill.

Lecture at the Max Beckmann Gesellschaft in Munich, June 13, 1959.

141. JOACHIM, HAROLD. Blindman's buff, a triptych by Max Beckmann. *Minneapolis Institute of Arts Bulletin* v. 47, no. 1: 1–13 incl. ill. Jan.-Mar. 1958.

142. KASCHNITZ, GUIDO. Max Beckmann. *Der Ararat* 2: 275–278 incl. ill. 1921.

143. KEIM, H. W. Düsseldorf: Die Beckmann-Ausstellung der Galerie Flechtheim. *Der Cicerone* 17: 381–382 Apr. 1925.

144. KESSER, ARNIM. Das mythologische Element im Werke Max Beckmanns. 1958. *In* Blick auf Beckmann (bibl. 17) p. 25–35 plus ill.

Lecture at the Max Beckmann Gesellschaft in Munich, June 16, 1958.

145. KESSLER, CHARLES S. Max Beckmann's Departure. The modern artist as heroic prophet. *Journal of Aesthetics and Art Criticism* v. 14, no. 2: 206–217 incl. ill. Dec. 1955.

146. KESSLER, CHARLES S. Santa Barbara: Max Beckmann. *Arts* v. 34, no. 2: 21 incl. 1 ill. Nov. 1959.

Review of exhibition at the University of California Art Gallery in Santa Barbara.

KESSLER, CHARLES S. The vision of Max Beckmann. See bibl. 137.

147. KEUTNER, HERBERT. Christliche Malerei der Gegenwart. *Das Kunstwerk* v. 5, no. 1: 40–44, 1951.

Beckmann p. 41, 43.

148. KNOWLTON, WALTER. Max Beckmann. *Creative Art* 8: 376 May 1931.

Review of exhibition, J. B. Neumann Gallery, New York.

149. KÖHN, HEINZ. Zur Max-Beckmann-Gedächtnisausstellung in München und Berlin. *Kunstchronik* 4: 281–285 Nov. 1951.

KÖHN, HEINZ. See also bibl. 258.

KÖLLER, ERNST. See bibl. 265.

150. Die Künstler und die Zeitgenossen. Eine Diskussion. *In* Blick auf Beckmann (bibl. 17) p. 213–234.

Discussion at the Max Beckmann Gesellschaft in Murnau, July 25, 1954. Moderators: Benno Reifenberg and Carl Linfert. Participating: Peter Beckmann, Theo Garve, Erhard Göpel, Werner Haftmann, E. W. Nay, J. B. Neumann, Franz Roh, Walter Warnach.

151. LACKNER, STEPHAN. Bildnis des Bildnismalers Max Beckmann. *Das Kunstwerk* v. 17, no. 4: 25–26 Oct. 1963.

Opening speech at the exhibition "Max Beckmann — Das Porträt," Karlsruhe, Badischer Kunstverein, 1963.

152. LACKNER, STEPHAN. The graphic art of Max Beckmann. *Artforum* v. 1, no. 10: 36–38 incl. ill. Apr. 1963.

153. LACKNER, S[TEPHAN]. Max Beckmanns Andenken. *Das Kunstwerk* 13: 75 Aug. 1959.

LACKNER, STEPHAN. Max Beckmann's mystical pageant of the world. See bibl. 31.

LACKNER, STEPHAN. Memoirs of a friendship. See bibl. 137.

154. LACKNER, STEPHAN. Die Triptychen Max Beckmanns zum 10. Todestag des Malers. *Das Kunstwerk* 14: 1–8 incl. ill. Nov. 1960.

155. LACKNER, STEPHAN. Das Welttheater des Malers Beckmann. *Das Kunstwerk* v. 9, no. 4: 5–8 plus 14 ill. (1 col.) 1955/56.

English version in bibl. 31.

LACKNER, STEPHAN. See also bibl. 272, 287.

156. LANGSNER, JULES. Symbol and allegory in Max Beckmann. *Art International* v. 5, no. 2: 27–30 incl. ill. Mar. 1, 1961.

On the occasion of an exhibition of German expressionist painting, from the May collection, at the University of California, Los Angeles.

157. LINFERT, CARL. Beckmann oder Das Schicksal der Malerei. *Di Neue Rundschau* v. 46, no. 1: 26–57 Jan. 1935.

Also *In* Blick auf Beckmann (bibl. 17) p. 57–82 plus ill.

158. LOUCHHEIM, ALINE B. Beckmann paints the inner reality. *New York Times* June 13, 1948. ill.

Occasioned by the exhibition at St. Louis City Art Museum.

159. MC CAUSLAND, ELIZABETH. [Beckmann exhibition, Buchholz Gallery.] *Parnassus* v. 10, no. 2: 28–29 Feb. 1938.

Analysis of Beckmann's *Departure*.

160. MC CAUSLAND, ELIZABETH. Max Beckmann. *Parnassus* v. 12, no. 1: 28 Jan. 1940.

Review of exhibition, Buchholz Gallery, New York. — Analysis of *Temptation* and of *Birth* and *Death*.

MC NAMEE, M. B. See bibl. 285.

161. The man with the rainbow. *Time* 50: 55 Dec. 1, 1947.

162. MARTIN, KURT. Max Beckmann: Persée. *Quadrum* no. 5: 76–77 incl. ill. 1958.

Text in German. — English summary p. 190.

163. Max Beckmann. *Art News* v. 29, no. 27: 9 Apr. 4, 1931.

Review of exhibition at J. B. Neumann, New Art Circle, New York.

164. Max Beckmann. *Artlover.* J. B. Neumann's Bilderhefte. v. 2, no. 6, 1928.

Entire issue consists of 15 illustrations of Beckmann's work.

165. Max Beckmann. *Artlover.* J. B. Neumann's Bilderhefte. v. 3: IV, 11, 20–21, 53, 88, 1930–1936, ill.

166. Max Beckmann. *MKR's (Maude Kemper Riley) Art Outlook* May, 1946: 4.

167. Max Beckmann. Querschnitt durch das Schaffen eines deutschen Malers, der ins Exil ging. *Heute* no. 18: 20–23 incl. ill. Aug. 15, 1946.

168. Max Beckmann. *Scala international* (German ed.) no. 11: 21–28 incl. 12 col. ill., Nov. 1961.

169. MEIER-GRAEFE, JULIUS. Max Beckmann. *In* Max Beckmann (bibl. 30) p. 27–34 incl. ill.

MEIER-GRAEFE, JULIUS. See also bibl. 59, 296.

MEISTERMANN, GEORG. See bibl. 25.

170. MOTESICZKY, MARIELOUISE. Max Beckmann als Lehrer. Erinnerungen einer Schülerin des Malers. *In* Franke, Günther, Galerie, Munich. Max Beckmann. Bildnisse aus den Jahren 1905–1950. 1964. (bibl. 291.)

Speech at the Max Beckmann-Gesellschaft in Murnau, 1963.

171. MYERS, BERNARD. From abstract expressionism to new objectivity. *American Artist* v. 16, no. 4: 26–28, 59–61, ill. Apr. 1952.

Beckmann p. 59.

172. NEMITZ, FRITZ. Max Beckmann. *Kunst* (München) no. 1: 86–92 incl. 5 ill. 1948.

173. NEUMEYER, FRED. Erinnerungen an Max Beckmann. *Der Monat* Apr. 1952: 70–71.

174. PAGE, A. FRANKLIN. [Max Beckmann's self portrait.] *Bulletin of the Detroit Institute of Arts* v. 35, no. 1: 18–19 incl. 1 ill. 1955/56.

175. PASSARGE, WALTER, Retrospective Max Beckmann. *Habitat* v. 5, no. 23: 36 incl. ill. Aug. 1955.

Review of exhibition at the 3rd Bienal, Sao Paulo.

PINDER, EBERHARD. See bibl. 289.

176. POPP, JOS[EF]. Max Beckmann. *Der Kunstwart* 42: 133–136 Nov. 1928.

Review of exhibition at Graphisches Kabinett, Günther Franke, Munich.

PRETZELL, LOTHAR. See bibl. 263.

177. RATHBONE, PERRY T. Introduction. *In* St. Louis. City Art Museum. Max Beckmann 1948. Retrospective exhibition. (bibl. 252) p. 11–39.

178. RATHBONE, PERRY T. Max Beckmann 1884–1950. [Eulogy.] *St. Louis City Art Museum Bulletin* v. 35, no. 4: 56–59 incl. 1 ill. 1950.

RATHBONE, PERRY T. See also bibl. 25, 257, 281.

179. READ, HELEN APPLETON. Max Beckmann's latest. *Magazine of Art* v. 31, no. 2: 105–106 Feb. 1938. ill.

Review of exhibition at Buchholz Gallery, New York. — Analysis of *Departure*.

See also bibl. 31.

180. REIFENBERG, BENNO. Max Beckmann. *Documents.* Revue mensuelle des questions allemandes. Numéro spécial: L'art allemand contemporain. 1951: 41–45 incl. ill.

Also English edition, 1952.

181. REIFENBERG, BENNO. Max Beckmann. *Ganymed* 3: 37–49 plus 10 pl. 1921.

Reprinted in Blick auf Beckmann (bibl. 17) p. 101–109 plus ill.

182. REIFENBERG, BENNO. Der Zeichner Max Beckmann. 1954. *In* Blick auf Beckmann (bibl. 17) p. 140–153 plus ill.

Lecture given at the Max Beckmann Gesellschaft in Munich July 24, 1954.

REIFENBERG, BENNO. See also bibl. 25, 273, 287.

183. ROH, FRANZ. Beckmann als Landschaftler. *Die Kunst und das schöne Heim* v. 50, no. 1: 9–15 incl. 9 ill. plus 2 col. pl. Oct. 1951.

184. ROH, FRANZ. Der Maler Max Beckmann. *Prisma* v. 1, no. 2: I–IV incl. ill. 1946.

185. ROH, FRANZ. Zum Tode Max Beckmanns. *Die Kunst und das schöne Heim* v. 49, no. 5: 175 Feb. 1951; *Kunstchronik* v. 4, no. 2: 25–26 plus 3 ill. Feb. 1951; *Werk* v. 38, no. 3: sup. 33 Mar. 1951.

186. SCHEFFLER, KARL. Berliner Chronik: Max Beckmann. *Kunst und Künstler* 31:146 Apr. 1932.
 Review of exhibition at Galerie Flechtheim, Berlin.

187. SCHEFFLER, KARL. Max Beckmann. *Kunst und Künstler* v.11: 297–305 incl. ill. 1913.

188. SCHEFFLER, KARL. Max Beckmann. *Kunst und Künstler* v.22: 107–110, 1924.

188a. SCHEIDIG, WALTHER. Max Beckmann in Weimar. *Kunstmuseen der Deutschen Demokratischen Republik* v.3:79–84, 1961.

189. SCHIFF, FRITZ. La peinture de l'Allemagne inquiète. *L'Amour de l'art* v.15, no.8:441–446 incl. ill. Oct. 1934.
 Includes biographical and bibliographical notes. — Reprinted in bibl. 57.

190. SCHMALENBACH, FRITZ. The term "neue Sachlichkeit". *Art Bulletin* v.22, no.3:161–165 Sep. 1940.

191. SCHMIDT, P[AUL] F[ERD]. Beckmann-Ausstellung in Magdeburg. *Deutsche Kunst und Dekoration* v.30:140, 1912.

192. SCHMIDT, PAUL F[ERD]. Max Beckmann zur Ausstellung seiner neuesten Arbeiten in Frankfurt a. M. *Der Cicerone* 11:380–381, 1919.

193. SCHMIDT, PAUL FERD. Max Beckmann. *Jahrbuch der jungen Kunst* 1920:117–127 incl. ill.

194. SCHMIDT, P[AUL] F[ERD]. Max Beckmanns "Hölle". *Der Cicerone* 12:841–847 incl. 4 ill. Dec. 1920.

195. SCHMIDT, PAUL F[ERD]. Max Beckmanns Lithographien der "Hölle". *Feuer* 2:461–463, 1920/21.

196. SCHMIDT, PAUL F[ERD]. Neue Graphik von Max Beckmann. *Jahrbuch der jungen Kunst* 1923:410–416 incl. 8 ill.
 Also published, with fewer illustrations, in *Der Cicerone* 15:180–184 incl. 5 ill. Feb. 1923.

197. SCHNITZLER, LILLY VON. Max Beckmann. *Der Querschnitt 8:268* Apr. 1928.

198. SCHNITZLER-MALLINCKRODT, LILLY VON. Das Entstehen einer Beckmann-Sammlung. 1958. *In* Blick auf Beckmann (bibl. 17) p.175–181 plus ill.
 Lecture in Cologne, Feb. 5, 1958, in connection with her donation of 10 paintings to the Wallraf-Richartz-Museum.

199. SCHÖNE, WOLFGANG. Ansprache zur Eröffnung der Beckmann-Ausstellung des Kunstvereins in Hamburg am 3. Mai 1947. *Jahrbuch der Hamburger Kunstsammlung* v.1:10–15, 2 ill. 1948.

200. SECKLER, DOROTHY. Can painting be taught? 1. Beckmann's answer. *Art News* v.50, no.1:39–40 incl. port. Mar. 1951.
 Interview.

201. SEELEY, CAROL. Notes on the use of symbols in contemporary painting. *Art Quarterly* 11:324–334 ill. Autumn 1948.
 Beckmann p.332–333.

202. SELDIS, HENRY J. A personal collection of Beckmanns. *Art Digest* v.29, no.15:12–13 incl. 3 ill. May 1, 1955.
 On the occasion of the exhibition at Santa Barbara Museum of Art of Stephan Lackner's Beckmann collection.

203. SIMON, HEINRICH. Max Beckmann. *Das Kunstblatt* 3:257–264, 1919.
 SOBY, JAMES THRALL. See bibl. 251.

204. SOUPAULT, PHILIPPE. Max Beckmann. *La Renaissance* 14:96–100 incl. 6 ill. Mar. 1931.
 Text in French.

205. STEINGRABER, ERICH. Max Beckmann nella raccolta di Günther Franke alla Galleria Statale di Monaco. *Arte figurative* v.8, no.6:36–37, 1960.
 STELZER, OTTO. See bibl. 266.

206. STOREY, BENJAMIN. Max Beckmann. *Emporium* v.115:15–18 incl. 2 ill. Jan. 1952.
 On the occasion of the exhibition at Stedelijk Museum, Amsterdam.

207. SWARZENSKI, GEORG. Max Beckmann. *Das Neue Frankfurt* v.1, no.4, 1927.
 SWARZENSKI, GEORG. See also bibl. 246.
 SWARZENSKI, HANNS. See bibl. 252.

208. TANNENBAUM, LIBBY. Beckmann. St. Louis adopts the international expressionist. *Art News* v.47, no.3:20–22 incl. ill. (1 col.) May 1948.

209. THOENE, PETER. Bemerkungen über die deutsche Malerei der Gegenwart. Zu den Ausstellungen von Otto Dix und Max Beckmann. *Das Werk* 25:345–349, 1938.
 Beckmann p.347–348.

210. THWAITES, JOHN ANTHONY. Max Beckmann — notes for an evaluation. *Art Quarterly* 14:274–282 incl. ill. Winter 1951.
 On the occasion of the exhibition in Munich's Haus der Kunst.

211. TÜNGEL, RICHARD. Max Beckmann. *Der Kreis* 10:148–152, Mar. 1933.
 Speech held at the opening of Beckmann exhibition in Hamburg.

212. TURKEL-DERI, FLORA. Berlin letter. *Art News* v.29, no.34:15, May 23, 1931.
 Review of Spring exhibition at the Academy of Fine Arts in Berlin — Whole room devoted to work of Beckmann.

213. TURKEL-DERI, FLORA. Berlin letter. *Art News* v.30, no.28:12, Apr. 9, 1932.
 Review of Beckmann exhibition at Galerie Flechtheim in Berlin.

214. VALENTINER, W[ILHELM] R. Expressionism and abstract painting. *Art Quarterly* v.4, no.3:210–238 incl. ill. Summer 1941.
 Beckmann's *The Loge* discussed p.220.

215. VALENTINER, W[ILHELM] R. Max Beckmann. c.1955. *In* Blick auf Beckmann (bibl. 17) p.83–90 plus ill.

216. WATSON, ERNEST W. The new look in education. An editorial. *American Artist* v. 12, no. 3: 19 Mar. 1948.

217. WERNER, BRUNO E. Max Beckmann. *Zeitschrift für Kunst* v. 1, no. 1: 68–71 plus 3 ill. p. 64, 1947.

218. WICHERT, FRITZ. Max Beckmann. *Kunst und Künstler* 29: 7–14 incl. 8 ill. Oct. 1930.

219. WICHERT, F[RITZ]. Max Beckmann und einiges zur Lage der Kunst. *Die Form* 3: 337–347 incl. ill. Nov. 1 1928.

220. WOLFRADT, WILLI. Berliner Ausstellungen: Beckmann. *Der Cicerone* 16: 142 Feb. 1924.

221. ZAHN, LEOPOLD. Deutsche Kunst der Gegenwart. *Das Kunstwerk* v. 2, no. 1/2: 55–65 incl. ill., 1948.
 Beckmann p. 56, 62.

222. ZIMMERMANN, FREDERICK. Beckmann in America n. p. n. d. 12 p. Mimeographed copy in the Museum of Modern Art Library. — Address delivered before the Max Beckmann Gesellschaft at Murnau on July 15, 1962.

SELECTED EXHIBITION CATALOGUES

1917

223. NEUMANN, J. B., GRAPHISCHES KABINETT, BERLIN. Max Beckmann: Graphik. 14 p. ill.
 Nov. 1917. — 110 works. — Foreword by Beckmann.

1918

224. NEUMANN, J. B., GRAPHISCHES KABINETT, BERLIN. Max Beckmann: acht Radierungen. 8 p. ill.
 1918.

1922

225. ZINGLERS KABINETT, FRANKFURT AM MAIN. Ausstellung Max Beckmann. Neue Arbeiten. In Gemeinschaft mit J. B. Neumann, Berlin. [3] p.
 Apr. 1922. — 41 works.

1928

226. MANNHEIM. STÄDTISCHE KUNSTHALLE. Max Beckmann: das gesammelte Werk. Gemälde, Graphik, Handzeichnungen aus den Jahren 1905 bis 1927. 32 p. incl. ill.
 Febr. 19–Apr. 1, 1928. — 272 works. — Foreword by Beckmann. — Text by G. F. Hartlaub. — Reviewed in bibl. 104.

227. FLECHTHEIM, ALFRED, GALERIE, BERLIN. Max Beckmann. 12 p. incl. ill.
 Apr. 22 — May 31, 1928. — 55 works. — Statements by Beckmann p. 6–7.
 Reviewed in *Der Cicerone* 20: 312–313 May 1928 and in bibl. 128.

228. GRAPHISCHES KABINETT, GÜNTHER FRANKE, MUNICH. Max Beckmann: Gemälde aus den Jahren 1920–1928.
 1928. — Text by Wilhelm Hausenstein, reprinted in bibl. 131. Reviewed in *Der Cicerone* 20: 639–640 Oct. 1928 and in bibl. 176.

1929

229. FLECHTHEIM, ALFRED, GALERIE, BERLIN. Max Beckmann. Neue Gemälde und Zeichnungen. [8] p. incl. ill.
 Jan. 12–31, 1929. — 30 works.
 Reviewed in *Der Cicerone* 21: 59 Jan. 1929 and in bibl. 118.

1930

230. GRAPHISCHES KABINETT, MUNICH. Arbeits-Stadien in Max Beckmanns graphischem Schaffen. [4] p. incl. ill.
 End of Feb. — end of Mar., 1930.

231. GRAPHISCHES KABINETT MUNICH. Max Beckmann-Ausstellung. [4] p. 1 ill.
 July 1930. — 35 works. — Text by Günther Franke.

232. BASEL. KUNSTHALLE. Max Beckmann. 16 p. plus 11 pl.
 Aug. 3–31, 1930. — 121 works.

233. ZURICH. KUNSTHAUS. Max Beckmann. 23 p.
 Sep. 6–Oct. 5, 1930. — 221 works.

1931

234. HANOVER. KESTNER-GESELLSCHAFT. Max Beckmann: Gemälde und Graphik 1906 bis 1930. [6] p. incl. ill.
 Jan. 15–Feb. 8, 1931. — More than 40 works. — Text by Bier. — Includes biographical and bibliographical note.

235. NEW YORK. MUSEUM OF MODERN ART. German painting and sculpture. p. 12, 20 plus ill.
 Mar. 13–Apr. 26, 1931. — 8 works by Beckmann. — Introduction by Alfred H. Barr, Jr.

236. GALERIE DE LA RENAISSANCE, PARIS. Max Beckmann. [6] p. incl. ill.
 Mar. 16–Apr. 15, 1931. — 46 works. — Includes "Beckmann et le problème de l'art européen," by Waldemar George.
 Reviewed in *Art News* v. 29, no. 30: 20 Apr. 25, 1931, and in bibl. 115.

237. LE CENTAURE, GALERIE, BRUSSELS. Exposition Max Beckmann. 2 p.
 May 16–28. 1931. — 21 works.
 NEUMANN, J. B., NEW ART CIRCLE, NEW YORK.
 For exhibition (1931) see bibl. 32, 148, 163.

1938

238. BUCHHOLZ GALLERY, NEW YORK. Exhibition of recent paintings by Max Beckmann. [4] p. incl. 2 ill.
 Jan. 11–Feb. 8, 1938. — 26 works. -

Reviewed in *Art News* 36:18, 28 Jan. 22, 1938, and in bibl. 159.

239. BERN. KUNSTHALLE. Ausstellung Max Beckmann. 11 p.
Feb. 19–Mar. 20, 1938. – 67 works.

240. WINTERTHUR. KUNSTMUSEUM. Max Beckmann. [6] p.
Apr. 3–May 8, 1938. – 59 works.
Reviewed in *Das Werk* v. 25, no. 7: XXII, 1938.

241. NEW BURLINGTON GALLERIES, LONDON. Exhibition of twentieth century German art. p. 10.
July 1938. – 7 works by Beckmann. – For Beckmann's address at opening see bibl. 10. – Reviewed in *Apollo* v. 28, no. 164:94–95 incl. ill. Aug. 1938.

1939

242. BUCHHOLZ GALLERY, NEW YORK. Max Beckmann: recent paintings. [4] p.
Feb. 21–Mar. 18, 1939. – 13 works.
Reviewed in *Art News* 37:16 Mar. 11, 1939.

1940

243. BUCHHOLZ GALLERY, NEW YORK. Max Beckmann: paintings 1936–1939. [6] p. incl. 2 ill.
Jan. 3–27, 1940. – 17 works.
Reviewed in *Art News* 38:12 Jan. 6, 1940, in *Art Digest* 14:15 Jan. 1, 1940 and in bibl. 160.

1941

244. BUCHHOLZ GALLERY, NEW YORK. Paintings by Max Beckmann. 1 p.
Apr. 28–May 17, 1941. – 30 works.
Reviewed in *Art News* 40:26 May 15, 1941 and in *Art Digest* 15:16 May 1, 1941.

1942

245. CHICAGO. ARTS CLUB. Max Beckmann exhibition. [6] p. Jan. 2–27, 1942. – 55 works.
Reviewed in *Art Digest* 16:15 Jan. 15, 1942 and in *Time* 39: 38 Jan. 12, 1942,

1946

246. BUCHHOLZ GALLERY, NEW YORK. Beckmann: his recent work from 1939 to 1945. [8] p. incl. ill.
Apr. 23–May 18, 1946. – 30 works. – Introduction by Georg Swarzenski.
Reviewed in *Art News* 45:46, 57 May 1946, in *Art Digest* 20:13 May 1946, and in bibl. 126.

247. FRANKE, GÜNTHER, GALERIE, MUNICH. Max Beckmann. [6] p.
June 21–Aug. 21, 1946. – 113 works. – Includes excerpt from bibl. 5. For opening speech see bibl. 133.

248. BUCHHOLZ GALLERY, NEW YORK. The actors by Beckmann. [8] p. incl. ill.
Nov. 19–Dec. 7, 1946. – 30 works. – Includes excerpts from bibl. 10.
Reviewed in *Art News* 45:42 Dec. 1946, and in *Art Digest* 21:7 Dec. 1, 1946.

1947

249. PHILADELPHIA. ART ALLIANCE. Max Beckmann. Oils. [4] p. incl. 1 ill.
Jan. 28–Feb. 23, 1947. – 15 works.

250. BUFFALO. FINE ARTS ACADEMY. ALBRIGHT ART GALLERY. Max Beckmann. Paintings from 1940 to 1946. [4] p. incl. 5 ill.
Mar. 31–Apr. 30, 1947. – 13 works. – Includes excerpts from Max Beckmann "On my painting." (Bibl. 10.)

251. BUCHHOLZ GALLERY, NEW YORK. Beckmann. [8] p. incl. ill.
Nov. 17–Dec. 6, 1947. – 18 works. – Introduction by James Thrall Soby.
Reviewed in *Art News* 46:35 Nov. 1947 and in *Art Digest* 22:17 Dec. 1, 1947.

1948

252. ST. LOUIS. CITY ART MUSEUM. Max Beckmann 1948. Retrospective exhibition. 114 p. incl. ill.
May–June 14, 1948. – 132 works. – Prefatory note by Hanns Swarzenski, p. 5–9. – Introduction by Perry T. Rathbone, p. 11–39. – Excerpts from the writings of the artist, p. 41–44. – Bibliography, p. 105–114. – Also shown at Los Angeles County Museum, Detroit Institute of Arts, Baltimore Museum of Art and Minneapolis Institute of Arts.
Reviewed in bibl. 208 and in *Bulletin of the Minneapolis Institute of Art* 38: 14, 17–18 Jan. 15–22, 1949.

1949

253. HANOVER. KESTNER-GESELLSCHAFT. Max Beckmann. [14] p. incl. ill.
Spring 1949. – 128 works. – Introduction by Alfred Hentzen. – Excerpts from Max Beckmann "Drei Briefe an eine Malerin." (Bibl. 12.)

254. COLOGNE. STAATENHAUS DER MESSE. Deutsche Malerei und Plastik der Gegenwart. Veranstaltet von der Stadt Köln. [37] p. plus pl.
May 14–July 3, 1949. – 5 works by Beckmann.

255. BUCHHOLZ GALLERY, NEW YORK. Max Beckmann: recent work. [16] p. incl. ill.
Oct. 18–Nov. 5, 1949. – 28 works. – Includes excerpts from Max Beckmann "Letters to a woman painter." (Bibl. 12.)

Reviewed in *Art News* 48:52 Nov. 1949 and in *Art Digest* 24:13 Nov. 1, 1949.

1950

256. FRANKE, GÜNTHER, GALERIE, MUNICH. Max Beckmann. 25 Bilder aus den Jahren 1906–1949. [8] p. incl. ill.
Jan.-Feb. 1950.

1951

257. BUCHHOLZ GALLERY, NEW YORK. Max Beckmann. [16] p. incl. ill.
Apr. 3–28, 1951. – 20 works. – Introduction by Perry T. Rathbone. – Notes on the triptych "Argonauts" from Max Beckmann's diary.
Reviewed in *Art News* 50:22, 52 incl. ill. Apr. 1951, and in *Art Digest* 25:17 Apr. 15, 1951.

258. ESSEN. MUSEUM FOLKWANG. Max Beckmann. Gemälde und Graphik aus der Sammlung Günther Franke, München. [13] p. incl. ill.
Apr.–May 1951. – 32 paintings and 90 graphics. – Introduction by H. Köhn.

259. [MUNICH. HAUS DER KUNST.] Max Beckmann zum Gedächtnis, 1884–1950. München, Prestel, 1951. 55 p. incl. 33 ill.
June–July 1951. – 212 works. – Includes: Dem Gedächtnis von Max Beckmann by Ludwig Grote (p. 5–6). – Gegenwart Max Beckmanns. Erinnerungen aus der holländischen Zeit by Erhard Göpel (p. 7–8). – Kriegsbriefe Max Beckmanns (Excerpts, p. 26–28). – Gedanken zur Malerei (p. 28–30; from *Kunst und Künstler*, 1914). – Alltag und Arbeit an "Blindekuh" by Q. B., (p. 31–32). – Katalog der Ausstellung by Leonie von Wilckens.

260. CHICAGO. ARTS CLUB. German expressionists and Max Beckmann from the collection of Mr. and Mrs. Morton D. May. [4] p.
Nov. 20–Dec. 15, 1951. – 14 works by Beckmann.

261. AMSTERDAM. STEDELIJK MUSEUM. Max Beckmann. 28 p. incl. ill.
Dec. 1951–Jan. 1952. – 105 works. – Introduction signed: H. L. – Exhibition prepared by Ludwig Grote and first shown in Munich and Berlin.

1952

262. FRANKE, GÜNTHER, GALERIE, MUNICH. Max Beckmann. Graphik-Sammlung G. F. [6] p.
Feb. 12–Mar. 31, 1952. – 91 works.

263. CELLE. SCHLOSS. Von Klinger bis Beckmann. Deutsche Graphik von 1880 bis 1930. [54] p. incl. ill.
Mar. 23–June 2, 1952. – 9 works by Beckmann. – Introduction by Lothar Pretzell.

264. FRANKE, GÜNTHER, GALERIE, MUNICH. Max Beckmann. Werke der Frühzeit. [4] p.
June 1952. – 23 works.

265. WELZ, GALERIE, SALZBURG. Max Beckmann. Gemälde – Graphik. [6] p. incl. 1 ill.
Summer 1952. – 137 works. – Introduction by Ernst Köller.

1953

266. BRAUNSCHWEIG. KUNSTVEREIN. Max Beckmann, 1884–1950. [40] p. incl. ill.
Oct. 25–Nov. 22, 1953. – 277 works. – Includes "Max Beckmans Herkunft" by O. St. – "Vom Werk" by Otto Stelzer. – "Das Schwert des Perseus" by Peter Beckmann.

267. BREMEN. KUNSTHALLE. Max Beckmann, 1884–1950. Gedächtnisausstellung. [36] p. incl. ill.
Nov. 28, 1953–Jan. 6, 1954. – 277 works. – Introduction by Günther Busch. – "Das Schwert des Perseus" by Peter Beckmann.

1954

268. HANOVER. KESTNER-GESELLSCHAFT. Paul Klee. Max Beckmann. [20] p. incl. ill.
Jan. 17–Feb. 21, 1954. – 57 works by Beckmann. – Introduction by Alfred Hentzen. – Zu dem Triptychon "Argonauten" von Max Beckmann by Mathilde Q. Beckmann.

269. VALENTIN, CURT, GALLERY, NEW YORK. Max Beckmann. [14] p. incl. ill.
Jan. 26–Feb. 20, 1954. – 23 works. – Text by Max Beckmann (speech delivered at Washington University, St. Louis; translation by Jane Sabersky.) (Bibl. 13.) – Notes from Beckmann's diary concerning the triptych *Blindman's Buff*.
Reviewed in *Art News* 52:42 Feb. 1954. Reply with rejoinder by Mrs. M. Beckmann in *Art News* 53:6 Mar. 1954. Also reviewed in bibl. 108.

1955

270. 1020-ART CENTER, CHICAGO. Max Beckmann. 1 folded leaf.
Mar. 3–Apr. 1, 1955. – 48 works.
Reviewed in *Art Digest* 29:20 Mar. 15, 1955.

271. HILL, THEO, GALERIE, COLOGNE. Max Beckmann. Zeichnungen und Aquarelle aus den Jahren 1902–1950. 19 p. incl. ill.
Apr. 1–30, 1955. – 64 works. – Includes: Max Beckmanns Weg als Zeichner by Erhard Göpel (p. 1–3).

272. SANTA BARBARA. MUSEUM OF ART. Max Beckmann. [6] p.
May 24–June 26, 1955. – 42 works. – Introduction by Stephan Lackner. – Also shown at San Francisco Museum of Art, July–Aug. and Pasadena Art Institute, Oct.–Nov. –
Reviewed in *Art News* 54:73 Summer 1955 and in bibl. 202.

273. FRANKFURT AM MAIN. FRANKFURTER KUNSTKABINETT. Max Beckmann. [16] p. incl. ill.
July 9–Aug. 12, 1955. – 83 works. – Introduction by Benno Reifenberg.

274. KASSEL. MUSEUM FRIDERICIANUM. Documenta: Kunst des XX. Jahrhunderts. Internationale Ausstellung. 2 Aufl. München, Prestel, 1955. [241] p. incl. pl. (some col.)
July 15–Sep. 18, 1955. – 11 works by Beckmann. – Foreword by Heinz Lemke p. 13–14. – Introduction by Werner Haftmann p. 15–25.

275. VIVIANO, CATHERINE, GALLERY, NEW YORK. Max Beckmann. [4] p. incl. 1 ill.
Nov. 1–26, 1955. – 23 works. – Includes extract from Max Beckmann's lecture given at the New Burlington Galleries, Jul 21, 1938. (Bibl. 10.)
Reviewed in Art News 54: 51 Nov. 1955.

276. ZURICH. KUNSTHAUS. Max Beckmann, 1884–1950. 38 p. plus 32 ill.
Nov. 22, 1955–Jan. 8, 1956. – 180 works. – Includes: Werk und Weg Max Beckmanns by Erhard Göpel (p. 7–10). – Meine Theorie der Malerei by Max Beckmann (p. 11–15) (Bibl. 10.). – Aus Max Beckmanns Kriegsbriefen (p. 16–17). (Bibl. 5.). – Bibliography (p. 18–21).
Reviewed in Werk 43: sup. 3–4 Jan. 1956.

1956

277. BASEL. KUNSTHALLE. Ausstellung Max Beckmann. 40 p. plus 25 ill. (1 col.).
Jan. 14–Feb. 12, 1956. – 169 works. – Text by Erhard Göpel p. 5–19.

278. THE HAGUE. GEMEENTEMUSEUM. Max Beckmann. [54] p. incl. ill.
Mar. 14–May 7, 1956. – 124 works. – Introduction by Günther Busch (in Dutch and German).

279. LONDON. TATE GALLERY. A hundred years of German painting. p. 11, 17 plus 1 col. pl.
1956. – 8 works by Beckmann. – Introduction by Alfred Hentzen.
Reviewed in Burlington Magazine 98: 203–205 June 1956 and in Studio 152: 65–71 Sep. 1956.

280. WUPPERTAL. STÄDTISCHES MUSEUM. Max Beckmann, 1884–1950. [45] p. incl. ill.
Nov.–Dec. 1956. – 91 works. – Text by Erhard Göpel [p. 7–14].

1957

281. VIVIANO, CATHERINE, GALLERY, NEW YORK. Portraits by Max Beckmann. [6] p. plus 19 ill.
Oct. 1–Nov. 2, 1957. – 19 works (all reproduced). – Includes: Beckmann as portrait painter by Perry T. Rathbone.
Reviewed in Art News 56: 16 Oct. 1957 and in Studio 155: 60 Feb. 1958.

282. NEW YORK. MUSEUM OF MODERN ART. German art of the twentieth century. p. 96, 99–100, 204–205 and passim, ill.
Oct. 1–Dec. 8, 1957, – 9 works by Beckmann. – See also bibl. 70.

1959

283. COLOGNE. WALLRAF-RICHARTZ-MUSEUM. Max Beckmann. Bilder, Zeichnungen, Pastelle, Aquarelle und Graphik. Sammlung Günther Franke. [14] p. plus ill. (pt. col.)
Mar. 21–May 5, 1959. – 134 works. Includes: Notizen über Max Beckmann by Günther Franke. – Besuche bei Max Beckmann in Amsterdam by Peter Beckmann.

284. VIVIANO, CATHERINE, GALLERY, NEW YORK. [The eight sculptures of] Max Beckmann. [14] p. incl. 9 ill.
Nov. 2–28, 1959.
Reviewed in Art News 58: 12 Nov. 1959, in Arts 34: 58 Nov. 1959 and in Burlington Magazine 101: 469 Dec. 1959.

1960

285. ST. LOUIS UNIVERSITY, MO. Paintings from the collection of Mr. and Mrs. Morton D. May. p. [8–9, 13–15] plus pl. 40–87.
Feb. 14–July 4, 1960, at the Pius XII Memorial Library. – 48 works by Beckmann. – Introduction by M. B. McNamee. – Includes bibliography. – Exhibition circulated to several American cities, and was last shown in Washington, 1962.
Reviewed in Time Mar. 14, 1960: 80–81, 83 incl. 1 col. pl.

1962

286. VIVIANO, CATHERINE, GALLERY, NEW YORK. Max Beckmann. Exhibition of paintings 1925–1950. [22] p. incl. ill.
Jan. 9–27, 1962. – 22 works. – Includes excerpts from the lecture "On my painting," from "Letters to a woman painter," and from a speech delivered at Washington University, St. Louis, Mo., June 1950. (Bibl. 10, 12, 13.)
Reviewed in Arts 36: 44 Mar. 1962.

287. KARLSRUHE. BADISCHER KUNSTVEREIN. Max Beckmann. Die Druckgraphik: Radierungen, Lithographien, Holzschnitte. n. p. Text plus 305 ill.
Aug. 27–Nov. 18, 1962. – 305 works (all reproduced). – Includes texts by Ernst Holzinger, Peter Beckmann, Stephan Lackner and Benno Reifenberg (opening speech). – Definitive catalogue of Beckmann's graphic work by Klaus Gallwitz.

288. MUNICH. HAUS DER KUNST. Entartete Kunst. Bildersturm vor 25 Jahren. p. XIX, [14–33] incl. 10 ill. (1 col.)

Oct. 25–Dec. 16, 1962. – 9 works by Beckmann. – Text by Jürgen Claus.

Retrospective of the exhibition of so-called "degenerate" art of 1937.

1963

289. BIELEFELD. STÄDTISCHES KUNSTHAUS. Max Beckmann. Druckgraphik: Selbstbildnisse, Buchillustrationen, Bildfolgen. 33 p. incl. ill.

Jan. 27–Feb. 24, 1963. – 32 works. – Introduction by E[berhard] P[inder] p. 4–5.

290. KARLSRUHE. BADISCHER KUNSTVEREIN. Max Beckmann. Das Portrait. Gemälde, Aquarelle, Zeichnungen. 185 p. mostly ill. (some col.)

Aug. 26–Nov. 17, 1963. – c. 100 works. – Introduction by Klaus Gallwitz. – Includes excerpts from writings and statements by Beckmann.

1964

291. FRANKE, GÜNTHER, GALERIE, MUNICH. Max Beckmann. Bildnisse aus den Jahren 1905–1950. [11] p. plus 38 ill.

Feb. 12–Apr. 15, 1964. – 38 works (all reproduced). – Max Beckmann als Lehrer. Erinnerungen einer Schülerin des Malers by Marielouise Motesiczky [p. 5–10].

The exhibition commemorating the 80th birthday of Beckmann.

PORTFOLIOS AND ILLUSTRATED BOOKS
(Arranged chronologically.)

292. GUTHMANN, JOHANNES. Euridikes Wiederkehr. Neun Lithographien von Max Beckmann zu den gleichnamigen Versen von Johannes Guthmann. Berlin, Paul Cassirer, 1909. 78 p. plus 9 pl.
Limited edition of 60 copies.

293. BECKMANN, MAX. Sechs Lithographien zum neuen Testament. Berlin, Tieffenbach, 1911.

294. DOSTOJEWSKI, F. M. Aus einem Totenhaus. Das Bad der Sträflinge. Neun Lithographien von Max Beckmann. Berlin, Cassirer, 1913.
Seven of the lithographs in *Kunst und Künstler* 11:289–296 1913.

295. EDSCHMID, KASIMIR. Die Fürstin. Mit sechs Radierungen von Max Beckmann. Weimar, Kiepenheuer, 1918. 81 p. plus 6 pl.
Limited edition of 500 copies.

296. BECKMANN, MAX. Gesichter. Original-Radierungen. Einleitung von J. Meier-Graefe. München, Verlag der Marées Gesellschaft, Piper & Co., 1919. 9 p. plus 19 pl. (Drucke der Marées-Gesellschaft. 13.)
Limited edition of 100 copies.
Introduction reprinted in Blick auf Beckmann (bibl. 17) p. 50–56. – Extract reprinted in bibl. 59.

297. BECKMANN, MAX. Die Hölle. Zehn Originallithographien. Berlin, Graphisches Kabinett, J. B. Neumann, 1919.
Limited edition of 75 copies. – Also published in small facsimile edition of 1000 copies.

298. BRAUNBEHRENS, LILI VON. Stadtnacht. Sieben Lithographien von Max Beckmann zu Gedichten von Lili von Braunbehrens. München, Piper, 1921. 47 p. plus 7 pl.
Limited edition of 500 copies. – Also published in portfolio in a de luxe edition of 100 copies.

299. BECKMANN, MAX. Der Jahrmarkt. 10 Original-Radierungen. München, Verlag der Marées-Gesellschaft, Piper & Co., 1922. [12] p. plus 10 pl. (Drucke der Marées-Gesellschaft. 36.)
Limited edition of 200 copies.

300. BECKMANN, MAX. Berliner Reise. Zehn Lithograpien mit Umschlag und Titelblatt von Max Beckmann. Berlin, J. B. Neumann, 1922.
Limited edition of 100 copies.

301. BRENTANO, CLEMENS VON. Das Märchen von Fanferlieschen Schönefüsschen. Acht Radierungen von Max Beckmann zu dem Märchen von Clemens von Brentano. Berlin, F. Gurlitt, 1924.
Limited edition of 220 copies.

302. BECKMANN, MAX. Ebbi. Komödie. Wien, Johannes-Presse. 1924. 46 p. plus 6 pl.
Contains 6 original etchings by the author.
Limited edition of 33 copies.

303. LACKNER, STEPHAN. Der Mensch ist kein Haustier. Drama. Mit sieben Originallithographien von Max Beckmann. Paris, Editions Cosmopolites, c1937. 111 p. plus 7 pl.
Also in limited edition of 120 numbered and signed copies.

304. BECKMANN, MAX. Die Apokalypse. Siebenundzwanzig kolorierte Lithographien. Frankfurt am Main, Bauersche Giesserei, 1943.

305. BECKMANN, MAX. Day & dream. XV lithographs. N. Y., Curt Valentin, 1946. [4] p. plus 15 pl.
Limited edition of 100 copies. – Each lithographs is numbered and signed by the artist.

306. GOETHE, JOHANN WOLFGANG VON. Faust: der Tragödie zweiter Teil. Mit Bildern von Max Beckmann. [Frankfurt am Main, Bauersche Giesserei, 1957.] 408 p., 2 l. incl. ill.
Edition of 850 copies printed for members of the Maximilian Gesellschaft in Hamburg. – The drawings were made by Beckmann in the years 1943–1944.

CATALOGUE OF THE EXHIBITION

prepared by Alicia Legg

This catalogue is divided into three sections – Paintings, Drawings and Watercolors, and Prints. Where known, the exact location where each work was executed is indicated. Dates in parentheses do not appear on the work. In dimensions height precedes width. Works marked with an asterisk are illustrated.

SCHEDULE OF THE EXHIBITION

Museum of Fine Arts, Boston: October 1–November 15, 1964
The Museum of Modern Art, New York: December 14–January 31, 1965
The Art Institute of Chicago: March 12–April 11, 1965
Kunstverein, Hamburg: May 10–July 4, 1965
Kunstverein, Frankfurt: July 15–September 9, 1965
Tate Gallery, London: September 25–November 8, 1965

Unless otherwise indicated below, all paintings, watercolors and drawings are included in all showings of the exhibition (these impressions of the prints are being shown in the USA only):

Boston and New York: Cat. 12
Boston, New York, Chicago: Cat. 16, 23, 39, 40, 52, 54, 55, 58, 74, 78, 93, 120–168
Boston, New York, Chicago, Hamburg: Cat. 13
Boston, New York, Chicago, London: Cat. 3, 22, 24, 32, 86, 91, 94
Boston, Chicago, Hamburg, Frankfurt, London: Cat. 31, 49, 67

PAINTINGS

*1 *Self-Portrait with Soap Bubbles.* (c. 1898). Mixed media on cardboard, 12⅝×9⅞". Collection Dr. Peter Beckmann, Munich-Gauting. Ill. p. 10.

*2 *Gray Sea.* Berlin, 1905. Oil on canvas, 37¾×43¼". Collection Dr. Peter Beckmann, Munich-Gauting. Ill. p. 12.

*3 *Great Death Scene.* Berlin, 1906. Oil on canvas, 50¾×54¾" Collection Günther Franke, Munich. Ill. p. 14.

*4 *Frau Pagel.* Berlin, 1907. Oil on canvas, 28¾×20⅛". Collection Dr. Peter Beckmann, Munich-Gauting. Ill. p. 16.

*5 *Self-Portrait, Florence.* Florence, 1907. Oil on canvas, 38½×34⅝". Collection Dr. Peter Beckmann, Munich-Gauting. Ill. p. 8.

*6 *Countess S. vom Hagen.* Berlin, 1908. Oil on canvas, 31×20½". Staatliche Kunstsammlungen, Gemäldegalerie Neue Meister, Dresden, German Democratic Republic. Ill. p. 17.

*7 *The Sinking of the Titanic.* Berlin, 1912. Oil on canvas, 8' 8½"×10' 10". Collection Mr. and Mrs. Morton D. May, St. Louis. Ill. p. 18.

*8 *The Street.* Berlin (1914). Oil on canvas, 67×28½". Collection Mrs. Mathilde Q. Beckmann, New York. (This painting is a detail from a larger work. In 1928 Beckmann divided the canvas and inscribed this section to Quappi, dating it erroneously 1913.) Ill. p. 20.

*9 *Christ and the Woman Taken in Adultery.* Frankfurt, 1917. Oil on canvas, 59×50½". City Art Museum of St. Louis. Ill. p. 29.

*10 *The Descent from the Cross.* Frankfurt, 1917. Oil on canvas, 59½×50¾". The Museum of Modern Art, New York, Curt Valentin Bequest. Ill. p. 28.

*11 *Landscape with Balloon.* Frankfurt, 1917. Oil on canvas, 29¾×39½". Wallraf-Richartz-Museum, Cologne. Ill. p. 26.

*12 *The Night.* Frankfurt, 1918–19. Oil on canvas, 52⅜×60½". Kunstsammlung Nordrhein-Westfalen, Düsseldorf. Ill. p. 31.

*13 *Synagogue in Frankfurt.* Frankfurt, 1919. Oil on canvas, 35½×55⅛". Private collection. Ill. p. 30.

*14 *Family Picture.* Frankfurt, 1920. Oil on canvas, 25⅝×39¾". The Museum of Modern Art, New York, gift of Abby Aldrich Rockefeller. Ill. p. 34.

*15 *The Dream.* Frankfurt, 1921. Oil on canvas, 71¾×35⅞". Collection Mr. and Mrs. Morton D. May, St. Louis. Ill. p. 33.

*16 *Iron Footbridge in Frankfurt.* Frankfurt, 1922. Oil on canvas, 47¼×33¼". Collection Richard L. Feigen, Chicago. Ill. p. 38.

*17 *Self-Portrait with a Cigarette.* Frankfurt, 1923. Oil on canvas, 23¾×15⅞". The Museum of Modern Art, New York, gift of Dr. and Mrs. F. H. Hirschland. Ill. p. 37.

18 *Spring Landscape (Park Louisa in Frankfurt).* Frankfurt, 1924. Oil on canvas, 37⅝×21⅝". Collection Frau Lilly von Schnitzler-Mallinckrodt, Murnau.

19 *Reclining Nude.* Frankfurt, 1924. Oil on canvas, 19⅛×24". Collection Dr. Peter Beckmann, Munich-Gauting.

*20 *Portrait of Quappi.* Frankfurt, 1925. Oil on canvas, 49⅝×19⅝". Collection Mrs. Mathilde Q. Beckmann, New York. Ill. p. 43.

*21 *Self-Portrait in Sailor Hat.* Frankfurt, 1926. Oil on canvas, 39⅜×27½". Collection Richard L. Feigen, Chicago. Ill. p. 42.

*22 *Duchessa di Malvedi.* Frankfurt, 1926. Oil on canvas, 26¼×10⅝". Collection Günther Franke, Munich. Ill. p. 44.

*23 *Old Actress.* Frankfurt, 1926. Oil on canvas, 46¾×35⅛". Collection Mr. and Mrs. Jean Mauzé, New York. Ill. p. 45.

*24 *Quappi in Blue.* Frankfurt, 1926. Oil on canvas, 23⅝×14⅛". Collection Günther Franke, Munich. Ill. p. 44.

25 *The Bark.* Frankfurt, 1926. Oil on canvas, 71¾×35½". Collection Richard L. Feigen, Chicago.

*26 *Portrait of Zeretelli.* Frankfurt, 1927. Oil on canvas, 55¼×37¾". Fogg Art Museum, Harvard University, Cambridge, Massachusetts, gift of Louise and Joseph Pulitzer, Jr. Ill. p. 46.

*27 *Self-Portrait in Tuxedo.* Frankfurt, 1927. Oil on canvas, 54½×37¾". Busch-Reisinger Museum, Harvard University, Cambridge, Massachusetts. Ill. p. 40.

*28 *View of Genoa.* Frankfurt, 1927. Oil on canvas, 35⅝×66⅞". Collection Mr. and Mrs. Morton D. May, St. Louis. Ill. p. 47.

29 *The Gypsy.* Frankfurt (1928). Oil on canvas, 53×22⅞". Kunsthalle, Hamburg.

*30 *Still Life with Candles.* Frankfurt, 1929. Oil on canvas, 22×24¾". The Detroit Institute of Arts. Ill. p. 49.

31 *Reclining Nude.* Frankfurt (1929). Oil on canvas, 33⅞×48⅜". Collection Mr. and Mrs. Morton D. May, St. Louis.

*32 *Carnival in Paris*. Paris (1930). Oil on canvas, 82⁵/₈×39³/₈". Collection Günther Franke, Munich, Ill. p. 52.

33 *The Bath*. Paris (1930). Oil on canvas, 68¹/₄×48". Collection Mr. and Mrs. Morton D. May, St. Louis.

34 *The Party (Society Gesellschaft)*. Paris, 1931; worked over and finished, Amsterdam, 1947. Oil on canvas, 43×69". Collection Stanley J. Seeger, Jr., Frenchtown, New Jersey.

*35 *Man and Woman*. Frankfurt, 1932. Oil on canvas, 68×48". Collection Dr. and Mrs. Stephan Lackner, Santa Barbara, California. Ill. p. 51.

*36 *Self-Portrait in Hotel*. Frankfurt, 1932. Oil on canvas, 46¹/₂×19³/₄". Collection Dr. Peter Beckmann, Munich-Gauting. Ill. p. 53.

37 *Morning*. (c. 1932). Oil on canvas, 16×31¹/₂". Collection Dr. and Mrs. Stephan Lackner, Santa Barbara, California.

*38 *Departure*. Frankfurt—Berlin (1932–33). Oil on canvas; triptych, center panel 84³/₄×45³/₈"; side panels each 84³/₄×39¹/₄". The Museum of Modern Art, New York, given anonymously (by exchange). Ill. p. 59.

*39 *Moonlit Night on the Walchensee*. Ohlstadt, 1933. Oil on canvas, 29¹/₂×30³/₄". Collection Frau Lilly von Schnitzler-Mallinckrodt, Murnau. Ill. p. 62.

*40 *Self-Portrait with Beret*. Berlin (1934). Oil on canvas, 39³/₈×27¹/₂". Collection Frau Lilly von Schnitzler-Mallinckrodt, Murnau. Ill. p. 54.

*41 *Quappi with White Fur*. Amsterdam, 1937. Oil on canvas, 42⁷/₈×25¹/₄". Collection Ala Story, Santa Barbara, California. Ill. p. 66.

*42 *The King*. Amsterdam, 1937. Oil on canvas, 53¹/₄×39¹/₄". Collection Mr. and Mrs. Morton D. May, St. Louis. Ill. p. 67.

43 *Bathers in August*. Amsterdam, 1937. Oil on canvas, 60×52". Catherine Viviano Gallery, New York.

*44 *Birth*. Amsterdam, 1937. Oil on canvas, 47⁵/₈×69¹/₂". Galerie des 20. Jahrhunderts, Berlin. Ill. p. 68.

*45 *Death*. Amsterdam, 1938. Oil on canvas, 47⁵/₈×69¹/₂". Galerie des 20. Jahrhunderts, Berlin. Ill. p. 69.

*46 *Apache Dance*. Amsterdam (1938). Oil on canvas, 67×59¹/₂". Kunsthalle, Bremen. Ill. p. 71.

*47 *Dutch Landscape*. Amsterdam, 1938. Oil on canvas, 27¹/₂×21⁵/₈". Collection Dr. Peter Beckmann, Munich-Gauting. Ill. p. 73.

*48 *Self-Portrait with Horn*. Amsterdam, 1938. Oil on canvas, 42¹/₈×39³/₄". Collection Dr. and Mrs. Stephan Lackner, Santa Barbara, California. Ill. p. 64.

49 *Acrobats*. Amsterdam (1939). Oil on canvas; triptych, center panel 78¹/₂×67"; side panels each 78¹/₂×35¹/₂". Collection Mr. and Mrs. Morton D. May, St. Louis.

*50 *Acrobat on Trapeze*. Amsterdam, 1940. Oil on canvas, 57¹/₂×35¹/₂". Collection Mr. and Mrs. Morton D. May, St. Louis. Ill. p. 74.

51 *Two Women*. Amsterdam, 1940. Oil on canvas, 31¹/₂×23⁵/₈". Wallraf-Richartz-Museum, Cologne.

*52 *Double Portrait of Max and Quappi*. Amsterdam, 1941. Oil on canvas, 76³/₈×35". Stedelijk Museum, Amsterdam. Ill. p. 76.

*53 *The Actors*. Amsterdam, 1942. Oil on canvas; triptych, center panel 78¹/₂×59"; side panels each 78¹/₂×33". Fogg Art Museum, Harvard University, Cambridge, Massachusetts. Ill. p. 80.

54 *Head of Woman on Gray (The Egyptian)*. Amsterdam, 1942. Oil on canvas, 23⁵/₈×11³/₄". Private collection.

*55 *Odysseuss and Calypso*. Amsterdam, 1943. Oil on canvas, 59×45⁵/₈". Kunsthalle, Hamburg. Ill. p. 78.

*56 *City of Brass*. Amsterdam, 1944. Oil on canvas, 41³/₈×59". Saarland-Museum, Saarbrücken. Ill. p. 79.

*57 *Portrait of Family L*. Amsterdam, 1944. Oil on canvas, 70⁵/₈×33¹/₂". Collection Dr. H. Lütjens, Amsterdam. Ill. p. 77.

58 *Self-Portrait*. Amsterdam, 1944. Oil on canvas, 37³/₈×23⁵/₈". Bayerische Staatsgemäldesammlungen, Munich.

59 *Self-Portrait*. Amsterdam, 1945. Oil on canvas, 23³/₄×19⁵/₈". The Detroit Institute of Arts.

*60 *Blindman's Buff*. Amsterdam, 1945. Oil on canvas; triptych, center panel 80⁷/₈×90³/₄"; side panels each 75¹/₂×43¹/₂". The Minneapolis Institute of Arts. Ill. p. 83.

*61 *Removal of the Sphinxes*. Amsterdam, 1945. Oil on canvas, 51×55". Collection Dr. H. Lütjens, Amsterdam. Ill. p. 85.

*62 *Olympia*. Amsterdam, 1946. Oil on canvas, 35¹/₂×59¹/₄". Collection Mr. and Mrs. Morton D. May, St. Louis. Ill. p. 86.

*63 *Still Life with Pears and Orchids*. Amsterdam (1946). Oil on canvas, 35¹/₂×35¹/₂". Collection Mrs. Mathilde Q. Beckmann, New York. Ill. p. 87.

*64 *Curt Valentin and Hanns Swarzenski*. Amsterdam, 1946. Oil on canvas, 51×29³/₄". Collection Mr. and Mrs. Hanns Swarzenski, Cambridge, Massachusetts. Ill. p. 88.

65 *Baou de St. Jeannet*. Amsterdam (1947). Oil on canvas, 31¹/₂×39¹/₄". Collection Mr. and Mrs. Perry T. Rathbone, Cambridge, Massachusetts.

66 *Euretta*. St. Louis, 1947. Oil on canvas, 36¹/₂×30¹/₂". Collection Mr. and Mrs. Perry T. Rathbone, Cambridge, Massachusetts.

67 *Christ in Limbo*. St. Louis (1948). Oil on canvas, 31×42³/₄". Collection Mrs. Mathilde Q. Beckmann, New York.

68 *Portrait of Quappi in Gray*. St. Louis, 1948. Oil on canvas, 42³/₄×31". Collection Joseph H. Louchheim, New York.

*69 *Wally Barker*. St. Louis, 1948. Oil on canvas, 45×25". Collection Mrs. Malcolm K. Whyte, Milwaukee. Ill. p. 92.

*70 *Fisherwomen*. Amsterdam (1948). Oil on canvas, 74×54⁵/₈". Collection Mr. and Mrs. Morton D. May, St. Louis. Ill. p. 93.

*71 *The Cabins*. Amsterdam (1949). Oil on canvas, 55×76". Collection Mrs. Mathilde Q. Beckmann, New York. Ill. p. 95.

72 *Mirrors*. New York, 1949. Oil on canvas, 24×18". Catherine Viviano Gallery, New York.

73 *Colorado Landscape*. New York (1949). Oil on canvas, 56×36". Collection Mr. and Mrs. Morton D. May, St. Louis.

74 *Hotel Lobby (The Plaza)*. New York, 1950. Oil on canvas, 56×35". Albright-Knox Art Gallery, Buffalo, New York, Room of Contemporary Art.

75 *Columbine*. New York, 1950. Oil on canvas, 53¹/₂×39³/₄". Collection Mrs. Mathilde Q. Beckmann, New York.

*76 *Falling Man.* New York, 1950. Oil on canvas, 55¹/₂×35″. Collection Mrs. Mathilde Q. Beckmann, New York. Ill. p. 96.

*77 *Self-Portrait in Blue Jacket.* New York, 1950. Oil on canvas, 55¹/₈×35⁷/₈″. Collection Mr. and Mrs. Morton D. May, St. Louis. Ill. p. 90.

*78 *The Argonauts.* New York (1950). Oil on canvas; triptych, center panel 80¹/₄×48″; side panels each 74³/₈×33″. Collection Mrs. Mathilde Q. Beckmann, New York. Ill. p. 99.

DRAWINGS AND WATERCOLORS

*79 *Mink.* Berlin, 1905. Pencil, 6¹/₄×5⁷/₈″. Collection Dr. Peter Beckmann, Munich-Gauting. Ill. p. 106.

80 *Self-Portrait.* Berlin, 1912, Pencil, 9¹/₂×8¹/₄″. Collection Dr. Peter Beckmann, Munich-Gauting.

81 *Burning Ruins.* Neidenburg, East Prussia, 1914. Pen and ink and wash, 12¹/₄×18¹/₂″. Collection Erhard Göpel, Munich.

82 *Self-Portrait.* Frankfurt, 1917. Pen and ink, 20¹/₈×13″. Collection Prof. Th. Garve, Hamburg.

*83 *Fridel Battenberg.* Frankfurt, 1918. Pencil, 18³/₄×13¹/₈″. Collection Prof. Th. Garve, Hamburg. Ill. p. 106.

84 *The Prodigal Son.* Frankfurt (1921). Series of 4 paintings; gouache on parchment, measurements without margins:
 The Prodigal Son among Courtesans. 7³/₄×8″.
 The Prodigal Son among Swine. 8¹/₄×8″.
 The Return of the Prodigal. 8×8″.
 The Feast of the Prodigal. 7¹/₂×8″.
The Museum of Modern Art, New York, purchase.

85 *Study for* The Rumanian Girl. Frankfurt (1922). Pencil, 25×18″. Kunsthalle, Bremen.

*86 *Minna Beckmann-Tube.* Graz, 1923. Pencil, 13³/₄×9″. Collection Günther Franke, Munich. Ill. p. 107.

*87 *Carnival in Naples.* Frankfurt (1925); worked over and signed in Amsterdam, 1944. Brush with India ink, crayon and chalk, 39¹/₂×27³/₈″. The Art Institute of Chicago. Ill. p. 110.

88 *Quappi Beckmann.* Vienna, 1925. Pencil, 18⁷/₈×12⁵/₈″. Collection Erhard Göpel, Munich.

89 *Boy with Lobster.* Frankfurt, 1926. Charcoal and gouache, 23³/₄×17⁷/₈″. Collection Mr. and Mrs. Richard S. Davis, London.

90 *Woman, half-nude.* Frankfurt, 1926. Pen and ink and wash, 25×13″. Catherine Viviano Gallery, New York.

*91 *Rimini.* Frankfurt, 1927. Pastel, 19¹/₈×25¹/₄″. Collection Günther Franke, Munich. Ill. p. 108.

92 *Bathers.* Frankfurt, 1928. Pastel and gouache, 34×22¹/₂″. The Art Institute of Chicago, gift of Mr. and Mrs. Stanley M. Freehling.

*93 *Quappi with Candle.* Frankfurt, 1928. Black and white chalk, 24¹/₄×18³/₄″. Kupferstichkabinett, Kunstmuseum, Basel. Ill. p. 107.

94 *The Oarsman.* Frankfurt, 1928. Black chalk, 20¹/₄×28³/₈″. Collection Günther Franke, Munich.

95 *Ulysses and the Siren.* Berlin, 1933. Watercolor, 39×26″. Collection Mr. and Mrs. Allan Frumkin, Chicago.

*96 *Brother and Sister.* Berlin, 1937. Watercolor, 25¹/₂×19³/₄″. Collection Mrs. Mathilde Q. Beckmann, New York. Ill. p. 56.

97 *The Chained One.* Amsterdam (1944). Pen and ink, 16×9⁷/₈″. The Museum of Modern Art, New York, gift of Curt Valentin.

98 *The Iceman.* Amsterdam (1944). Pen and ink, 14¹/₄×5¹/₈″. The Museum of Modern Art, New York, The John S. Newberry Collection.

*99 *Double Portrait (Max and Quappi).* Amsterdam, 1944. Pen and ink, 16×10″. Collection Mr. and Mrs. Perry T. Rathbone, Cambridge, Massachusetts. Ill. p. 105.

*100 *Champagne Fantasy.* Amsterdam, 1945. Pen and ink and wash, 19³/₄×10¹/₂″. Collection Mr. and Mrs. Frederick Zimmermann, New York. Ill. p. 109.

101 *Café.* Amsterdam, 1945. Pen and ink and watercolor, 17¹/₂×12″. Catherine Viviano Gallery, New York.

102 *Butshy.* Amsterdam, 1945. Pen and ink, 19¹/₂×11¹/₄″. Collection Mrs. Mathilde Q. Beckmann, New York.

103 *Dream of Three-headed Woman.* Amsterdam (1945). Pen and ink and watercolor, 12⁵/₈×9″. Collection Mrs. Mathilde Q. Beckmann, New York.

104 *Father Christmas.* Amsterdam (c. 1946). Pen and ink, 9⁷/₈×13⁵/₈″. City Art Museum of St. Louis.

105 *Path through Fields.* Laren, 1946. Pen and ink, 10¹/₄×8¹/₄″. Collection Erhard Göpel, Munich.

106 *Return from the Graveyard.* Amsterdam, 1946. Pen and ink, 10¹/₄×12³/₄″. Catherine Viviano Gallery, New York.

*107 *Woman Reading.* Amsterdam, 1946. Pen and ink, 12⁷/₈×19⁷/₈″. Collection Mrs. Mathilde Q. Beckmann, New York. Ill. p. 108.

*108 *Self-Portrait.* Amsterdam, 1946. Pen and ink and wash, 12³/₄×5⁷/₈″. Collection Dr. H. Lütjens, Amsterdam. Ill. p. 105.

109 *Primordial Landscape.* Amsterdam (1946); worked on later in St. Louis, 1948–49. Gouache and ink, 19³/₄×25¹/₂″. Collection Miss Jane Sabersky, New York.

110 *Study for* The Sacrificial Meal. St. Louis, 1947. Watercolor and ink, 19¹/₂×12″. Collection John S. Newberry, New York.

*111 *Meeting.* St. Louis, 1947. Pen and ink, 13×19¹/₂″. Collection Mrs. Mathilde Q. Beckmann, New York. Ill. p. 111.

112 *The Chapel, Washington University Campus.* St. Louis (1948). Charcoal, 13¹/₂×12³/₈″. Collection Mrs. Mathilde Q. Beckmann, New York.

113 *Perry T. Rathbone.* St. Louis (1948); signed and dated 1950. Pencil, 10³/₄×7⁷/₈″. Collection Mr. and Mrs. Perry T. Rathbone, Cambridge, Massachusetts.

114 *Fred Conway.* St. Louis, 1949. Charcoal, 23⁵/₈×17³/₄″. Catherine Viviano Gallery, New York.

115 *Woman with Hand on Face.* St. Louis, 1949. Crayon, 23×17⁵/₈″. Catherine Viviano Gallery, New York.

116 *Man with Fish.* Boulder, Colorado, 1949. Brush with India ink and chalk, 23³/₄×17³/₄″. Kunsthalle, Hamburg.

117 *Portrait of Edie Rickey.* St. Louis (1949). Charcoal, 19¹/₈×13″. Catherine Viviano Gallery, New York.

*118 *Portrait of Marion Greenwood.* New York (1950). Charcoal, 23³/₄ × 17⁷/₈". Catherine Viviano Gallery, New York. Ill. p. 109.

119 *Portrait of W. R. Valentiner.* New York (1950). Charcoal, 22⁷/₈ × 17⁵/₈". North Carolina Museum of Art, Raleigh, North Carolina.

PRINTS

This section is based on the catalogue of Beckmann prints compiled by Klaus Gallwitz for the exhibition *Max Beckmann, Die Druckgraphik* at the Badischer Kunstverein, Karlsruhe, August 27–November 18, 1962. Gallwitz catalogue numbers for each entry are in parentheses. Dimensions of etchings and drypoints are plate size; lithographs and woodcuts are composition size.

*120 *Self-Portrait.* 1901. Drypoint, 8¹/₂ × 5¹/₈". (G. 1). Collection Dr. Peter Beckmann, Munich-Gauting. Ill. p. 114.

*121 *Self-Portrait.* 1904. Drypoint, 8⁷/₈ × 7". (G. 2). Collection Klaus Piper, Munich. Ill. p. 114.

122 *The Return of Eurydice.* (1909). Illustration to *Eurydikes Wiederkehr* by Johannes Guthmann, Berlin, Paul Cassirer, 1909. Plate 8 of 9 lithographs, 7⁷/₈ × 6⁹/₁₆". (G. 3/8). The date "1911" inscribed lower center in pencil is erroneous. The Museum of Modern Art, New York, gift of J. B. Neumann.

123 *David and Bathsheba.* (1911). Lithograph, hand-colored, 12³/₈ × 9⁷/₈". (G. 14). Collection Mrs. Mathilde Q. Beckmann, New York.

*124 *The Bath of the Convicts.* 1912. Illustration to *Aus einem Totenhaus (House of the Dead)* by Dostoevski, Berlin, Paul Cassirer. Plate 8 of 9 lithographs, 7¹/₄ × 5¹/₂". (G. 28/8). Collection Allan Frumkin, Chicago. Ill. p. 116.

*125 *Self-Portrait.* 1912. Drypoint, 5⁷/₈ × 4¹/₂". (G. 35). Collection Allan Frumkin, Chicago. Ill. p. 115.

*126 *Weeping Woman (The Widow).* (1914). Drypoint, 9¹³/₁₆ × 7⁷/₁₆". (G. 49 b). The Museum of Modern Art, New York, gift of Abby Aldrich Rockefeller. Ill. p. 21.

*127 *Self-Portrait.* (1914). Drypoint, 9¹/₈ × 7". (G. 51). The Museum of Modern Art, New York, gift of Paul J. Sachs. Ill. p. 115.

*128 *Carrying the Wounded.* 1914. Drypoint, 6¹/₄ × 4³/₄". (state prior to G. 52 a). Collection Allan Frumkin, Chicago. Ill. p. 22.

*129 *Carrying the Wounded.* 1914. Drypoint, 6¹/₄ × 4³/₄". (G. 52 b). Collection Allan Frumkin, Chicago. Ill. p. 22.

*130 *Declaration of War.* 1914. Drypoint, 7⁷/₈ × 9⁷/₈". (cf. G. 57; first state, not mentioned by Gallwitz). The Museum of Modern Art, New York, purchase. Ill. p. 22.

*131 *The Morgue.* 1915. Drypoint, 10¹/₈ × 14¹/₈". (G. 59). The Museum of Modern Art, New York, purchase. Ill. p. 23.

132 *Party (Gesellschaft).* (1915). Drypoint, 10¹/₄ × 12¹/₂". (G. 63 b). The Museum of Modern Art, New York, purchase.

FACES (GESICHTER). Portfolio of 19 drypoints and etchings, published by Marées Gesellschaft, R. Piper & Co., Munich, 1919.

*133 *Evening (Self-Portrait with the Battenbergs).* (1916). Drypoint, 9⁷/₁₆ × 7". FACES, plate 10. (G. 67). The Museum of Modern Art, New York, purchase. Ill. p. 116.

*134 *Self-Portrait with Burin.* (1917). Drypoint and etching, 11³/₄ × 9³/₈". FACES, plate 1. (G. 82 b). The Museum of Modern Art, New York, gift of Edgar Kaufmann, Jr. Ill. p. 112.

135 *Happy New Year.* 1917. Drypoint, 9¹/₄ × 11³/₄". FACES, plate 17. (G. 86). The Museum of Modern Art, New York, gift of Victor S. Riesenfeld.

136 *Landscape on the River Main.* (1918). Drypoint, 9⁷/₈ × 11³/₄". FACES, plate 6. (G. 99). The Museum of Modern Art, New York, purchase.

137 Illustration to *Die Fürstin (The Princess)* by Kasimir Edschmid, Weimar, Gustav Kiepenheuer, 1918. Plate 2. Drypoint, 7¹/₈ × 5¹/₂". (G. 89/2). The Museum of Modern Art, New York, gift of Mrs. Bertha M. Slattery.

HELL (DIE HÖLLE). Portfolio of 10 lithographs and title page, published by J. B. Neumann, Berlin, 1919.

138 *Ideologists.* (1919). Lithograph, 28³/₁₆ × 19³/₄". HELL, plate 5. (G. 118). The Museum of Modern Art, New York, Larry Aldrich Fund.

139 *The Night.* (1919). Lithograph, 21⁷/₈ × 27⁵/₈". HELL, plate 6. (G. 119). The Museum of Modern Art, New York, purchase.

140 *The Family.* (1919). Lithograph, 29⁷/₈ × 18³/₈". HELL, plate 10. (G. 123). The Museum of Modern Art, New York, Larry Aldrich Fund.

*141 *Portrait of J. B. Neumann.* (1919). Drypoint, 8³/₈ × 6⁷/₈". (G. 125 b). Collection Allan Frumkin, Chicago. Ill. p. 120.

142 *Old Lady in Bonnet.* (1920). Drypoint, 11³/₄ × 7¹³/₁₆". (G. 131). The Museum of Modern Art, New York, purchase.

*143 *Woman with Candle.* (1920). Woodcut, with watercolor, 11³/₄ × 6". (G. 143 b). Collection Mrs. Mathilde Q. Beckmann, New York. Ill. p. 121.

*144 *Self-Portrait with Bowler Hat.* 1921. Drypoint, 12⁵/₁₆ × 9⁵/₈". (G. 153 a). The Museum of Modern Art, New York, given anonymously. Ill. p. 117.

*145 *Self-Portrait with Bowler Hat.* (1921). Drypoint, 12³/₄ × 9³/₄". (G. 153 d). The Museum of Modern Art, New York, gift of Edward M. M. Warburg. Ill. p. 117.

146 *Dostoevski II.* (1921). Drypoint, 6⁵/₈ × 4⁵/₈". (G. 160). The Museum of Modern Art, New York, Larry Aldrich Fund.

147 *Portrait of Georg Swarzenski.* 1921. Lithograph, 16 × 8¹/₄". (G. 161). Museum of Fine Arts, Boston.

ANNUAL FAIR (JAHRMARKT). 1921. Portfolio of 10 drypoints, published by Marées Gesellschaft, R. Piper & Co. (Meier-Graefe, ed.), Munich, 1922.

148 *The Barker.* (1921). Drypoint, 13¹/₄ × 10⁷/₁₆". ANNUAL FAIR, plate 1. (G. 163). The Museum of Modern Art, New York, purchase.

149 *Behind the Scenes (Garderobe I).* (1921). Drypoint, 8¹/₄ ×

THE MUSEUM OF MODERN ART PUBLICATIONS IN REPRINT

AN ARNO PRESS COLLECTION

Abbott, Jere. *Lautrec-Redon.* 1931

Art in Progress. 1944

Barr, Alfred H., Jr., ed. *Art in Our Time.* 1939

Barr, Alfred H., Jr. *Cézanne, Gauguin, Seurat, Van Gogh.* 1929

Barr, Alfred H., Jr. *Cubism and Abstract Art.* 1936

Barr, Alfred H., Jr. *Fantastic Art, Dada, Surrealism.* 1936, 1937, 1947

Barr, Alfred H., Jr. *Matisse, His Art and His Public.* 1951

Barr, Alfred H., Jr. *Modern German Painting and Sculpture.* 1931

Barr, Alfred H., Jr. *The New American Painting as Shown in Eight European Countries.* 1958-59

Barr, Alfred H., Jr. *Picasso: Fifty Years of His Art.* 1946-55

Barr, Alfred H., Jr. *Vincent Van Gogh.* 1935-42

Barr, Alfred H., Jr., et al. *Three American Modernist Painters: Max Weber, Maurice Sterne, Stuart Davis.* 1930, 1933, 1950

Barr, Alfred H., Jr., Henry McBride, Andrew Carnduff Ritchie. *Three American Romantic Painters: Burchfield, Stettheimer, Watkins.* 1930, 1946, 1950

Barr, Alfred H., Jr., Lincoln Kirstein, Julien Levy. *American Art of the 20's and 30's.* 1929, 1930, 1932

Barr, Margaret Scolari. *Medardo Rosso.* 1963

Bayer, Herbert, Walter Gropius, Ise Gropius. *Bauhaus: 1919-1928.* 1938

Bennett, Wendell C., and René d'Harnoncourt. *Ancient Art of the Andes.* 1954

Cahill, Holger. *American Folk Art.* 1932

Cahill, Holger. *American Painting and Sculpture: 1862-1932.* 1932

Cahill, Holger. *American Sources of Modern Art.* 1933

Cahill, Holger. *New Horizons in American Art.* 1936

Cahill, Holger, et al. *Masters of Popular Painting.* 1938

Douglas, Frederic H., and René d'Harnoncourt. *Indian Art of the United States.* 1941

Drexler, Arthur. *The Architecture of Japan.* 1955

Eliot, T.S., Herbert Read, et al. *Britain at War.* 1941

The Film Index: A Bibliography. 1941

Frobenius, Leo, and Douglas C. Fox. *Prehistoric Rock Pictures in Europe and Africa.* 1937

Haftmann, Werner, Alfred Hentzen, William S. Lieberman. *German Art of the Twentieth Century.* 1957

Hitchcock, Henry-Russell. *Latin American Architecture Since 1945.* 1955

Hitchcock, Henry-Russell, Philip Johnson, Lewis Mumford. *Modern Architecture: International Exhibition.* 1932

Hitchcock, Henry-Russell, and Catherine K. Bauer. *Modern Architecture in England.* 1937

Jayakar, Pupul, and John Irwin. *Textiles and Ornaments of India.* 1956

Johnson, Philip. *Machine Art.* 1934

Kaufmann, Edgar, Jr. *What Is Modern Design?* and *What Is Modern Interior Design?* 1950-53

Paul Klee: *Three Exhibitions.* 1930, 1941, 1949

Lieberman, William S. *Max Ernst.* 1961

Lieberman, William S. *Edvard Munch.* 1957

Linton, Ralph, and Paul Wingert. *Arts of the South Seas.* 1946

McBride, Henry, Marsden Hartley, E.M. Benson. *John Marin.* 1936

Miller, Dorothy C., ed. *Americans 1942-1963: Six Group Exhibitions.* 1942-63

Miller, Dorothy C., and Alfred H. Barr, Jr. *American Realists and Magic Realists.* 1943

Mock, Elizabeth B. *The Architecture of Bridges.* 1949

Mock, Elizabeth B., Henry-Russell Hitchcock, Arthur Drexler. *Built in U.S.A.(1932-1944* and *Post-War Architecture.* 1944-52

Noyes, Eliot F. *Organic Design in Home Furnishings.* 1941

Paine, Frances Flynn. *Diego Rivera.* 1931

Read, Herbert, et al. *Five European Sculptors.* 1930-48

Rich, Daniel Catton. *Henri Rousseau*. 1946

Ritchie, Andrew Carnduff. *Abstract Painting and Sculpture in America*. 1951

Ritchie, Andrew Carnduff. *Charles Demuth*. 1950

Ritchie, Andrew Carnduff. *Masters of British Painting 1800-1950*. 1956

Ritchie, Andrew Carnduff. *Sculpture of the Twentieth Century*. 1952

Ritchie, Andrew Carnduff, et al. *Three Painters of America: Charles Demuth, Charles Sheeler, Edward Hopper*. 1933, 1939, 1950

Ritchie, Andrew Carnduff. *Edouard Vuillard*. 1954

Rogers, Meyric R., et al. *Four American Painters: Bingham, Homer, Ryder, Eakins*. 1930-35

Schardt, Alois J., et al. *Feininger-Hartley*. 1944

Seitz, William C. *Arshile Gorky*. 1962

Seitz, William C. *Hans Hofmann*. 1963

Seitz, William C. *Claude Monet*. 1960

Seitz, William C. *Mark Tobey*. 1962

Selz, Peter. *Max Beckmann*. 1964

Selz, Peter. *The Work of Jean Dubuffet*. 1962

Selz, Peter. *New Images of Man*. 1959

Selz, Peter. *Emil Nolde*. 1963

Selz, Peter. *Mark Rothko*. 1961

Selz, Peter, and Mildred Constantine, eds. *Art Nouveau*. 1961

Soby, James Thrall, ed., *Arp*. 1958

Soby, James Thrall. *Giorgio de Chirico*. 1955

Soby, James Thrall. *Contemporary Painters*. 1948

Soby, James Thrall. *Salvador Dali*. 1946

Soby, James Thrall. *Juan Gris*. 1958

Soby, James Thrall. *Joan Miró*. 1959

Soby, James Thrall. *Modigliani*. 1951

Soby, James Thrall. *Georges Rouault*. 1947

Soby, James Thrall. *Yves Tanguy*. 1955

Soby, James Thrall. *Tchelitchew*. 1942

Soby, James Thrall, and Dorothy C. Miller. *Romantic Painting in America*. 1943

Soby, James Thrall, and Alfred H. Barr, Jr. *Twentieth-Century Italian Art*. 1949

Sweeney, James Johnson. *African Negro Art*. 1935

Sweeney, James Johnson. *Marc Chagall*. 1946

Sweeney, James Johnson, et al. *Five American Sculptors*. 1935-54

Sweeney, James Johnson. *Joan Miró*. 1941

Tannenbaum, Libby. *James Ensor*. 1951

Twenty Centuries of Mexican Art. 1940

Wheeler, Monroe. *Soutine*. 1950